# Women of the Underground: Art
## Cultural Innovators Speak for Themselves

# Women of the Underground: Art

## Cultural Innovators Speak for Themselves

### Interviews by
### Zora von Burden

Manic D Press
San Francisco

*Dedicated to the freedom that artistic creative expression brings*
*and*
*to my love Michael Slavinsky*

Disclaimer: Opinions and statements made by the interview subjects herein do not necessarily reflect the views of the editor or publisher, nor have any statements by the interview subjects been verified for accuracy.

Cover photo: Irina Ionesco. self-portrait, courtesy of the artist

*Library of Congress Cataloging-in-Publication Data*

Burden, Zora von, 1968-
 Women of the underground : art : cultural innovators speak for themselves / interviews by Zora von Burden.
     pages cm -- (Women of the underground)
 ISBN 978-1-933149-33-2 (pbk.) -- ISBN 978-1-933149-72-1 (ebook)
 1. Women artists--Interviews.  I. Title.
 NX164.W65B87 2012
 704'.042--dc23
                         201203537

# Table of Contents

# Introduction

This book explores the minds behind the work of contemporary women artists who have acted as cultural architects, influencing generations with art that is innovative, pushes boundaries, and dares to question, investigate, and redefine society in the spirit of the underground. Their art retains a truth and combines uniqueness with personal integrity and vision. These women use their art, not only as a form of expression but as a call to arms for justice, equality, and transformation, either on a personal level or for society as a whole.

Until the 20th century, women's creative skills were often relegated to craft and decorative arts, and their skills were valued predominantly for utilitarian purposes in service to facilitate others and in the manufacturing of products to benefit society. Women throughout history have been forced to create personal art in secret, were denied visibility, training, and schooling, and have remained, for the most part, self-taught. It was not until the 20th century, when women's rights became a reality in many countries, that women's art was truly acknowledged. The plight of oppression and ignorance towards women in art was depicted in Foundations of Modern Art (1952), in which artist and author Amedee Ozenfant states, "There is a hierarchy in the arts: decorative at the bottom, and the human form at the top. Because we are men!" The greatest injustice: women being denied the freedom and celebration of the human spirit that self-expression brings through art.

Art is often crucial to the development of one's intellect, the growth of one's psyche, and one's mental and physical wellbeing. It's integral to spiritual growth, the cognitive process, and divergent thoughts. Most importantly, it is a form of communication and exchange of ideas. With art, the body, mind, spirit, and the sacred spark of life all become one, so that a person may experience fulfillment. Art is a transcendental, metaphysical expression that lifts one up into the divine. With women being natural creators, art is their innate terrain. These women are revolutionary examples of this process. It is important to illustrate its contemporary history and cultural foundations in the artists' own words.

*Zora von Burden*

# Marina Abramovic

Marina Abramovic (born 1946; Belgrade, Yugoslavia) is a performance artist whose work focuses on the body's limitations and endurance under mental and physical extremes in pieces of long duration. Her work can last for hours or days, rooted in acts of personal, social, and political symbolism that border on the dangerous to life-threatening. These performances have involved an arrow pointed at her heart, standing in a star of flames, lying on a cross-shaped slab of ice or above lit candles on a metal bed frame, laborious repetitions of cleaning bones, ingesting combinations of psychotropic medications resulting in seizures or paralysis, and weeks without eating or talking. In *Rhythm 0*, Abramovic allowed the viewers to manipulate her body and use seventy-two objects on her to inflict pleasure or pain consisting of such items as a whip, gun, knives, thorns, and scissors. Though she mainly performs live, she has presented her art as audio, installation, photography, sculpture, and film in museums and galleries worldwide. Some of her most notable works include *Rhythm 10* (1973), *Rhythm 5* (1974), *Rhythm 2* (1974), *Rhythm 0* (1974), *Balkan Baroque* (1997), and *Public Body-Artist Body* (1998). In 1976, Marina met performance artist Uwe Laysiepen, known as Ulay, which lead to collaborative work investigating the themes of melding duality and the union of identity. After numerous performances, their work together ended with *The Great Wall Walk* (1988). In 2005, Abramovic performed *Seven Easy Pieces*, recreating five integral works from the formative years of performance art in the 1960s and 1970s. These performances were Bruce Nauman's *Body Pressure* (1974), Vito Acconci's *Seedbed* (1972), Valie Export's *Action Pants: Genital Panic* (1969), Gina Pane's *The Conditioning* (1973) and Joseph Beuys' *How to Explain Pictures to a Dead Hare* (1965), along with her own *Lips of Thomas* (1975) and *Entering the Other Side* (2005). After teaching at many art schools, she founded the Marina Abramovic Institute for the Preservation of Performance Art in Hudson, New York in 2007, devoted to the research and production of duration-based works of art. Her work has been exhibited in the Venice Biennial (1976/1997), the Whitney Biennial (2004), and New York's Guggenheim Museum (2005). She was awarded the Golden Lion for Best Artist at the Venice Biennial (1997) for *Balkan Baroque*, the Bessie (2003) for *House with the Ocean View*, and Best Exhibition of Time-Based Art from the U.S. Art Critics Association (2005/2006). She received an honorary doctorate from the Art Institute of Chicago in 2004 and University of Plymouth, UK in 2009. Marina has been the subject of many books, including the definitive title, *When Marina Abramovic Dies* (2010). New York's Museum of Modern Art held a major retrospective of Marina's work in 2010, *The Artist is Present*, in which she performed.

*What was your first performance piece and inspiration? Why express yourself in this artistic medium?*

*Rhythm 10* was my first performance. Up to that point, I had been making paintings and sound installations. The idea came after one day when I was walking in the streets of Belgrade and I looked up into the sky and saw ten military planes fly by, leaving traces of smoke in the sky which disappeared slowly. It appeared like an abstract painting. I thought it was so fascinating. After this, I went to the local military base and asked if I could use ten planes, so I could make my own abstract drawing in the sky. They, of course, refused and at that moment I decided that I would not return to painting, with its limitations and restrictions. I wanted to use elements like fire, water and most importantly, the body.

*What is most significant in your work and what have you learned from it?*

Well, every piece leads to another piece, it's an accumulative experience. So in the beginning of my work in the 1970s, before I started working with Ulay, the work was really about exploring the physical body on any kind of endurance level. Work with Ulay, it was on the same physical level but [with] the relationship of male and female energy. My latest work, which came from the experience of living with diverse cultures, especially my encounter with Aborigines, came to dealing with duration. After the *Wall of China Walk*, the piece where Ulay and I said goodbye, my work actually came to the public. I made several pieces with sensory objects like tools, sets, and props that would trigger the public's own experiences, and I didn't perform. Then I came back to learn; to performance again. The most interesting thing for me in the last period of my work was the durational pieces. I work with time in the pieces, performance that stops time. It's much more a mental level than physical. The physical level is always present because if you do work for long stretches, it's physically very draining but actually it addresses more the mental than physical powers.

*Can you give an example of one of these more recent works?*

*The House with the Ocean View*; it lasts for days. The piece is being used for the retrospective at the MoMA, which will be for three months. I will perform every single day, except for when the museum is closed.

*Was there a time when the audience, known to intervene out of concern for your safety, ended what could have continued on to a lengthier piece?*

I never once stopped a performance, even though I have been sick or hurt from time to time. I would never do this, at any cost. Regarding the audience, I consider whatever happens in those moments of the performance, both my actions and those of the audience, to be 100 percent valid in the work.

*Have you ever engaged in a performance that you regretted during the process?*

I did make one work called *Positive Zero*, which upon reflection, I think was misguided and I realized its failures during the piece. However, it was an important process and I learnt so much from it, so it's not regret at all.

*What is the driving force in testing the limits of the human body and psyche? Is your work provocative, reactive, or invocative?*

It is not about provocation, reaction or even invocation, it is about trans-formation; mentally and physically.

*What was the most dangerous performance you've done to date?*

I was never seriously injured but there were two occasions when I was not in control and there lies the danger. Once in *Rhythm 2*, where the audience was in control, and secondly in *Rest Energy* where Ulay was in control, pointing the lethal arrow at my heart.

*How did working with your partner Ulay change your perspective towards your work, yourself, your goals?*

I met Ulay at the right moment. My own work was becoming more and more destructive. I was unsure of a way out. In meeting and working with Ulay, we could create a new balance: of man and woman in a form--we called that self, the unity of two. We focused on the relationship of man/woman and how energy combined can create a third new energy.

*With* Rhythm 0 *and* Rhythm 5, *you push yourself to the point of being in danger of death; why did you go to these extremes? What was the expression you were creating with this type of extreme performance?*

Well, first with *Rhythm 5*, I didn't understand that the fires would take the oxygen, and this was my mistake. I was not aware that I would actually lose consciousness. So this experience brought me to thinking I would like to make

these pieces. Whether I was conscious or unconscious, I can actually still perform [and] experience performing in front of the public, pushing the body even farther but I never wanted to die. Aside from that piece, I never had any other accidents in my forty-plus year career. So, I created pieces like *Rhythm 2* and *Rhythm 4*. Those pieces are an example of pushing my body, conscious or not. After that I understood it's not necessary to repeat the same experience. I really think that staging danger in front of the public is very important because they put the public in the moment of here and now. I didn't want a presentation where they could escape somewhere else, they're always thinking about the past and the future, never actually living in the here and now. If you are in a dangerous position, with the public witnessing, both you and the public are in the here and now, and this is the only reality we have, which is the message I want to give.

*How do you prepare for a piece and how do you recover afterward? Do you take a long break between each piece because they are so exhausting?*

First off, I have to stress, it's not a break I have between pieces because I'm mentally or physically exhausted but it's just that I may not have any good ideas at the time. I think that it is very important to make one significant piece, than make many pieces in between. So for each piece, I need to have good ideas, even if it takes two or three years. I always take this approach with performance. I always hate the attitude towards performance, like we're entertainers. You know, people always send me emails, saying we are doing a big show at a museum and we would like you to make a performance at the opening. To me this is entertaining. My performances aren't dealing with that agenda or issue. Basically I don't prepare in any way, like people think I would prepare, like being vegetarian, doing Pilates, I don't do these things. I don't do yoga or mediation, any of this. I have a trainer now, who trains with me two times a week, which is normal conditioning of the body because I'm sixty-two, and I have to train so my body can remain flexible. But when I was younger, I didn't train at all. I think the will power and motivation is most important because I came to the understanding that even if you train for the Olympics and are in perfect health or physical condition, still your performance may lose if you don't have the mental determination and will, or a real understanding as to why you're doing it. It's very important. This part of my work, this ability, I think is genetic, I was born with it, it's not any kind of secret, it's just that I can't do it any other way.

*Is the exploration and application of suffering something that is more exclusive to a woman?*

I always refuse this approach of males versus females in art. You know, the art has to be one when dealing with important issues. Pain, suffering, dying, sexuality, life, all issues have been addressed by male and female artists since the beginning of humanity, it's nothing new. It's just the way of delivering things. I don't think there's a difference. Yes, a woman can give birth to a child which is a very painful experience but there are plenty of male heroes who've done lots of great things, too, so you could not make this division.

*Why did you choose the works you reprised in* Seven Easy Pieces? *How did you decide which of your own performances to contribute to this work?*

The choices are really very simple: these are performances I really admire, I like them but I never saw them myself. These are performances from the 1970s I would like to experience. For the pieces of my own, one piece was new, *Entering the Other Side* (2005). It was my choice to present a new piece. For the other, *The Lips of Thomas* was not my first choice because it was originally *Rhythm 0* but I could not get permission to use the piece in America. I could not do it in the museum. So this was my second choice [*The Lips of Thomas*], as it was one of the most complex pieces I've made, the other pieces are much more simple. It deals with so many autobiographical issues like communism, Christianity, my upbringing, the relationships with my mother and father.

*Have you sacrificed greatly for your art and work? Are you satisfied with it?*

You know, I come from a family who thinks sacrifice is a good thing. It's not sacrifice, it's my choice. I really love what I'm doing and I believe in it, so I don't feel dissatisfied ever. It's more of a passion, very satisfying. The only thing that I worry about when I do the work is that I won't be there 100 percent. I need to completely, unconditionally give to the piece, to the people, and only when I give my 100 percent it's beyond being good or bad. But if I know I haven't given 100 percent, then I get very upset and sick and I know the piece was not good. This is the only thing I demand from myself. I don't question, I don't even feel the sacrifice. There's nothing else I can do. It's like when someone asks, how do you know you're an artist? It's like asking about breathing, there's no questioning breathing, you just breathe, and it's the only way to live for me. The only way to live is for me to make the work that I'm doing.

*Does critique by your viewers mean anything to your work? Does the way in which people interpret your work affect it?*

No, it doesn't matter how they interpret it because everybody has a different interpretation. If you ask one person looking at a simple painting and ask twenty other people the same, what is their opinion, they will always have a different opinion. It's not really important; what's more important is if I really move them, emotionally. But I want to say the most important message of the work is the elevated spirit of the viewer. The public is very important to me, every single person is incredibly important to me, that they get what I'm trying to do, it doesn't have to be verbally but they have to feel it. When I succeed, I'm very happy. Another important thing for me is the young audience, that I really have the interest of the young audience to understand what I'm trying to say because they are the ones who can carry this message or idea.

*When you're finished with a piece, especially the dangerous ones and the pieces that require endurance, do you feel a sense of euphoria and empowerment?*

It's the same as after a concert, you have so much energy after, from the work and the energy of the public. It's incredible; it's such a wonderful feeling. It's the same kind of feeling of being a child, something very pure, simple.

*How is your Foundation for the Performing Arts coming along? Will you talk about its formation?*

All my life I wanted to have my own foundation, I wanted to have a foundation for the preservation of performance art. Because performance art comes and goes, in different periods it disappears completely from the art scene, then it's there again. So I really want to have something with workshops, a library full of books, people making finer tools to work with, also grants programs and it will present performances to the public. The Center would not only be performance, there will be dance, film, theater, with only one condition: every piece has to be long durational. I want everything to be from six hours on, so the public has to also come to learn and see how long performance works, what are the tools, and understand it. So this is really my legacy, the Foundation. I bought the building with the money from a house I sold in Holland years ago. And now I have to raise the funds to restore it, meeting codes, and using a lot of architects. I really believe in this, I put everything I have into this idea.

*In the early years, performance had a body-conscious focus. Has this changed? What do you see as more of the focus now?*

It's changing all the time, depending on the different tools. I think now it's a lot to do with sound and music. I really love the whole noise culture that

comes from Japan and how the body reacts to vibration. There's so much new technology. I think there will be another big time for performance but we're not there yet. I think my Center should help that. Technology has caused performance to move away from the body, it's going to be more virtual. When I see these new concepts, like second life programs, this is people thinking virtual. The performance has become virtual, it is very detached from your real experience, and it is more mental. It's quite interesting. But I think not only performances are going in that direction, entire humanity is going in this direction.

*Do you have a piece most memorable or precious to you?*

The most memorable and precious is always the last big one.

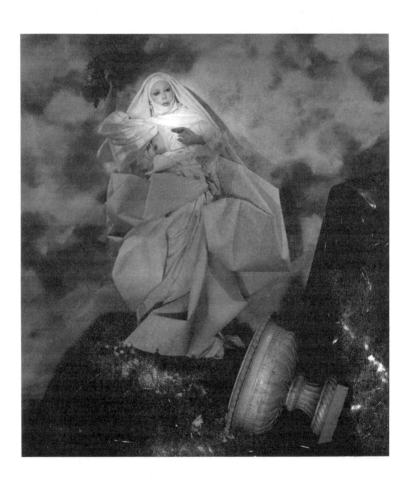

# Orlan

Orlan (born Mireille Suzanne Francette Porte, 1947; Saint-Étienne, France) is a controversial performance artist and feminist activist, whose own body is her canvas, used to break the concepts of conformity, beauty and aesthetic identity. Orlan has had herself surgically altered in numerous live performances, in what she calls "carnal art." She also works with video, sculpture, installation, and photography. She has taught as a professor and artist in residence at many universities internationally. She began exploring the female form and sexuality in her photographic works of black-and-white images called *Vintages* (1964-66). In 1971, she baptized herself Saint Orlan. Soon after, she exhibited herself with the new title as living sculpture, in a series of elaborately staged, Baroque-costumed pieces in photographic collages of tableaux vivants. In 1977, she performed *The Kiss of the Artist* at the FIAC Art Fair (Foire Internationale d'Art Contemporain), to confront the concepts of art and prostitution. In 1978, she created the International Symposium of Performance in Lyon, France. With her presentation of *The Draped, The Baroque* (1979-80), she examines the virgin/whore dichotomy. In 1982, she created the online art magazine *Art-Acces-Revue*. In 1989, Orlan wrote the *Manifesto of Carnal Art*, which resulted in her most infamous work: *The Reincarnation of Saint Orlan* (1990-93). These performances consisted of nine facial-altering surgeries that molded her face into an amalgamation of mythological goddesses and female imagery depicted in classic painting and sculpture throughout art history, as a confrontation of male- defined womanhood. According to the *Manifesto of Carnal Art*, Orlan's art "transforms the body into language" using her physical alterations as enlightened, informative messages, in opposition to the biblical passage regarding "the word made flesh." During the surgeries Orlan is awake, while they are broadcast live internationally to institutions and galleries as theatrical performances or artistic conceptual operas, and presented with props, music, readings and costumes. The surgeries are further produced into art in photo documentation, installations, books, and with remnants of the surgeries; blood drawings, reliquaries (containers of her flesh), shrouds, bloodied gauze and the worn costumes. In 1998, she began *Self-Hybridizations*; manipulated digital images confronting standards of beauty in various cultures. Orlan currently works out of Los Angeles, New York and Paris. In 2003, she was awarded the title Chevalier de l'ordre des Arts et des Lettres by the Minister of Culture in France and serves on the board of administrators at the Palais de Tokyo in Paris. She has collaborated with architects, photographers, musicians, scientists, fashion designers, and filmmakers such as David Cronenberg. Interview translated by Saori Ezuka.

*How does your work articulate the breaking of Western cultures' standard ideals of beauty, and what do you convey in your work?*

Every society, whether Western or not, creates images of normal bodies and gives us models to which we have to conform. All my performances, before my surgical operations, cited and questioned the history of Western art, based on the Christian culture. I've looked into and interrogated this culture, even though I was raised by parents who were anarchist, libertarian, anti-religious, nudist, Esperantist, etc. This interrogation is legitimized in the fact that I wanted to see how this culture portrayed the female body. With the surgical operations, I transformed an image, my image, which I loved very much, in photo, video, and sculpture, during the first part of my work. This work was also a way to "put a face" on my face of the representation. This series of surgical performances was titled *Images, New Images*. It was thus a question of creating a new image, showing that beauty could take a non-reputed form. I then decided, following the surgical operation practices between 1990 and 1993, to work solely with non-Western cultures. This allowed me to put our current standard of beauty in perspective. It was about having a new image to make new images by choosing a new point of reference that spoke of the accepting of the other within oneself.

*Why did you decide to use your own body as the canvas for your art?*

I started with sculpture, drawings and paintings. Then I decided to use the representation of "my body is my body" in the 1970s. At that time, women were demanding the right to sexual freedom, sexual pleasure, freedom of speech, and also the freedom to choose to have a child or not with abortion but also, of course, equality in the workforce as well as in the private life. Using one's own body was, at the time, political by choice. This work that questioned the social, cultural, religious, and political pressures that were put on the body was addressed in different ways; video, photography, sculpture, performance, object, installation, etc. I've always tried to find the right material to elaborate an idea. All my work is multimedia, pluri-disciplinary, and trans-disciplinary. As far as surgery is concerned, its usage was the choice for its literalness in showing the violence done to women's bodies in particular. That was a radical way to say it, but it was always about questioning the formatting we undergo.

*How are the procedures played out from beginning to end, and how do your surgeries become the performance?*

The surgical performance operations were put together from political, literary,

psychoanalytical, or philosophical texts. The operating room was completely invested. It became my art workshop, where I produced works of art; drawings that I did with my fingers and my blood, also medical gauzes that I recovered and dried and used for photographic transfers. In this operating room, I directed the photography, video, and film while answering the spectators' questions. The operation was retransmitted by satellite to the Centre Georges Pompidou in Paris, to the McLuhan Center in Toronto and in my gallery, Sandra Gering in New York, etc. The operating room was entirely redecorated, as was the surgical team; my team was dressed by famous designers, Paco Rabanne, Issey Miyake, etc. As a plastic surgery artist, it was about changing the aesthetic codes of the operating room in order to make it a place of joy and action and not a place where one suffered and where the power of the man can leave the biggest trace on the woman's body. Satellite transmissions allowed the images to go from private to public, and CNN News even came into the operating room in New York. It is worth noting that less than a year later, the show *Extreme Makeover* was created. This show showed plastic surgeries.

*What are examples of your most profound works, those which are most important and meaningful to you personally and to your audience?*

The works that transformed my life and also had the largest media audience were *The Kiss of the Artist*, the surgical operations, and currently my work on my cell culture elaborated from Michel Serres' text *Laïcité*, which talks about the Harlequin, among other things, as a metaphor of multiculturalism, hybridizing and the acceptance of the other within oneself. The works that weigh the most for me are my first photographic pieces *Vintages*, which I did between 1964 and 1966, as well as the series of documentary studies *The Draped—The Baroque*, the sculpture of folds, and the new works done with digital photography of The *Self-Hybridizations: Pre-Columbian, African, and American Indian.*

*Why does theology play a part in your work if you have also expressed a strong atheist message?*

I wrote the manifesto called *Carnal Art*, which clearly stated why I wanted to inscribe ideas in the flesh. I discovered the Christian religion through paintings because all paintings from a certain period were religious propaganda. In these paintings, I questioned the image of the woman through the Virgin, the Madonna, and the stereotypes of prostitutes, two stereotypes that were difficult to avoid.

*Why do you choose the particular works of art or female archetypes for your surgeries and transformations?*

I have three distinct works of art. The first is the surgical operations. The second is a piece of work constructed by media and popular newspapers. My work adopted a logic that was completely different and that isn't based on feminine models in the history of art like the media says. The moment of the surgery is a moment of intensity, a moment of the construction of video images. The third is the photographic works, the videos, the paintings, the films, and the objects that came out of these operations. They are full-fledged and autonomous, although it partly came out of this moment of intensity. It's a question of showing that the standards of beauty only hold value for a certain period in history, in a certain geographic area, and, that sometimes, it is about mini groups or social castes that are conforming to a dictator.

*How do alterations to your physical self affect your inner being? What is it like to see a constant flux of new exteriors of your body?*

The physical differences from my plastic surgeries don't change my interior. Not any more than a change of clothes, dress, or the color of my hair. What really transformed me are all the events and encounters that have come as a result of my surgeries and that have greatly nourished me.

*Has there been a surgery that you did not attempt because it was too dangerous to complete? How do you handle the pain involved?*

The first deal with the surgeon was that I wouldn't feel any pain, not during, not after, only the injection of anesthesia and then we only feel the strange sensations like we do at the dentist. I am against pain; I think it's anachronistic. The body suffered enough during the thousands of years when there wasn't even aspirin to ease the pain of a headache or a toothache.

*Has your art ever evolved into a spiritual process or is it purely based in the visceral and physical?*

When I say, "This is my body, this is my software," this means I don't know what [the] soul is, sometimes being a body, sometimes having a body.

*How long do you wear a particular image as living art before undergoing another alteration? Does the recovery time necessary to heal affect your work?*

I don't ever suffer, I don't ever submit, but I organize, I elaborate, I put in place, while being mindful of the balustrades and the guide rails with the maximum

distance possible. The projects are always difficult to finance. I am able to do them because of the good will of volunteers, but also because the surgeons with whom I've worked liked my work and were ready to exchange their work for my art. I have never sacrificed myself for my art. I created a work of art.

*How do you ensure its success and its placement? How do you handle negative responses, if any, for those sensitive to these images in your work?*

I had a big media success on behalf of a large audience. I touched a nerve by asking questions that we needed to ask in this day and age in the medium of surgery. I was the first artist to use surgery as a medium. The reactions were as they were for the Impressionists and for Malevich's *White on White*, some said it was brilliant, and others said that it wasn't art. I show images that sometimes make us blind; images that fall between the impossibility to see and the desire to see. What is strange is that within fine arts, we are, for the majority of the time, considered apartment decorators. It is easier to sell pieces that speak of nothing or of happiness. However, in the public of fine arts, there is often confusion and rejection.

*How does the vulnerability you must feel on the surgical table, broadcast and recorded for the world to see, aid in the process of your message?*

In the operating room, I don't feel vulnerable, but voluntary, leading, and strong. My work is controversial and my body has become a place of public debate. I have a lot of fans around the world, and a lot of universities have published texts on my works.

*Your work is so highly regarded that people purchase biological matter left from the surgeries, will you talk about this?*

You can actually buy the reliquaries that were made with an excerpt of Michel Serres' text, cited before. In each reliquary, the text is in a different language. In the middle, there are a few milligrams of my flesh. It's a relationship between flesh and the word, and it returns to the Christian principle of the word that becomes flesh in favor of the flesh that becomes the word.

*Are you content with the recognition you've had?*

I recently had my third retrospective of my works put on by Lorand Hegyi at the Museum of Modern Art at Saint-Étienne that was set up over 2,000 square meters. I also have some works of art in collections.

# Penny Arcade

Penny Arcade (born Susana Ventura, 1950; New Britain, Connecticut) is a performance artist, playwright, cultural icon, and social satirist. Her work in theater and stage productions is meant to effectuate equality and liberate the world around her. She began her career in the 1960s, working with Jack Smith, Andy Warhol, and John Vaccaro. She starred in the cult classic film Women in *Revolt* (1971), directed by Paul Morrissey and produced by Andy Warhol. Penny starred in some of Jackie Curtis's plays, such as *Femme Fatale* (1970) and *I Died Yesterday* (1983). Surprising to those in the Factory, she rejected a life as a Warhol Superstar and left to reside in Europe for many years. She returned to the United States in 1980 to continue her work in experimental theater. By the mid-'80s, she was performing improvisational monologue solo works. Starting in 1990, she wrote and performed in full-length autobiographical shows including *Based on A True Story, Invitation to the Beginning of the End of the World*, and *La Miseria*. Her groundbreaking work, *Bitch!Dyke!Faghag!Whore!*, began in 1992 and has continued to tour internationally to more than twenty cities. This highly acclaimed stage production confronts issues of censorship, sexuality, politics, and human rights. She also wrote and performed in *Bad Reputation* (1999), which redefined female stereotypes. In 2002, her show *New York Values* addressed what she calls "the death of Bohemia" and the commodification of rebellion. As an advocate for free speech and human rights, she is a member of Feminists for Free Expression, the National Coalition Against Censorship, and the Visual AIDS organization. She is also a founding member of FEVA (Federation of East Village Artists). In the early 1990s, she befriended the revolutionary Quentin Crisp. Later she conducted a series of interviews with him, creating the production *The Last Will and Testament of Quentin Crisp* (1999). In 2005, she performed in *Rebellion Cabaret* with her husband, Chris Rael, a musician, writer, composer, and founding member of the band Church of Betty. She also performed in Earl Dax's *Weimar New York*, a musical cabaret tribute to the days of Weimar Berlin. Since 1999, she co-created the award winning documentary film series *The Lower East Side Biography Project: Stemming the Tide of Cultural Amnesia*. She is developing several new projects: *Old Queen, Longing Lasts Longer, Denial of Death*, and *The Girl Who Knew Too Much*. In 2009, she released a book chronicling her life's work called *Bad Reputation*.

*How did you become known as Penny Arcade?*

At seventeen, I was a street kid in the East Village. It was 1967; there were a lot of kids like me who were homeless, crashing around, with nothing to do but talk. When I named myself Penny Arcade, it was an act of self-preservation. I was living in the studio apartment of Jamie Andrews. I had found a paperback book on a garbage can near Jamie's, in which the protagonist's name was Penny Kincaid. I later told Jamie I changed my name, from internal desperation and word association, because when I amused Jamie I bought myself more time off the streets, the only protection I had from returning to living in the shooting galleries and crash pads where I had been molested and abused. There was no persona involved, which is probably the thing that distinguishes me from most other performing artists. People liked it because it was an example of pop [art] culture in some ways. Taking a name was the cultural equivalent of painting a Campbell's soup can.

*How did you become interested in working as a performer at such a young age?*

I spent my childhood trying to create theaters, circuses, etc. in my garage, or daily acting out alternative realities with neighborhood kids. There was a lot I needed to escape from in my childhood. When I was older, Jamie Andrews took me to see John Vaccaro of the Playhouse of the Ridiculous, the original queer camp, glitter glam rock and roll theater that he was part of. Vaccaro asked me if I wanted to join his theater and to help on a play. I said yes and became the dresser for Elsene Sorrentino, who the woman Tralala in *Last Exit to Brooklyn* was based on. She had like thirty costume changes in the play *The Moke Eater* by Ken Bernard. My job was to stand in the wings and help her change costumes rapidly. *The Moke Eater* became, in a few weeks, the first play I would ever do, when John shoved me out onto the stage in the middle of the play screaming at me, "Go out there and do something!"

*Were you a bad girl growing up? What is your definition of a bad girl?*

My family was a displaced Southern Italian family with a lot of secrets and drama. I was extremely intelligent in a superstitious, peasant household where no one had ever read a book, and my intellectualism was viewed with suspicion. Somewhere in there was ADD and dyslexia, which these days is a big element in how I create work. I was very rebellious. In retrospect it was in reaction to a very controlling mother and this extremely primitive lifestyle with its oppressive morals, particularly towards a girl. I say, being a bad girl isn't about how you dress; it is about being left out of society because you can't

handle the pain in your life in a way society thinks is appropriate: you are mute with rage, you act out, you are bad.

*How much did your experiences with John Vaccaro's Playhouse of the Ridiculous influence your work? Who else do you feel inspired you?*

The content and the motivation behind how and why I create theater and performance is heavily influenced by my early experience with John Vaccaro. Also, I was inspired by the great geniuses of performance: Taylor Mead, Jack Smith, Jackie Curtis, Ondine, H.M. Koutoukas, and Loudon Wainwright. I sought out the ridiculous in real life and my work has always retained camp elements.

*How did you get inducted into the Warhol crowd? What was your first impression of Warhol?*

Warhol came to see all the Playhouse shows and I was a standout in them. I threw myself all over the stage and had a physical intensity that was very directed. I think my energy level is still a hallmark of my style. Jackie Curtis told me Warhol wanted to meet me and it was Jackie who arranged it. In New Britain, Connecticut, I knew a lot of gay men like Warhol; Catholic, who lived with their mothers. Andy was very familiar to me.

*Did you realize how important you were as a part of the Warhol group, especially having a role in his film* Women in Revolt?

I realized, in my relationship with Jackie Curtis, the dominant culture that had always seemingly rejected us was desperate for our participation. Our energy, honesty, irreverence, nothing-to-lose bravura was our ticket into the worlds of wealth and privilege, and we saw that there was a ratio of criminality to creativity. We were mixing with highly accomplished artists: Judy Garland, Tennessee Williams, Leonard Bernstein, Anaïs Nin. So many people were gay but, more than that, there was a world where no one cared about your sexual orientation, who your family was, where you went to school, your race, ethnicity, etc. This was a profound moment when the walls separating class collapsed, a very powerful time in society. It didn't last very long. The late 1960s were very political and Andy was someone who wanted to capitalize on the issues of the day. Many people do not realize that Andy was already very wealthy from his work as an illustrator by the late '60s. He was a great reader of trends and because of that, was able to co-opt a lot of other people's ideas and get them across in ways that people who were less ambitious couldn't. Andy

needed people who could work in an ensemble way in his films because they were mostly very chaotic; no scripts, people jacked on speed with pushy egos or a sense of entitlement. Andy liked self confidence, strong egos, around him. Andy asked me many times to be in *Women in Revolt*. We shot *WIR*, directed by Paul Morrissey with Andy, without a script as usual. Andy often ran out of film because he would just turn the camera on, and it took people a long time to warm up before anything good happened. I think Morrissey and Warhol got into some litigation over the film because it was shown once and then got taken off the market in the late 1990s.

*What brought Warhol's crowd together? What attracted him to you?*

He wanted people around him that offered something to him, that gave him something. As I get older I have a much greater appreciation for Andy's talents and I have realized that he always supported my ideas. In truth, the original work that I started to do in my mid-thirties [in the mid-1980s] was stuff that Andy had thought was a good idea in the late '60s. Andy saw me as a star and offered me starring roles in films. He saw me as a sex symbol which was something that, because of my multiple rapes background and [because] most people saw me as a sexual entity, frightened me very much. Because of my family's attitudes towards sex, and early sexual abuse, and then the rapes in my mid-to-late teens, I had disowned my sexuality as an identity. Andy was obsessed with physical beauty because he had , and of course he was obsessed with movie stars. He wanted me to be a movie star and while there was a part of me that wanted that, too, it wasn't something I could just succumb to.

*Did Warhol's portrayal of women affect society's perception of women and their roles at a time when feminism was considered radical?*

The women in Andy's films are always a little or a lot crazy. They are not someone's mother or friend. Except for Viva or Brigid Berlin, few women in Warhol films were articulate or had anything to actually say. In reality, the way women appeared in Warhol's films was not any different than '20s to '50s noir bad girls, and most of their performances were postured. There was another element which was a silliness factor that we see today in reality TV shows like [with] Paris Hilton or Anna Nicole Smith, in Jane Forth and Geri Miller of Warhol's stable. Andy influenced reality TV like any other art form. People will watch for hours something that is inane, silly, with sex and seediness running through it, hoping eventually to get more of it. This is true of Warhol films and of reality TV. Secondly, Andy was not a director. He was not creating or defining the women he put on film. He just used them as he found them, usually

like an arrow pointing to the man who was the focal point in the scene. There was also a great sense that he didn't care what happened to them, that they were not real to him. With the exception of Brigid Berlin, the lunatic genius; Nico, the ice goddess; and Mary Woronov, the Amazon warrioress, they were all interchangeable. They were hoping that Andy would invent them but he was too busy with all his other projects and only worked with what you gave him. If all you did was sit on a couch and chew gum, that was what he used. Andy was not creating something new here. Andre Breton and Salvador Dali, who made films in the 1940s and '50s, influenced Andy. Also Charles Henri Ford, the American surrealist poet, took Andy to buy his first camera. Jack Smith, whose film *Flaming Creatures* made a huge impact on experimental film in 1962 and from whom Andy took the idea of Superstars, which Jack called Flaming Creatures.

*When you said, "They are not someone's mother or friend," did this portrayal show women in an unconventional, non-possessive, or objectified light? Did Warhol's attempted murder by Valerie Solanas create a relationship between Andy and feminism?*

As I said earlier, I felt that women were portrayed in the same loser, broken way they have always been in noir films. Brigid is exceptional but she is scary, monstrous, and self-loathing. Is that a powerful message to send to society? Andy offered me the headlining role in the Rona Page story. Rona was a psycho, and most of the women who were in the films were either masochistic or just numb. As for Valerie Solanas, while I think she had some extraordinary thoughts on women in society that were radical, she was insane and unpleasant. She was not the cute East Village dyke that is portrayed in *I Shot Andy Warhol*, a movie which should be called *I Shot Fran Lebowitz*, since they patterned Solanas on the bold, articulate, smart aleck Fran Lebowitz. But in 1969, people were streaming to New York to try to get Andy Warhol's attention in order to get into an Andy Warhol film.

*How do you think Warhol himself viewed women?*

I am not sure, except I think he liked them at a distance. He was someone who was quite a loner in most ways, and a voyeur. He didn't participate, and a gay man who won't participate isn't the kind of person who has intense relationships with women.

*Would sum up your favorite Warhol Superstars in one line from something that each one said, revealing their character?*

Jackie Curtis: "It is a small world, but not if you have to clean it!" Taylor Mead: "Oh well, I was born into a very rich family, you never get over it." Jack Smith gave Andy not just the idea of Superstars but the idea of making films. He made some films with Andy and he said so many brilliant things. My favorite was, "You have to be willing to be bad for twenty years in order to be great and then there is no guarantee."

*What do you consider yourself first: comedian, actress, or artist?*

I guess I would say first and foremost, I am a performer which includes comedian, actress, and speaker. Secondly, I would say a writer and director.

*What's most important in regards to what your work tries to provoke?*

I perform to assuage suffering and to break down self delusion and isolation, my own and that of the audience.

*What were your relationships with Jackie Curtis and Quentin Crisp like?*

Interestingly, Jackie was my first soulmate, fag/faghag relationship that incorporated a working relationship, and Quentin was my last. Jackie was magical. So hard to explain... he was ruthlessly honest, wildly philosophical, and deeply sad with a forceful sense of humor that had a great brutal energy to it, and Quentin shared this also. You can't get smarter or develop your thoughts or ability to think and reason if you don't have anyone to do it with. We were that to one another. Quentin was like a grandfather to me. He was almost twice my age. In me he saw where he had been and I in him saw where I was going. We shared certain intellectual standards, the world tends to fear people who are intellectually powerful but who don't seek power in the world. People find that very suspicious and we both suffered from that, from being misunderstood and misinterpreted.

*Of all the wisdom Quentin Crisp imparted to you, what was the most poignant?*

After I had a terrible love affair with a bisexual sexual abuse survivor like myself, I returned to New York brokenhearted. When I told Quentin about it, he was very brisk as he did not believe in romantic love. So he said to me, "What matters, Miss Arcade, is what you think of yourself!" Then he said, "Miss Arcade, happiness is for the untalented."

*Which of all your quips was Quentin known to quote?*

Quentin liked my sense of humor and my one-liners. He was especially fond of my saying, when asked if I had children, "I don't take hostages." He loved everything I said about being bisexual in a lesbian world, particularly when I said, "If you are bisexual, a lot of lesbians think you are just not trying hard enough."

*With whom else have you felt a kindred spirit?*

Charles Henri Ford, the American surrealist poet who died at ninety-two, was the most youthful person I have ever known. Vali Myers, the great Australian painter, whose face was tattooed with Berber symbols in 1968. She was extraordinary. Debbie Harry, I really appreciate her integrity, her talent, and that she has fought to keep an authenticity. Marianne Faithfull; she came to see *B!D!F!W!* twice without my knowing she was there and then asked me if she could sing in the show. Marianne is wildly intelligent, I learned a lot from her. Phoolan Devi, India's famous Bandit Queen. She was extraordinary; she was both Mata Durga, the mother, and Kali, the destroyer. She understood that I got her, her life, her pain and everything she had lost and sacrificed. Also, Romy Ashby, a New York-based writer from Seattle. Her book, *The Cutmouth Lady*, is an extraordinary tale. She is like Jane Bowles, Djuna Barnes, Anne Sexton, and Sylvia Plath, all rolled into one. Also Bina Sharif, one of New York's most prolific writers.

*Was the Cinema of Transgression crowd reminiscent of the Warhol faction?*

The Warhol scene was made up of highly unique and brilliant people who had nowhere to put their talent like Ondine (for whom Andy basically created the Factory) and a series of methamphetamine-addicted, larger-than-life madmen and women. Then there were people like Joe Dallesandro, Eric Emerson, Nico, Jane Forth, etc., who were emotionally unavailable and who were highly objectified. This was an era of people inventing themselves. It was about singular individuality. Then there were people like Jack Smith, Warhol, Vaccaro, and others who put individuals in their singular visions. People who weren't there envision that the scene was about being an egomaniac, enfant terrible, but they were not the ones who became famous for their art, with the exception of Dallesandro and Nico, whose physical beauty became somewhat iconic. In the Cinema of Transgression, Nick Zedd was trying to copy Jack Smith and was becoming a parody of it. Richard Kern seems to be someone who can control women pretty easily. In that way, I think you see a similarity. Certainly

the most inventive that I saw was the performance art explosion of the 1980s. In the '60s there was a great theater movement but it was groups of people following the vision of one charismatic figure. In the '80s, it was individuals creating personal theater, even though it was not necessarily autobiographical. The AIDS epidemic was happening at the same time. We were surrounded by death and suffering, and the country, society and the government turning a deaf ear. I think it made the work people were doing have a higher standard in truth-telling. From 1978 until 1992, there was an incredible period of creativity in the East Village and in the Lower East Side.

*After* Bitch!Dyke!Faghag!Whore!, *how has your work affected the queer community? What kind of feedback and support do you get?*

Both feminist academics and the art scene looked down on women who did erotic dancing and it was certainly not considered an art form or a self-empowering feminist economic option. Posters of *Bitch!Dyke!Faghag!Whore!* were torn off the street and the walls of clubs, shops, and university campus bulletin boards, and decried as offensive. Meanwhile, people of all sexual orientations flocked to this sex-positive, diverse combination of humanist politics and erotic dancing. I spoke about politics, prostitution, feminism, family, AIDS, identity, race, religion, and called for a new language in feminism that didn't come from academics or activists who always use a language of debate that must, by its nature, always exclude someone. We demanded a new language that included and accepted anyone and everyone.

*What was that show like?*

*Bitch!Dyke!Faghag!Whore!* started in 1990. I had presented it to the National Endowment for the Arts as my solo fellowship audit. This was at the height of the [Senator Jesse] Helms/NEA censorship crisis. *B!D!F!W!* was an unvarnished picture of prostitution from the prostitute's point of view, from the penthouse to the peepshow, to the corporate art hustle. It was a criticism not only of the right wing's judgment of prostitution but of the downtown art scene's exploitation of sex without content. When you entered the theater for *B!D!F!W!*, you entered a palace of lights, video, and one hour of rotating strippers. *B!D!F!W!* was a series of monologues which melded the comedic and dramatic about prostitution and the sex industry, combined with a subtext of separation of church and state. The central piece of the show was the AIDS/Faghag/Love section, a queer history that set straight the real story of pre-Stonewall politics and AIDS, its history. It is my tribute to the over 300 people I personally knew who died of AIDS. *B!D!F!W!* dealt with the mistrust towards

bisexuals, the isolation one feels, the pain of intimacy problems, all interwoven with how the government tries to legislate morality. Near the end, I strip to Lenny Bruce's rap on obscenity. We played in the same mall that housed Donald Wildmon's American Family Association headquarters, the group that went after Mapplethorpe and Wojnarowicz for obscenity, and they never made a peep because they didn't want to call attention to a show that anyone could understand, that was not created for the same 300 art school cripples.

*Could you talk about some of your other notorious performances?*

Well, in *Bad Reputation*, it is about the failure of feminism, how women betray women, and about how the art world and entertainment business has co-opted the bad girl aesthetic. In *Bad Rep*, at the end, there are the girls reading a series of rape stories, very violent and harsh, along with video of jury testimony from the St. John's University rape case and a sodomy case. During this, I crack open and swallow raw eggs. It is very intense for the audience for obvious reasons. Amazingly, it gives people who have never been able to empathize with the rape experience a very visceral and intense experience.

*Will you talk about your production of* Rebellion Cabaret?

Well, *Rebellion Cabaret* is Chris Rael and I working together. He was writing songs about the political and social climate we were in, the same subjects my comedy and performance were about. So we decided to fuse them together in a show. It was about the commoditization of rebellion today, the death of bohemia, the taking the teeth out of what it means to be alternative and how difficult it has become to live a life outside of the mainstream.

*Do you have a maxim or motto you live by?*

I have a lot of maxims. I should do a book of them. The distance between a high priestess and a sacred cow is very short. Hope is a killer. Faith is everything.

*Would you give some other examples of authenticity being eroded in America?*

A big part of the problem is that we are living in a mono-generational culture. Bohemia has always been multigenerational, a continuation of itself, about your lineage, influences, teachers. Today people try to hide their influences. When careerism rules the arts, authenticity is not valued. People don't feel they have the time to develop and authenticity can't be forced. Authenticity is the application of depth and time to character or characteristic. I see the lack

of authenticity almost everywhere. The fact that there is so much desperation to have an identity, no one has time to develop an identity. It's choose one from column A, one from column B; it's paint by numbers. The people who are older are also to blame. They too buy into the youth culture, afraid that they will be left out. Youth has nothing to do with age; it is a point of view. In the end, your personal authenticity is of great comfort to you.

*What would you say to destroyers of the bohemian lifestyle and individuality, the ones pushing you out of the world you created only to claim it for their own?*

See, everyone has this idea that it is rotten at the top. I say it is rotten at the bottom, too! Every 22-year-old who buys into the "if you haven't made it by the time you are twenty-five" is creating this blight. People are considered midcareer artists at 35 now instead of at fifty. Those who don't spend their twenties learning the history of everything around them will find it hard not to get sucked into the stagnant world of age. People with the ageist opinion that fresh ideas are only from 25-year-olds will find themselves with no voice and no community when they are thirty-five.

*Why has the homogenizing or gentrification of what was once a genuine lifestyle and art, what you call the new Bohemian Bourgeois, happened?*

In *New York Values* I said, "There is a gentrification that happens to buildings and neighborhoods and there is a gentrification that happens to ideas." The lure that the alternative and the underground has for people, has been co-opted by that strata of society that will sell anything it can. It is no secret that a lifestyle has been the big market in recent years. People try to purchase a lifestyle because they don't have the time or the imagination to develop or live one. There is no longer the multigenerational aspect to the arts that was, and remains, the backbone. The idea that "because you went to art school for four years, you are an artist" is the problem. Few people believe in development. The arc of someone's development is their art form, which takes place over decades.

*What is a memorable moment you've had while performing?*

At my shows, people forget they are at a performance and think that I am spontaneously talking directly to them and they start talking back to me. One example: I was doing a section of *B!D!F!W!* that deals a lot with AIDS, in the dark. Out of the dark a man's voice said, "Come here. I want to give you something." I went near his voice and he said, "Open your hand." I did and he

put something slimy in it. I said, "What is it?" The audience gasped. He said, "It is a condom. My wife had AIDS for ten years and we made love all the time. I am negative. She died last year. I want everyone to know that condoms save lives." We were all crying.

## Babeth Mondini VanLoo

Babeth Mondini VanLoo (born 1948; The Netherlands) has been a filmmaker, director, producer, multimedia artist, cultural archivist, and human rights activist for almost four decades. She received her master's degree in film and fine arts at the San Francisco Art Institute while acting as assistant instructor with George Kuchar during 1974 to '77. Prior to this, she studied Social Sculpture with Joseph Beuys in Germany from 1971 to '72. She has been a professor at the Free International University in Amsterdam and, in 1999, co-founded the Free International University World Art Collection. Babeth has been teaching her art since 1976, at schools such as the San Francisco Art Institute, the Royal Conservatory of The Hague, the Free Academy of Arts in the Hague, along with many guest lectures at learning institutions throughout Europe. She founded Film Art Productions Amsterdam in 1980. From 1994 to 2001, she worked as a personal assistant and producer for Johan van der Keuken. Since 2000, Babeth has been programming director of the Buddhist Broadcasting Foundation (BOS). She has produced a prolific amount of work, over forty video and film projects. Some of her notable 16mm films have been *Andy Warhol's Unfinished Symphony* (1975), *Balls on the Line–Hommage á Joseph Beuys* (1976), *Das Kapital: Joseph Beuys at the Venice Biennale* (1977-87), *Crime in the Streets* (1978), *Berlin Wall & the Sex Pistols* (1978), *Chance versus Causality* (1979), *The Slits in New York* (1980), *Etant Donnes* (1989), *Kiss Napoleon Goodbye* (1990), and *Haiti: Killing the Dream with President J.B. Aristide* (1992). Many of her films have been presented as installations such as *Protect the Flame* (1988) and *Compassion* (1991) with His Holiness the Dalai Lama. The musical accompaniments for her films have been performed by Lydia Lunch, Nick Cave, Z'EV, J.G. Thirlwell, David Bowie, the Velvet Underground, Cabaret Voltaire, and The Tubes. Her videography includes *California New Wave* (1979), *War Against War: One World Poetry* (1981), *Ken Kesey: Remembering John Lennon* (1983), and *President Aristide in Amsterdam* (1993). As director of Holland's Buddhist Broadcasting Foundation, she has created many documentary features, most notably *Bhutan: Women of the Dragon Kingdom*. In 1995, she created a CD-ROM for MPC/Windows on Segregation and Integration of Art in a Decentralized World. Since the 1970s, Babeth has created television documentaries and cultural broadcasts on the subjects of Maya Deren, Jean-Luc Godard, Noam Chomsky, Andy Warhol, Punk and the Situationists, subcultures, media, and cinema.

*What interested you in film work and how did your first film come about?*

During my study at an art academy in Germany with the artist Joseph Beuys in Dusseldorf, I started to make Super 8 movies to document and complement the performance art pieces I did. I was a member of the art movement in Germany, Fluxus Zone West, at that time. And even before that, I studied painting with Professor Ernst Wille in Aachen, making installation works. As my art was often addressing the issues of identity and social action, the films became vehicles for that. Also, music was very essential to me because of its directness, so I became inspired to make films because it is an interdisciplinary medium in which I could combine all these disciplines that interested me. So these Super 8 films I view as complementary parts of installations or actions. The first film I directed and consider an autonomous work in 16mm is *Andy Warhol's Unfinished Symphony*. That film was scripted, with actors, and a reflection of my first years living in the United States when Warhol was an inspiration yet at the same time a symbol for alienation to me. He was cast as a TV host and his guest was played by George Kuchar, a famous underground filmmaker. George was a very talented filmmaker and an extremely funny actor, and Warhol had really been inspired by his films, especially the early ones he made with his twin brother, Mike. My film also starred the filmmaker, Virginia Giritlian, and Raymond Mondini, who later became my husband, a great scholar. His art history courses at the San Francisco Art Institute were legendary and he was the head of the World Studies department. Later on, I also became known as an actress in several of George Kuchar's films and those of Curt McDowell and Barbara Linkevitch. I was also George's teaching assistant, which was great fun.

*How difficult is a work's process now, as opposed to when you began?*

In the beginning of the 1970s when I started to make art movies, I just did it. I was driven to do everything myself: writing, directing, camera, the soundtrack, and editing. Also in terms of financing, I worked on a shoestring. It was fun though and extremely creative with lots of underground activities, as I became very much the chronicler of the punk and new wave movement in San Francisco. I also worked with V. Vale as a contributing editor to the magazine *Search & Destroy*, and with Target Video. And because I had also become internationally known for my films with and about Joseph Beuys, I continued making films with artists like Daniel Spoerri, Niki de Saint Phalle, and Jean Tinguely in a film with double screen projection, called *Chance versus Causality*. The music soundtracks were often made in collaboration with great musicians, in that case, Cabaret Voltaire. Several other films were in the expanded films genre, as they are all were made for multiple screens and with live music. When I

made *The Sex Pistols at the Berlin Wall*, it was the last time Sid Vicious actually performed before he died. That film was a dialectal montage on the great text writing by John Lydon and the zeitgeist of the political climate that resulted in protest on the Wall. My films have a political base, be it public or private. Sometimes it's the politics of widening the arena of television by showing poetry or punk; sometimes making the private public is a political act. Other times it's really commenting on world politics like my films with and about President Aristide, called *Haiti: Killing the Dream* or the works I made with Chomsky called *Censored Information*. Nowadays, my criteria is much defined by working in the medium of television, as I am the programming director for the first Buddhist Broadcasting Foundation in the Western world. So it is a very different process, less artistic and less spontaneous, but very important work in my opinion to enter into television and other media, a more spiritual dimension. What I miss most is the direct exchange with an audience that I used to have when working in the performing arts.

*Is training, learned technique, and formal art education essential to your work?*

Yes, the training was very essential, but not in a formal sense. Technical skills are very important, but the most important thing about my art education came from the dialogue with a teacher like Beuys, where art was neither a retinal activity nor a purely aesthetical discourse, but really at the service of the mind. That exchange was so extremely precious in the context of relationships with other fellow students or artists. Trial and error affected my work, as I believe putting that to use to be part of an artistic practice.

*Since you've taught at art schools, how does prescribed treatment of the arts manifest in the students and their work? Is it productive or can it be detrimental?*

What has blown my mind is that I have encountered numerous students who were only searching for prescribed methods to become successful or commercially viable in the art market, very much dictated by commerce. There seemed to be no need of self-exploration or sense of curiosity about their own work, nor a necessity for expressing the soul. Yet what I find equally detrimental is the fear that big artists display of not sharing their "secrets" when they become professors at art schools, or merely want students to use their methods or even copy their style.

*Can one err in their work? Are you always satisfied with your work?*

Rarely. It took me years to even have a glimpse of satisfaction about my own

work. I have personally been surrounded by extremely good artists, so that shaped my sense of quality. So I could hardly live up to my own expectations to be even half as good. Art that is truthful cannot err. But artists fail if they do not aim to attain some sort of truth.

*What is the most integral theme your work embodies? Is there an agenda? What is most obvious to the viewer and what is most obscure?*

My theme is Media as Social Sculpture. Broadening the concept of art is my agenda, re-sensitizing our outlook on reality, the inquiry of inter-human relationships. Obvious is the fragmentation; the most obscure is the aesthetic notion.

*What attracted you to the work of Joseph Beuys and Abel Ferrara?*

Beuys was the greatest teacher I ever had. His art made me see reality in a totally different way. The ecological and political dimension in his work in combination with the poetic, almost mystical, force of his drawings touched my soul and his art notion was what the planet desperately needed. Collaborating with him was a blessing and changed my life forever. Abel was touched by the mad genius muse and for some time was able to make this productive. Walking the edge was what attracted me. My friend, Menno Meyjes, and I were hanging out with him at the time. Abel and I only made one film together. I was unsuccessful at guiding him away from the seduction of the banality of evil.

*When did you first work as a curator? What shows have been most memorable?*

In Germany, in the early 1970s, and later in the late '70s in San Francisco. Curating the Joseph Beuys at the New School film retrospective in New York was most memorable for me but I also co-curated a few shows at the Modern Art Museum in the Hague on the Academy of Light with the inclusion of Lev Termen, who came from Moscow at age ninety-four. He invented the Thereminvox, an instrument that one plays without touching it. But I also really contributed immensely to festivals like One World Poetry and Holland Experimental Films. Visiting people like Teeny Duchamp, exchanging ideas and getting a small insight into Marcel's personal life: those are memorable events to me. Also going to Haiti to follow the footsteps of my muse, Maya Deren, to prepare shows was unforgettable.

*As a woman, does your work have a perspective that men cannot achieve?*

There might be a slightly more personal intimacy sometimes. A female outlook on the world enables other females to connect in a different way.

*Do you see your work progressing over time?*

Progress sometimes, regress sometimes. I do hope that as my work gets seen by a larger amount of people now at a regular basis, since I have a weekly program on TV, it will also inspire more people to look at their motivation and inspire their conduct in life. Diversity is my path, no committed pattern or style.

*What is your most profound work to date?*

On artistic merit, I would say my light sculpture I made about the Dalai Lama is my best art piece. On films, *Joseph Beuys at the Venice Biennale* and *Beuys: Invisible Sculpture* because his persona shines through these works. As a Social Sculpture, my contribution as a programming director in establishing the Buddhist Broadcasting Foundation in the Western world. My film *Bhutan: Women in the Dragon Kingdom* is a three-part series I would love to share with as many people as possible, as these women and their culture inspired me so much.

*Do you feel satisfied with how much you've achieved in your career?*

I continue at it, but would wish for it to be seen more widely.

*Of your peers, who inspires you?*

Maya Deren, in particular. Not only did I lecture extensively on her work but I also feel I have several things in common with her. I was like her as a student, involved in the Fourth International Trotskyist Movement. I make movies, my work has played an active part in the museum circuit like hers, and I also went to film in Haiti and shared part of my life with a Haitian man. I organized many cultural events just like her. With peers, Laurie Anderson, Patti Smith, and filmmaker Jennifer Fox in the U.S. The artists Katharina Sieverding and Mary Bauermeister, Germany, and poet/linguist Dorothea Franck in the Netherlands.

*How do you wish the viewer to see your work? How should they be affected?*

Inspired at the mind level and hopefully touched at the heart level.

*What is most poignant as catalyst in your productions?*

A sense of impermanence.

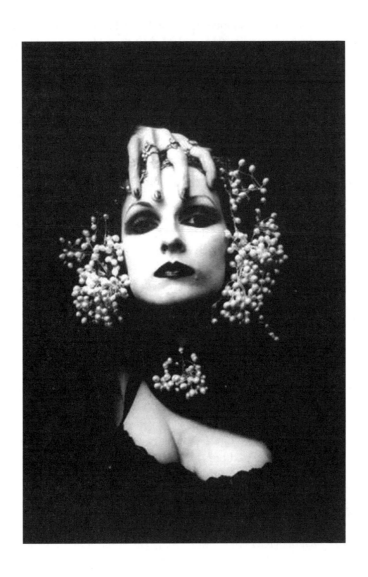

# Irina Ionesco

Irina Ionesco (born in 1935; Paris, France) has been a world-renowned photographer for more than four decades, known for her photographic art of female portraiture, couture fashion, and erotic imagery. Her photos celebrate the female form, focusing on women with a commanding, exotic beauty in a dark, fetishistic, and highly stylized atmosphere. Irina's work has a signature style of black and white compositions, imbued with the spirit of the Symbolists. Her work is described by critics as a combination of Baroque Orientalism, Gothic Eroticism, and Surrealist Fantasy. Many of her photos are taken in her home, displaying her own personal taste for couture, her collection of elaborate costumes and ornate antique décor. Irina is known as a style icon in the fashion world and has worked with Givenchy and *Vogue* magazine. Irina's experiences in her formative years greatly influenced her art; growing up in Romania with performer relatives, spending years as a cabaret dancer, and traveling the world. She had turned to drawing and painting for a period after recovering from a dance injury. Subsequently she moved to France to study art. She soon took up photography with a Nikon F camera that was a gift from her partner in the 1960s, which she continues to use today. She had her first solo exhibit in 1970, and was quickly recognized for her talent, especially with her show at the Nikon Gallery in Paris, in 1974. Irina became so celebrated for her work internationally that she was named "Woman of the Year" for photography in 1977 by Time-Life books. Irina has produced many books featuring her work, including *Liliacées langoureuses aux parfums d'Arabie* (1974), *Femmes Sans Tain* (1975), *Nocturnes* (1976), *Litanies pour une Amante Funèbre* (1976), *Le Temple Aux Miroirs* (1977), *Le Divan* (1981), *Les Passions* (1984), *The Eros of Baroque* (1988), *Les Immortelles* (1991), *Kafka ou le passant de Prague* (1992), *Irina Ionesco* (1992), *Metamorphose de la Medusa* (1995), *Eva: Eloge De Ma Fille (2004), and her biography L'oeil de la Poupée* (2004). Her photographs are displayed in galleries and museums around the world. Irina Ionesco is now a grandmother and resides in France. She currently works as a photographer for UNESCO and within the couture fashion industry. Interview translated by Serena Lucine Verseau.

*What inspired you to work in the medium of photography?*

To transcend, to dramatize reality: the only resonance possible.

*Why is the female form your subject? Is your work evocative of Symbolist art?*

My art is dedicated to Woman. This need is justified by, and goes back to, my childhood. I was raised by a woman, my grandmother, and I constantly dreamed of my estranged mother. The influence of literature was an important one over the years. There were the heroines of classic novels such as *The Charterhouse of Parma* by Stendhal and Georges Bataille's *Madame Edwarda*, as well as Proustian Symbolist paintings, and chamber music with its quarter chords. Also, the gaze I had during my childhood on the rituals of my country, Romania, and Constanta, my city and inspiration. It is located on the edge of the Black Sea: archipelago of all ethnicities, Tower of Babel, and tower of my dreams combined. It was there that originated the traditions of witchcraft and vampire legends like Dracula that pervade Central Europe in the "cult of the symbol."

*What is your definition of the erotic and that of beauty, in art and literature?*

In erotic literature? What a complex question. Stendhal and Flaubert express ardent passions and sacrifice. Eroticism is an impulse of life more than that of death. Georges Bataille excels at conveying that in *Le Bleu du Ciel (Blue of Noon)*. In his essay on Madame Edwarda or in his *Story of the Eye*, and indeed throughout his complete works. Eroticism is linked to death in the sense of expiration and rebirth. I feel an affinity for this mysticism.

*Do you have influences or inspirations that come from others' art?*

The symbolism of religious art in the great works of Delacroix and in particular iconic art.

*What work environment is preferable? What techniques do you use?*

I create a photographic image like I would a painting, composing it little by little after introducing the object, the model, in a setting with light and shadow sculpting the scene. The elements of the set are never premeditated. They fall into place according to whether it is day or night, and depending on what happens during this day or night between the model and myself. The model is presented and captured, and the elements that figure in—clothing, jewelry and other accessories, props and costumes—introduce themselves in a kind of slow and mysterious ballet. This usually takes place in my house, a theater with its Magic Lantern.

*Do you ever work with other subject matter?*

Besides the images dedicated to women, I have created portraits of cities. I have followed in the footsteps of Kafka in Prague, creating a Tunisian theme; rituals and days, including religious celebrations, weddings, and burials. I've also photographed the City of the Dead in Cairo, and Flemish villages empty of its characters, just the places.

*What is your greatest accomplishment, be it a book, a gallery show, or a piece?*

Each book is an accomplishment. I have published many. My book, *Temple of Mirrors*, with an important written entry by Robbe-Grillet, is a sort of intellectual illustrated novel, which enchanted me. It was published by Seghers in 1974 and is a beautiful book. I've always been prefaced by great authors and poets.

*Do you have favorite artists or contemporaries whose work you admire?*

I admire Man Ray, Cecil Beaton, Robert Mapplethorpe, Berenice Abbott for her study of New York, August Sander, Diane Arbus. They are the ones who come to mind at the moment, but there are many others.

*Is your erotic work ever misinterpreted as pornographic by the viewer?*

I personally feel like art is subjective, and that if one sees something in an image, that projection is a reflection of the spectator, who sees what he or she wants to see, whose critique is relevant to him or herself, exposing his or her own perversions. The issue of pornography doesn't interest me, personally. Never in any country in the world has my work been confused with pornography.

*Have you taught photography classes or given conferences?*

Although I am well-known, I'm a very solitary person. I try to write more now. Writing is a good means of investigation and communication. I have held the occasional conference, but that was focused on psychoanalysis, which is also a work tool for me. I don't have a didactic temperament and I'm constantly trying to answer my own questions.

*What advice would you give photographers to develop and improve their work?*

I wouldn't know how to suggest any one thing over another to photographers, if not to "be in love with your work."

# Aleksandra Mir

Aleksandra Mir (born 1967; Poland, raised in Sweden) is a conceptual performance artist and social satirist. She has a background in communications and anthropology, academic disciplines that inform her art. Her work is often enormous in scale, involving entire cities, with contributions by everyone from the artist's friends to strangers. Her work frequently takes on taboo subject matter and confronts conditioned social ideals with irony and humor, dealing with sexism, femininity, death, poverty, love, communication, and unconventional success. Her work includes actions like *First Woman on the Moon* (1999), a reenactment of the moon landing in which she created a moon landscape on a Dutch beach using the American flag; and *Love Stories* (2006), 1,000 submitted stories of real love were documented by carving the couples' initials in trees throughout a forest. *48 Hours Underground, NYC* (2003) consisted of her moving out of her apartment and going underground for forty-eight hours, in a total disconnect from daily living. She would then appear in disguise in public and refrained from using credit cards, making phone calls, sending emails, or engaging in "unspecified anarchist activities." In 2007, with her performance *News Room 1986–2000*, she recreated a newsroom at the Mary Boone Gallery, New York City, in which she mocked the media and its shock value. Aleksandra's *Cinema for the Unemployed: Hollywood Disaster Movies 1970-1997* (1998) was a collaboration with an unemployment office and a cinema, in which she showed popular disaster movies during its business hours, meant to challenge the idea of unemployment. Some of her largest performances are ongoing pieces like *HELLO* (2001), a photographic series of submitted images that link people from all demographics, backgrounds, and social status into a continuous daisy chain of human experience. Another ongoing piece is *Naming Tokyo* (2003) at Palais de Tokyo, Paris, in which she has been creating a more recognizable map of Tokyo for Westerners by having people submit various references from pop culture and applying them as fictitious street names. Her work fluctuates between making a serious statement about society's boundaries or conventionality and ridiculing the contentions of the art world itself. She also creates self-published 'zines, books, biographies, posters, videos, records, and t-shirts, and publishes random people's biographies. She has had numerous group and solo exhibits. In 2011, *The Seduction of Galileo Galilei* was presented at the Whitney Museum. In 2012, Alexandra was part of the MoMA PS1 group exhibition *Print/Out*.

*How did you acquire your artistic techniques and skills?*

I first learned about cultural production by organizing really large theater shows and parties with friends in my school when I was 11. Around high school, I was taking night classes in life drawing, pottery, fashion design, photography, wood working, typography-—you name it—but it was all quite aimless then. My first really conscious engagement with cultural production came from hanging around the local rock'n'roll scene in Gothenburg, Sweden, where I grew up, and watch that happen backstage. Although I wasn't playing any music, watching mostly, I was producing fanzines early on, and I then studied Communications in college, thinking I would be working in the publishing industry. It wasn't until my mid-twenties though that I started thinking through the trajectory that is contemporary art. I then worked for a decade with various nonprofit art spaces and connected with local peer groups in places like Copenhagen, Glasgow, and Utrecht. They were the first to grant me an intellectual, social, financial, and physical space to develop ideas in, as well as their validation. This then led me to more complex organizations. My work now veers between the public institution, the private nonprofit foundation, the gallery system, the art market, the museum, the corporate world, the publishing house, the magazine, the Xerox copy machine, the grand municipal commission, the monumental, the ephemeral, the zero budget initiative with friends, etc. Every day I still feel I am just at the beginning of something.

*How do you feel about art education in relation to an artist's success?*

I studied communications, media arts, and cultural anthropology in college. I occasionally do give talks and workshops at art schools but I have never taught art at any extensive length. I am always happy to share my experience but I am not a pedagogue. Success for me only implies the carving out of a personal trajectory and the endurance to sustain it. I have a B.F.A. in Media Studies from the School of Visual Arts and I spent three years doing Cultural Anthropology in the graduate school at the New School for Social Research in New York, but I never graduated from there. I don't really believe in art education. Sure, you can learn a lot of technique and history as well as have a very productive social life in art school but, in the long run, there is no formula. I think every mature practicing artist goes through a very solitary and quite unique track that can't be repeated or handed over as a blueprint to anyone else.

*Who influenced your work and did you work in an apprenticeship starting out?*

My contemporaries are my influence. My closest friends are my greatest

mentors. Collaboration is the best form of apprenticeship. I have learned very little from art history or people older than myself.

*Which women artists do you feel were crucial to your work?*

For me, personally, the women I have active dialogues with are the most profound: Los Angeles artist Lisa Anne Auerbach and I have just realized a big collaborative project in Naples, Italy, called *Marzarama*. The U.K. curator and critic Polly Staple and I have had an ongoing publishing project called *Living and Loving since 2002*. I would say that every informal minute spent in the company of Andrea Zittel has great critical and productive implications on my work. I am immensely grateful to them all.

*What inspires your work? How long does it take to complete a single piece?*

Ideas usually come instantly in response to a real-life situation, an encounter with power, or a construct that provokes my interest or simply demands a response. But to go into actual production and realize a work can take years.

*Which medium do you prefer: installations, video, or interactive works?*

All of them, depending on the purpose.

*What are you trying to convey with your work?*

There is no particular or preconceived agenda. Art is just a way for me to relate to the world, a form of public conversation with what surrounds me at any particular moment and place.

*What satisfaction do you get from working on a larger scale?*

I work both large and small, I prefer the variety. The satisfaction of being able to realize large-scale work stands in direct relation to the labor invested in it. If it takes three years, fifty people, and loads of money to pull something really big off, it is deeply satisfying not to have failed, although that happens, too. If it takes thirty seconds to draw a cartoon that can make a sharp point in reaction to something that happened the same afternoon, the feeling is equally great.

*What has brought you the most praise and notoriety?*

*First Woman on the Moon* (1999) is probably my most well-known piece in

terms of venues in which the documentary video has been shown, and in terms of quotations.

*What prompted* Moon Landing?

It was, in part, a big joke on the machismo of land art but such influence never goes in a straight line for me. More importantly, facing the end of the millennium, I was dealing directly with trying to beat JFK to his words, "Putting a man on the moon before the end of the decade," while playing with the fantasy of placing a woman there, acting it out, but knowing very well this wasn't going to happen for real. So in this and in most of all my work, I am more concerned with world history than with art history.

*What is your most controversial piece and why?*

I would say all pieces that are prematurely cancelled are the most controversial. I have had work cancelled because of safety issues, copyright issues, personal issues, and/or political content. I never consciously seek out controversy. It is always a loss when it happens.

*In what country is your work most understood? Which is most reactionary?*

It happens that I do a lot of work in the U.K. and I have always had a lot of support from peers, institutions, galleries, and public commissioners who have gone to great lengths to follow me through sometimes difficult and complex processes. In comparison, and in my own limited experience, I would say the U.S.A. has been the most reactionary. I have had work prematurely cancelled both at the Whitney Museum and the Museum of Contemporary Art, Chicago.

*What are the current differences between American and European art?*

While the frameworks in which art is shown varies greatly between these continents, artists themselves and their works move around so much and so easily now I cannot even define myself according to that matrix anymore. I am making work about the history of American election campaigns at the moment. This dichotomy has pretty much dissolved in favor of a more general dialogue between the local and the global.

*Is it more satisfying to work alone or in collaboration with other artists? Do you prefer amateur audience participation to art professionals?*

I definitely prefer the collective experience, although successful collaborations depend on each and every member's absolute personal integrity and skill, and to see it work well is quite rare. Both amateurs and professionals are invited to get involved with my work. I don't make the audience selection.

*Will you talk about your map project,* Naming Tokyo?

My map drawings are a direct response to my life on the road and to thinking about how travel relates to drawing itself. As for *Naming Tokyo*, the idea was based on the fact that Westerners often complain that Tokyo has no street names and that you can't find your way around without a guide who simply knows the logic of his own city. I always thought that was such a superb form of local resistance: no key! So I felt it would be interesting to start naming the streets of Tokyo with names from Western culture and society to help us around. I asked my friends for help by providing me with a short list of names on any coherent theme, any poignant literary or political moment of the West, or any of the most banal elements of our society, that then was printed on a map and reflected back in the physical neighborhoods of Tokyo. Some of the names were inspired by furniture designers to Rolling Stones songs, Vivienne Westwood designs to names on the *Forbes* list, New York drag queens to names of women of the Black Panthers. The first *Naming Tokyo* map, a freebie distributed in 10,000 copies, took place at Palais de Tokyo in Paris, 2003. The work was developed further for the Swiss Institute, New York City, in 2003 and also shown at the Philadelphia Institute of Contemporary Art in 2004.

*Where do ideas for* Death Notes *or smaller pieces come from?*

From something stupid or funny somebody just said to me or from something that I read in the paper that day.

*How long did your project* Pink Tank *take to create?*

*Pink Tank* took two days to make, as opposed to my other projects that take two years or more. One day for my friend and curator/producer Polly Staple and I to clean the rust off it, and one day for us to paint it with the help of three other girls. The public dialogue around it, which is part of the work as a compilation we call "Tank Talk," was ongoing since we did it in 2002.

*What was the longest piece you've ever done?*

*Plane Landing* took three years to produce. *HELLO London* is 333 images long.

*When did the* HELLO *project start and how long was this piece?*

*HELLO* is a photographic daisy-chain linking people with other people they have met in varying circumstances, spanning a wide geographic, historical, and social spectrum depicted through various types of found photography: snapshots, press, and studio photos. It started from a show I did at the Fruitmarket Gallery in Edinburgh in 2000, where I involved mostly my friends, and has since expanded to seven other cities and longer and longer chains, connecting people from all over the world.

*Where did you go during your 48-hour disappearance in 2003? What was the main point to that piece?*

I announced that I would disappear and I haven't disclosed what I did to anyone, but the rumors of what I was supposedly doing were extremely varied and very interesting. In a way, this is the perfect conceptual artwork, made up completely by other people's imaginations.

*Will you create an autobiography about you and your works?*

I have never intended to make a biography about myself, but I have made three about other people: *Living and Loving #1: the Biography of Donald Cappy*; *Living and Loving #2: the Biography of Zoe Stillpass*; and *Living and Loving #3: the Biography of Mitchell Wright*.

*What are your favorite performance art pieces done by another artist?*

*The Battle of Orgreave* by Jeremy Deller; various dances by the Black Leotard Front; all shows by Los Super Elegantes; the sheer existence of the Icelandic Love Corporation: all close friends of mine.

*Which artists were most fascinating to you growing up?*

I had no access to art, artists or art history when I was growing up. I only knew of Picasso and Salvador Dali from TV. I discovered the Impressionists when I went to Paris at seventeen and my favorite then was Toulouse Lautrec whose graphic work seemed the most accessible. I learned about Allan Kaprow and Fluxus when I moved to New York at twenty-two. And I only took a serious look at Robert Smithson after I had produced the *First Woman on the Moon* at thirty-six.

*What general themes do you address in your work?*

Aviation and space travel is a recurrent theme in my work. There is something both so tragic and so alluring by our human resistance to simply stay put, to constantly need to have more, to develop, and see what's around the corner.

*What are some of your latest works?*

I have recently been looking at the aesthetics of journalism, trying to locate the point where it crosses over with art, its formal aspects, seductive mechanisms, and poetic ambiguities. This research resulted in a show called *Newsroom 1986–2000* at the Mary Boone Gallery in New York City, 2007, followed up by another show in the same gallery in October 2008 called *White House*, more specifically focused on the aesthetics of election campaigns.

*What are your most important works?*

Probably all those that were fully realized, that didn't demand too many strenuous negotiations, where nobody fell out, and that have left me with lasting relationships that I can build upon and develop into new work.

# Daria Nicolodi

Daria Nicolodi (born 1950; Florence, Italy) is an actress and screenwriter, known for her illustrious work in Giallo cinema. She moved to Rome in the late 1960s to attend the National Academy of Dramatic Arts. Daria began her film career in the early 1970s, starring in both television and film, moving from traditional dramatic work to horror and suspense within a few years. After she had seen Dario Argento's film *The Bird with the Crystal Plumage* (1970), she became immediately enthralled by its rich occult and esoteric imagery and felt driven to meet and work with Dario. The two became what she calls "mirrored twins," leading to a love affair and creative partnership in film that would last for many years. Starting in 1975, she starred in Dario Argento's film *Profondo Rosso (Deep Red)*. The most infamous result of their artistic union was the film *Suspiria* (1977), considered an operatic, high art masterpiece in filmmaking that extends beyond the appreciation of the horror genre. The film created a new genre: supernatural horror. This genre engages intellectualism, art, feminist lore, the surreal, metaphysical elements, and powerful female protagonists. Daria had written the screenplay for Suspiria based on stories told to her by her grandmother, and combined it with the writings of Thomas De Quincey's *Suspiria de Profundis*. The film also hinted at their mutual interest in the mysterious controversy behind the Rudolf Steiner schools in Europe. *Suspiria* is part of a trilogy based on De Quincey's essays in prose: *Levana* and *Our Ladies of Sorrow* (from *Suspiria de Profundis*). The trilogy is based on a triad of ancient witches, beginning in the 11th century, known as The Three Mothers. Each seeks power and wealth to reign over the earth through evil forces and witchcraft. The Mothers represent the antithesis of the three Fates and Graces depicted in classical mythology. They are Mater Suspiriorum (Mother of Sighs) in Freiburg; Mater Tenebrarum (Mother of Darkness) in New York City; and Mater Lachrymarum (Mother of Tears) in Rome. The second film in the trilogy, *Inferno* (1980), is based on Mater Tenebrarum, with the third film based on Mater Lachrymarum called *Mother of Tears* (2007). She has written additonal screenplays, including *Paganini Horror* (1989). Daria has worked on many films with Dario Argento, among them *Inferno* (1980), *Tenebrae* (1982), *Phenomena* (1985), and *Opera* (1987). She has also worked with Lamberto Bava, Luigi Cozzi, and starred in Mario Bava's *Shock* (1977). She has appeared in many horror documentaries and was included in the Deep Red 25th anniversary documentary in 2000. She starred as Asia Argento's mother in *Scarlet Diva* (2000), which was written and directed by her daughter, Asia. Her life and work is documented in the book *Deep Red Diva* (1995).

*Did your early environment influence your aesthetics and interest in cinema?*

The first images to influence me were a lot of landscapes. I grew up on a hill called Bellosguardo, which means very beautiful view, in Florence, Italy. So nature was the most important relationship as a child for me, more than parents and all the rest. Of course it was very ambient, full of music. My grandfather was a great Italian composer who studied in Paris, who was friends with Stravinsky. My grandmother was a pianist, so in the house there was always music: classical, jazz, spiritual, Venetian, Neapolitan; the music of Bach, Beethoven, Chopin, Mozart. It was the most precious, intellectual and incredibly generous of surroundings. But at the same time, our childhood was so desperate with a sadist mother, which only my sister and I could laugh about. My mother was very young when she conceived my sister, one year before myself. My sister is a famous musicologist, she teaches history of music in a university in Florence. Now she has composed an incredible lexicon about all music from 1000 A.D. to current. She is really brilliant.

*What was the relationship like between your mother and your grandmother?*

It's very hard to reason about this. My mother hated her mother. Actually all of my family liked to fight, to have big fights. They were half Jewish, half Catholic; in fact, many were atheist, some Buddhist. It causes great confusion in my family. Some come from the real southern part of Italy, some from Paris, some from Germany. It's messy. So my mother hated my grandmother and treated her badly, though my mother was very young at the time. My grandmother always remained very calm and was incredibly bright.

*What was the relationship like between you and your grandmother?*

Sometimes we were allowed to visit my grandmother in Rome from Florence and had a lot of fun. It was all music, art, theater, museums, cinema, beautiful places; having the pleasure, the perfume of fine culture. This was a big pleasure for my sister and I, but it was not as frequent as I would have liked. Maybe once a year we would go to Venice, to festivals. We were not, unfortunately, living in the same town. She was a famous pianist who really inspired the history of Suspiria and Inferno. Her name was Yvonne Muller Loeb Casella (Loeb, from her mother). She and my grandfather were really deeply in love and they shared the arts, sometimes poorness, sometimes richness. They had a collection of art you should see, between Florence, Rome, and Switzerland. My grandfather, Alfredo Casella, worked with [Maurice] Ravel and the Ballets Russes. My grandfather was the one who discovered Vivaldi. If you hear the *Four Seasons*,

it's due to him. He found this in a mount in a little house of the old priests, this music, this fantastic opera of the seventeenth century by Antonio Vivaldi. They were magnificent. My grandfather, unfortunately, died three years before my birth. But I know his music and I know he created something beautiful. To pass within a house where you can see the violets of Giorgio Morandi or all the metaphysical paintings and drawings from the beginning of the twentieth century is so amazing, artists like [Alberto] Savinio, and [Giorgio] de Chirico. This is a collection I hope my mother will make present to a museum in the north, the Guggenheim in Venice.

*When did you first hear the story of Suspiria? How did you write the screenplay?*

First of all, like the old tellers, I just told the story because it was not my story; it was something that really happened. My grandmother transformed it for me into a tale when I went to bed as a child each night. I could listen to other stories but I was always going back to this one, saying, "Tell me more." So it was something that happened to her that she transmuted, transformed into a tale, a fairy tale. Then I enriched it more. But the children always want to listen to the same poem or story, the most important for them. Some of those remain the same, but others like this could change, like a wave, a phantasm. It's her story, then I told it to Dario and he liked it very much. I suggested to write it, and I started with five, then ten, suddenly twenty pages. Then I wrote the treatment, then the script.

*Will you talk about the film or art schools you've attended?*

It was at the National Academy of Dramatic Arts in Rome, in 1967. They taught a lot of things, for directors and actors. You can enter three directors each year and also ten actors and ten actresses but you have to pass an exam. I started being in theater groups at fifteen, I was the youngest in them. Some students from the university and myself, we were making avant-garde theater in Florence before [I was] going to this school [the National Acaademy]. I was going to normal public high school at time, which in Italy is better than the private schools. In contemporary time, I was acting already, I started very young. But not as young as Asia, she started when she was nine.

*You studied mainly acting or screenwriting there?*

No, you study singing and dancing there, cinema, directing, mimics. It was a lot of subjects, eight hours a day. I had the chance of meeting the one who is considered the best theatrical director in Europe, who was very young, called

Luca Ronconi. Immediately after, I was chosen by my teacher to be in a play about a man, Giordano Bruno, who was burned by the Catholic Church in 1600 A.D. in Campo de' Fiori, Rome. I played the magician. Giordano Bruno was the famous philosopher who wrote magnificently about memory [the mnemonic system or Epistemology] and was also a Utopist, and you know Utopia is not so accepted in society. He was a very free thinker. So the Church, which put in prison Galileo Galilei, the great mathematician, had killed Giordano by burning.

*Why did you choose roles involving heretics? Were you fascinated by religion?*

Well, the position of the Church, sometimes it goes too far, sometimes it is too regressed. I don't think that the words of Jesus Christ are that of the Pope. But I'm not discussing anything about the church because from the church, I can have strong emotions when I attend, by myself or with a priest who is very intelligent and you can share a mystical experience, which doesn't happen all the time. I adore all the music of the church, the children singing and the organs. The fact that this culture attracted me, I don't think it was rebellion; it was some kind of energic, some kind of incandescent energy.

*Was the film* Suspiria *close to what you had imagined the story to be?*

Well, my grandmother saw it, she died very old, so it was two years before she died. When the film came out in Rome, she saw it, in Paris too. She liked it very much. She's the real author. In theater, the cinema tends to be avaricious; the director is not only the director but can also become the author, as with the actors. But the original idea was due to Yvonne and what I know is she was very happy with it and she really liked Jessica who took the role I should have played. Because of American distributors, I couldn't play her. My grandmother and I were really proud and admired this marvelous actress, Jessica Harper, playing the role of Suzy Bannion.

*Did your loss of the role cause any tension with the film?*

No, not at all. The problem was only that Dario, in this film, he talks about Dornach. I remember meeting a woman, with my grandmother and Dario, who studied in Steiner's Academy in Dornach, Germany, saying please never say we talked together; she said so many things, it was so nasty about the Suspiria history. It was a long time ago, I don't care. Jessica was fantastic and the film also respected a lot of what the history was, what I had written, and my grandmother had imagined, the reinventing, the marvelous colors through the

Tri-Pack; the systems of the old years. Reds are red and blues are blue.

*What was the inspiration for the baroque, operatic, and elegant set design?*

The inspiring images of all the beautiful paintings in the museums, of my life, and Dario inspired himself totally.

*What do you think about* Mother of Tears *as the last of the trilogy?*

In Italian, it's *La Terza Madre*. I play a little cameo as the mother, for the pleasure to be with Asia. But I didn't fight it; it doesn't resemble *Suspiria* and *Inferno*. I don't know how he could do this, it's another story really. I had seen the film in Milan; it won an award. Watching the film, you are really afraid, especially in the first part, but I want to at least have adrenaline in my veins when I see a film. For me, I just enjoyed playing the cameo with my daughter. I really like her as an artist.

## Mars Tokyo

Mars Tokyo (born Sally Mericle, 1952; Baltimore, Maryland) is a visual, conceptual and multimedia artist. She was active in the Stamp and Mail Art movement starting in the mid-1970s and founded Mars Tokyo Rubber Stamp Company (1990-2000). She has worked in digital design, photography, etching, lithography, and assemblage. Her first major work involved the creation of hundreds of tiny dioramas in miniature scale, assemblage art called *Theaters of the 13th Dimension*. She says her theaters are an example of how scale has no relation to the ability to convey a powerful message in art. The themes of these theaters are intense and dramatic, containing elements of sociology, politics, psychology, love, religion, sex, and pop culture. Some of the most notable pieces include *Theaters of Dissent, Spirits of War, Theater of the War Monger, Theater of the Liars, The Dictator, The Mouth of Hell, The White Sepulchre, The Insane Mob, Theater of Metropolis, Theater of Puppets, The Cards, Positive Negative,* and *Eye Opener.* She says a goal of her art is to encourage interaction, and to empower and create an experience of discovery. Her achievements also include the *Secret Works* series (1996-2000), an interactive diorama exhibit; a series of *Artist's Books* (1999-2001), 3-D fold-out books of her collages; and a series of *Visual Diaries*, an artistic recording of her experiences traveling the world. In 2008, she began the *Black on Black* series of graphite pencil on India ink, as a type of response and recovery to the traumatic electroconvulsive therapy (ECT, formerly known as electroshock) treatments she had undergone. Her most current work is an ongoing series entitled *Coastlines*, paintings created with gouache paint on black paper. This series addresses coastlines around the world undergoing changes due to global warming, with textual and dimensional imagery. In 1995, Mars Tokyo attended the United Nations Fourth World Conference in Beijing, China, presenting *Art as Information vs. Commodity.* She also designs and carves semiprecious stones into wearable art with her Mars Tokyo jewelry line. In the 1990s, she taught graphic design at Notre Dame of Maryland University. Mars Tokyo has received awards and acknowledgments for her work from the Visionary Art Museum, Johns Hopkins School of Medicine, and the Shreveport Art Guild, Louisiana. She has had a retrospective of three decades of her work at Barrister's Gallery in New Orleans (2008) and is currently shown and represented by the Gallery Neptune in Bethesda, Maryland.

*Were your parents supportive of your artistic abilities as a child?*

Well, my mom was very supportive and taught me a lot about drawing, encouraged me when I made art, but my dad was another story. He believed the only profession a woman could have was to be a teacher so I should go to a state school for teachers and major in education. Under no circumstances would he allow me to major in art. When I insisted on declaring my art major, he pulled the plug on school, and I dropped out and went to work in a sweatshop. I finally got myself back on track five years later and finished my B.F.A. on a full scholarship and graduated the top-ranked student in a class of 730. I applied for an M.F.A. program at University of Wisconsin-Madison. I was accepted in printmaking, my undergrad major, and was all set to go, but my financial aid fell through at the last minute. I was forced to scramble to get a loan to pay my tuition. I had no credit and the only person who could co-sign the loan was my dad. He refused. After all that, he still refused to help me. I wouldn't say I got too many breaks with support where I needed it.

*What artistic interests did you have in your youth?*

I was artistic pretty much from the get-go, kindergarten even. I was singled out as being gifted. I guess that is because I was drawing pictures of the children that were in proportion and had details you don't usually see at that age. But I'd entertain people with caricatures of the teachers. I've always been a figurative artist.

*Was this a kind of communicative thing?*

"Communicative" is a good word to use with me; I was once called a communication artist. Not in the standard commercial or graphic art sense, but because my work always had something to say: a message, a story, a narrative. I just like people, their being, their faces, bodies, etc. Another thing that influenced me greatly as a kid was writing letters. We moved from Baltimore to Illinois when I was three, and when I was about seven or eight I started writing letters to my grandfather. He wrote me back and we developed a very special correspondence. My mom was a big letter writer too and she encouraged me to make pen pals. There used to be ads in back of magazines where you could write seeking a pen pal. That joy of getting a letter in the mail stuck with me. When I was in my twenties, in the 1970s, I entered the Mail Art movement, which seemed tailor-made for me. Mailing art to strangers, what a thrill. I amassed a huge collection of Mail Art that was sent to me.

*Have you curated any events or shows from your Mail Art collection?*

I hosted a Mail Art exhibit when I was living in Syracuse in 1986 called *Is There No Justice?* People sent in Mail Art responses to that question and then I posted it locally at a community art center. It's hard to remember individual pieces but one that stands out was from a man in Italy. It was in the form of a flat corrugated box that opened up like a shuttered window, inside was a photocopy image of his own face, with his tongue sticking out. Then there was a sheet behind that, also a copy of his face, but there were guns pointing at his head from the flaps of the box; very colorful: red, black and yellow. Back then, what you did is you kept a mailing list of all the people you'd sent to, all of the people who'd listed their address in other shows, etc., and I did a mass mailing calling for entries. It was a lot of stamps and postcards, tons of mailing, but that was the fun of it. The international entries were always fascinating. Some were in their foreign language that I couldn't translate. Remember this was way before Google translators! Some of the work was really artistic and of a high quality, and some was mediocre and minimal effort. Back then you could mail all sorts of stuff through the mail just by sticking a stamp on it. You could send a shoe if you wanted, anything. I once sent out a series of old 78 records with a stamp and address stuck on them. The postmen, I heard, were thrilled and delivered them quite carefully. Terrorism and the modern era have crushed all of that. And the internet has completely wiped out Mail Art. But now we blog.

*How long were you involved in Mail Art?*

I was involved in Mail Art from, say, 1975 through 1999, and my stamp business operated from 1991-1999; called Mars Tokyo Rubber Stamps, it ran until I sold it. I handcarved many of the designs. I was fairly well known in the rubber world.

*How did you come up with the name Mars Tokyo?*

I honestly dreamt it up one night. I had this dream I was inventing a pen name for my correspondence art and in my dream I thought up Mars Tokyo. It blended the 1950s sci-fi culture I loved and the influence of Japanese art. I also felt the Japanese were quite heroic for surviving the A-bombs and coming back as a major economic force, leaders in technology, etc.

*What inspires your work in the* Theaters of the 13th Dimension?

Quite a lot from my dreams, my waking thoughts, my daydreams, and also just

experiences that I have. In the series of theaters, there were ones inspired by films and directors, authors, poets, actresses, etc. Then there were ones that came from childhood experiences and some that came from dreams. Another thing that enters into all of my work is being diagnosed with major depression from the age of twenty-one on. I think it shows in the somberness of a lot of the work. I tend to be pessimistic.

*How did you acquire and choose the objects for each piece?*

I'm a born collector. I'd been collecting little things for years and years, just amassing stuff in boxes and bins etc. When I first started making the miniatures, it was like I'd been preparing for it for twenty years or more. I had lots to work with; things picked up at flea markets, antique and junk shops, old bookstores. I finally felt like I had a reason to get more little stuff, too. Finding and buying little stuff is a lot of fun. Then it's just a matter of seeing what I need, and what I have that I can use in some way. Some things I'd make myself out of tiny matchsticks or Sculpey.

*How long did each box take to finish?*

Usually, I was producing about one a week. But I was working nonstop on each piece. There's so much soul in those theaters, a lot of heartache, too.

*Which of the theaters would you never part with?*

The ones I'd never part with, I'll give you the translated titles: *The Avalon*, that's a real ivory rabbit in there that was a gift from an old boyfriend. *The Green Bed*, *The Paradise. Magical Dancing* has a Buddha with roses around it and tiny ballroom dancers over a bridge. *The LuLu (Louise Brooks), The Fragility, Cafe Voltaire, Mr. Mojo, The Cabinet of Dr. Wu, Infinity I, II, III, Chinese Passion I, II, III*. I could go on and on.

*Would not part with them because of the time and energy, or more sentimentality?*

Sometimes because of an element that is irreplaceable but usually because of the idea or spirit behind it. One of the first homages I did was for the writer W.G. Sebald. Not long before he died, I'd actually gifted one of the theaters to him because I loved his books so much. And he wrote back to me this beautiful letter of thanks and that it had moved him so. I was so thrilled. Two weeks later he died in a sudden car crash. Very sad. The theater I'd sent him was *The Never Anger Forest*, with a small child abandoned in a forest at night.

*Have you gifted a box to anyone else?*

I sent the *Theater of the False Smiles* to Jim Carrey. Unfortunately that was a big mistake, as I don't think it ever got to him. But it was probably just taken by someone in his P.R. office. I stopped doing that then.

*How many do you think you've made in total?*

I've made over 200 of them from 2000 to 2007. I have a stack of big Rubbermaid boxes in my laundry room that houses the collection.

*Will you talk about the history of the* Secret Works?

The *Secret Works* were my first foray into three-dimensional assemblages. I'd been strictly 2-D up till then. Somewhere I came across an article, I think for an exhibit, on African art and the nature of secrecy in their work. Secrecy is very important in tribal religions. I'm no expert so I can't really discuss it other than to say that they believe the power in something comes from it being held as a secret. There's power in secrecy. That's what makes the magic work, so to speak. And I really liked this idea of covering something, covering art, and not letting it be seen until it was uncovered by the viewer. My inspiration came first from that African idea of secrecy, then the more I researched it, I discovered things like Cabinets of Curiosity, collections of oddities dating back to the Renaissance that were privately held collections. They kind of predate the notion of museums but are totally dependant on the owner being gracious enough to share his collection with you. Then I read about secret art works, i.e., works that are either stolen and held in secret, held in secret because of their taboo nature, or for some other reason. And all of this inspired me. The idea I had was that the true power of art comes when the work is not shown, i.e., covered or held secret. So instead of letting people openly view something in a gallery, I decided to cover each piece I made with a cloth that the viewer would have to lift themselves. Some people were so ingrained not to touch anything that they thought the covers and all were the artworks. I had to encourage people to lift up the covers. When they did they almost always were struck by a very intimate experience. It's much different than seeing a large painting across the gallery in a museum. It's easy to not react to art when you have no investment in it. I like to force people to discover the work and in that way, it becomes interactive and they have something invested in seeing the work. I've carried that through with the series of theaters, too, in the way that I display them.

*Can you explain the process of making the images of the theaters dimensional?*

That was a really important part of the whole process. I would construct the theater and get it completed, than I would rush to photograph it and upload the photos to the computer. It's weird because so often I would see things inside the theaters in the photos that I hadn't noticed with my naked eye. Compositionally that is, as you point the camera in from one angle, then the other, shifting focus, etc., new things become apparent. I often didn't feel like I really saw the work until I photographed it and looked at the pictures. The pictures are wonderful. But the 3-D object in person is really mind-bending. I use a Nikon Coolpix 995, an oldie at this point from 2000, with a wide angle macro lens that gets real close. It's all digital. I use copystand lighting from above but I take into account the ambience of a piece when I photograph it, adjusting the exposure if it needs to be darker or nocturnal. Some of the pieces use colored glass in the skylight for effect, pink sometimes for a rosy glow, or blue for a nighttime look. Sometimes I put slats in the skylight to make it look like Venetian blinds when I light it and photograph it. *The Green Bed* is like that, also *Mr. Mojo*. Some have lace paper ceilings for a different kind of lighting effect. But all of that is built into the piece, so you take that in with the eye, as well as the camera when you photograph it. *The Prison* has a hardware cloth ceiling, like a wire grid. Oh, and the Chinese triptych, *Chinese Passion*, has a brass screen for the skylight. That really did some amazing things with bouncing the light around. I think I'm a frustrated set designer.

*What is the feeling of power that can occur when looking at small objects?*

Sometimes less is more. When looking at small objects, it's totally empowering! Like when you were a kid and looking at a little toy scene you created. Finally you were bigger than something! People often ask me why I call them "theaters." To me, there's always a story of some kind in there, a drama with characters. I mean, they are figurative and narrative and I like the idea of imagining tiny dramas being played out on these stages I create. I'd like to use them as jumping-off points for creative writing classes, see what people would come up with.

*To get an idea of size, how big are the average boxes?*

There are really only the two sizes. The bulk of the theaters are what I call "full-sized" and measure 3.25"Wx4.25"Hx4.75"D; the smaller ones are half that size.

*Will you talk about the political theaters?*

Those three are some of my favorites. With the *Theaters of Dissent*, I started this series in 2001, and I've been enraged ever since; politically, that is. Oh my god, I've lived through a lot of rotten presidents: Nixon, Reagan, Bush I, Bush Jr. I'm very anti-war. I've been protesting war since Vietnam. The first Gulf War I was actively protesting with a stamp project called the *400,000 NO WAR Patches*. Involved my rubberstamping NO WAR design onto squares of torn sheets at stamp-in events and then distributing them for people to wear. I got a lot of satisfaction making the dissent pieces that I did. *The Dictator* was in response to the election of 2004.

*Have the creations of artist Joseph Cornell or other artists inspired your work?*

When I first looked at Cornell and his work, it was so magical and had this magnetic power. In 1980, I saw the big show on Cornell that the MoMA put together and it blew me away. The pieces are so different in person; the photos can't really do them justice. It was like seeing Paul Gauguin's actual palette in the [Gallery Nationale de] Jeu de Paume in Paris. I also was struck by how the glass fronts on his pieces conducted movement in the reflections you saw in them. People moving in the room would be reflected on the surface of the glass fronts. It became very cinematic and, of course, Cornell was also a filmmaker and so probably liked that added result. I don't think he was just protecting the pieces or hermetically sealing them with the glass, it very much added another dimension to the work. That show in 1980 was one of most formative experiences for me as an artist. Another was an exhibit I saw in 1978 at the Museum of Contemporary Art in Chicago of the work of Adolf Wölfli. I guess that was probably the first Art Brut that I'd seen but his work in particular is amazing. Very obsessive but he tells fantastic epic stories that fill rooms full of pages. He really opened up a new way of seeing for me.

# Anna Banana

Anna Banana (born Anne Lee Long, 1940; British Columbia, Canada) has been an artist in the Mail Art and Artistamp movements, and a performance artist, writer, publisher and curator for nearly four decades. In 1971, she began publishing the *Banana Rag* newsletter, through which she discovered the International Mail Art Network. This network involving hundreds of artists who exchanged images and ideas through the mail provided an ongoing outlet for her work, a sense of community, and affirmation of her conceptual approach to art. Primarily based in Canada, she moved to San Francisco in 1973, spending eight years collaborating with Bill Gaglione and the Bay Area Dadaists. During this time she performed *Futurist Sound* (1978), *Toward the Future* (1980), and for the 1984 Inter-Dada Festival, Anna collaborated with Victoria Kirby on *In the Red*. Anna also organized many events including the Going Bananas Fashion Contest, Art Race, and the Banana Olympics. In 1976, Anna joined the Stamp Art movement, creating statements of independence through parodies of the postage stamp. These works made social, political, and economic statements that were radical, anti-establishment, and anti-consumerist. The *Banana Rag* became *Artistamp News*, a forum for the rapidly expanding field of artistamps, returning to the banana theme in 1998. Anna created a 'zine, *VILE*, to document and showcase mail art. She produced eight issues of *VILE* from 1974-82, some with Bill Gaglione. She ended the series in 1983 with the book *About VILE*. In 1976, she founded her graphic design and production company, Banana Productions. In 1988, she began publishing *International Art Post*. Since 1993, Anna is also known as Dr. Anna Freud Banana, creating interactive events and performances that parody contemporary sociology and encourage critical and creative thinking. From over 36 years of mail art exchanges, she accumulated the *Encyclopedia Bananica* files, with the idea of parodying the *Encyclopedia Britannica* and focusing on the banana in collected ephemera and 3-D objects. Anna has produced art for *Griffin & Sabine*, Canada's National Post Museum, Washington State Museum, and the American Philatelic Society. Noteworthy exhibits include *Twenty Years of Fooling Around with A. Banana* (1982) at the Grunt Gallery in Vancouver, Canada, and a solo exhibit at the Sarenco Art Club Gallery, Verona, Italy (1998). As a member of the artist group Specific Research Institute, Anna parodies scientific research in her works *Bananas in Distress* (1998) and *Proof Positive Germany is Going Bananas* (1993). One of her more recent works, *Tie a Knot on Me*, was part of Berlin's annual Transportale event. Anna continues working in art, currently creating a series of one-of-a-kind books from her collection of amassed ephemera, making artist trading cards, and creating custom orders through Banana Productions.

*What is mail art?*

Mail art is a process of exchanging art through the mail to others in the International Mail Art Network (IMAN). The emphasis is on the process of exchange, not on the objects exchanged. Mail artists like taking on the formats and trappings of official culture and making them over in their own image. The postage stamp format was an obvious target. The earliest artistamp editions I know of were made by Robert Watts of the Fluxus movement in the 1960s. Donald Evans, who knew nothing about mail art, hand-painted stamp sheets in the 1960s as an extension of his childhood interest in stamps and the creation of fantasy lands. In the early '70s, Ed Higgins in New York City and Carl Chew in Seattle were both making artistamps and discovered each other's work through an exhibition of miniature art in Seattle. They began exchanging stamps and collaborating on editions and these works were distributed through the IMAN. Robby [Robert] Rudine in Seattle is another stamp collector-artist. He created an imaginary country, Tui Tui, creating artistamps and other official documents for it. Geir Sor-Reime in Norway and Bruce Grenville in New Zealand collaborated on the International Council of Independent States, producing both stamps and a newsletter documenting the works of participating artists.

James Felter, a.k.a. Jas, produced the first known exhibit of artistamps at the Simon Fraser University Gallery in 1974, which traveled for ten years. An extensive catalogue was produced in 1976. Ed Varney in Vancouver was another early producer of artistamps who, as partner in a printing business, was able to produce a number of full color editions of stamps by network artists in the mid-1970s. The arrival of the color Xerox machine in the mid-1970s was a turning point in the production of artistamps. A few artists tracked down old pinhole perforators, which in combination with color photocopying made producing real-looking stamp sheets possible. The period from the mid-'80s to mid-'90s was the heyday of artistamp making, which I documented in *Artistamp News* from 1991 to 1996. I quit producing this twelve-page newsletter even though I had 250-plus subscribers because subscriptions only paid for printing and mailing. I documented a number of artists with no connection to the IMAN in *Artistamp News*. Then the advent of home computers and inexpensive inkjet printers made this art form possible to more and more people.

*How long have you been creating artistamps?*

I did my first stamp editions in 1978 in San Francisco when my friend, Eleanor Kent, who had a color Xerox machine in her home, invited me to do some work with it.

*Where did your name, Anna Banana, come from?*

In 1968, my students at Vancouver's New School called me Anna Banana. At Esalen Institute in Big Sur, in 1969-70, the name resurfaced as my kitchen crew, the Flying Lettuce Kitchen Company, took up where my students left off. Before returning to Canada in 1971, I fell into a box of bananas at a mountaintop party, accepted the name as my own, used it ever since, and in 1985 did a legal name change. Because the banana theme is so popular, my exchange partners in the IMAN have gifted me with all manner of things banana, in particular news stories and magazine articles. It's been like having an international clipping service; as artists spotted bananas in their news, they clipped and sent them to me. The result is the *Encyclopedia Bananica* files, which occupy a four-drawer file cabinet in my studio. I dream of publishing the *Bananica* but haven't found the time to edit the material into a presentable form. I use some of it in the *Banana Rag* and in some of my interactive events such as *Proof Positive Germany is Going Bananas.* I have approached a few publishers with an outline of the book but that hasn't been sufficient to convince them to pay an advance to buy me the time to do the work.

*Will you explain what the* International Art Post *is?*

Initially *I.A.P.* was my way of making full-color printing available to artists, but given the costs and amount of work involved I had to revise my pricing so I could be paid for my labor. It is now one of the ways in which I earn my keep.

*Has your technique changed greatly over the years?*

I now use the computer to assemble my *I.A.P.* editions but not in the creation of my own work. I still prefer to work by hand-making images, using collage and printmaking techniques.

*Were you involved in the Fluxus art movement? Who was most influential?*

The Fluxus movement was before my time. Many mail artists call themselves Fluxus artists because they identify with Fluxus principles. The spirit of the work I have undertaken over the years is in the same vein as Fluxus/Dada. Dick Higgins, with his Something Else Press, was one of the more influential of the Fluxus artists.

*How much artistamp or mail art have you produced over the years?*

Over the years, easily thousands. All the mail art I've produced, with rare exceptions, was sent to my mail art partners, who number in the hundreds. I was extremely active in the 1970s producing *VILE* magazine and the *Banana Rag* newsletter; a great many artists exchanged works with me. While I didn't keep a record of what I mailed out, I do have a large archive of works received, the only record of the works I sent out. In the last fifteen years, I've kept a record of the mail I send out, the recipient, date, and very brief coded reference to what it was I sent but I don't keep numerical records of it.

*What is the process involved in creating a single piece?*

I respond (or not) to invitations if the theme inspires me. Claudia Putz invited my participation in her PIPS Dada Corporation assembling on the subjects Good/Evil. She asked for seventy-five original pieces. I chose Evil, so I could comment on advertising, which I consider to be responsible for the mass sleep known as consumer culture. I used a crow from one of Ed Varney's mailings in a stormy background I created using textured Letraset backgrounds. I made the background very light at the bottom where I stuck Ed's crow on a branch. I collaged letters cut from magazine ads spelling out "The Deification of" at the top and along the branch "The Superficial." I made ninety-two photocopies of this background, and then inserted cosmetic items cut from women's magazines into the bird's beak. I signed and numbered the pages, then sent them off to Putz for inclusion in her fall issue.

*How radical was this type of art when you first became involved?*

It was astonishing. Up until the time I stumbled into the network in 1971 with my *Banana Rag* newsletter, I had no idea about conceptual art, or networking, or any of the forms that cross-pollinate each other through the networking process.

*Can you explain the free exchange ethic?*

By freely exchanging work with other artists, one circumvents the money market and all the shortcomings of that scene. It is a way of valuing and validating each other's worth without involving money, which seems often to corrupt.

*Have you had any problems when sending art through the Postal Service?*

I had a shipment of *VILE* magazine sent from my San Francisco home to Art

Metropole in Toronto seized by Canada Customs, and declared as obscene and/or immoral.

*Has anyone ever been charged or fined that you know of?*

The artists Michael Hernandez de Luna and Michael Thompson of Chicago received a "cease and desist" order from the U.S. Postal Service for mailing things to themselves using only their artistamps for postage, but I have not heard of them being fined for it.

*How serious a crime is counterfeiting and forgery within postal services?*

Both are serious crimes, but quite a different matter than making parodies of postal editions or money, which is not a crime. However sending mail using only fake postage is getting into the area of illegal activity.

*Are imaginary states or countries based on real residences or utopian societies?*

Most are imaginary but you'd have to ask the individual artists about that. I do know that Tui Tui exists as a houseboat in Seattle.

*Have you created your own personal states?*

The Queendom of Bananaland and Banana Post stamp editions and various artifacts such as the Great Stone Pyramids of the Queendom.

*How is mail art collected or appreciated today?*

The works of some early mail artists and Fluxus members is being collected. The Getty Museum has Jean B. Brown's archive of Dada, Fluxus, and Mail Art, and it purchased Lon Spiegelman's collection after his death. The library of New York's MoMA purchased John Held's collection of mail art books, zines, and catalogues, and the Tate Modern took Robin Crozier's archive after his death. Yale University's Beinecke Rare Book and Manuscript Library purchased a complete set of *VILE* magazines. So selected works are being collected by a few art institutions but for the most part these collections remain in file cabinets, boxes, or basements of the recipients.

*Who are some of your favorite mail art contemporaries?*

PLG, [Vittore] Baroni, Rod Summers, R.F. Côté, Carol Stetser, Robby [Robert]

Rudine, G. Simone, Dale Speirs, Enrico Sturani, Bill Thomson, Keith Bates, A-1 Waste Paper Co., Ed Higgins, Edition Janus, Eric Langolff, Pascal Lenoir, to name a few.

*What was the most controversial piece of mail or stamp art you've seen?*

Al Brandtner's stamp, *Patriot Act*, picturing George Bush with a gun pointed to his head. It was published in the book *Axis of Evil*, and almost closed the exhibition of artistamps at the Glass Curtain Gallery, Columbia College, Chicago, when the Secret Service responded to alarmist protests.

*How much mail art is political activism? Is this humorist rebellion?*

The Mail Art of Clemente Padin comes from a political awareness that reflects Argentina's repressive political history. Many mail artists address political issues using humor and irony.

*What other projects have you contributed to or collaborated on with Jas Felter?*

Felter, Ed Varney, and I had a joint exhibition of our artistamp works in Vancouver in 1992. In 1998-99, I was a special consultant, collaborator, and editor of Felter's texts for the book *Artistamps: Francobolli D'Artista* which was published in 2000 by Vittore Baroni and Piermario Ciani's AAA Edizioni.

*How did your magazine* VILE *come about?*

It came about in response to *FILE* magazine's 1973 condemnation of Mail Art. I decided it was time for another 'zine that would champion the works of the newly burgeoning Mail Art Network. It was an opportunity to provide a showplace for mail art, to recognize and document a process I considered revolutionary. The 1995 *VILE* History in *Eternal Network: A Mail Art Anthology* was an account clarifying who did what in the various issues of *VILE* magazine I published between 1974 and 1983.

*What types of performance art pieces have you done?*

In the 1970s, I collaborated with Bill Gaglione and the Bay Area Dadaists, performing Dada Sound Poetry and Italian Futurist Sintesi. Gaglione and I toured Europe in 1978 presenting our program *Futurist Sound* in twenty-nine cities, in thirteen countries, then an expanded program, Toward the Future, in fourteen cities and across Canada in 1980. In 1975 and again in 1980, I

organized and produced my parody, The Banana Olympics, in San Francisco and Surrey, B.C. These are interactive events in which I set up the structure and invite the public to participate. Over 100 persons took part in each of these events. I also organized the Columbus Day Parade entries and interactive April Fool's Day events throughout the 1970s. Most of my performance works are interactive and I prefer working on the street or other non-art settings than on a stage. As a researcher, Dr. Anna Freud Banana, I did *Proof Positive Germany is Going Bananas* in 1993, presenting an exhibition of over 100 banana-related items from the German press. At the opening I explained to viewers that I was researching the cause of this banana phenomena, asking them to do my tests. These were the *Roar Shack Banana Peel Tests*, a parody of the Rorschach Ink Blot Test, and the *Personality Inventory for Banana Syndrome*, a parody of the MMPI-Minnesota Multiphasic Personality Inventory. I presented this exhibit and interaction in eight cities in Germany and one in Hungary. In 1998, I did *Bananas in Distress* in Toronto, which was broadcast nationally on CBU/Canadian TV, and a "Banana Communion" in conjunction with an art exhibit in Verona, Italy. Also in 2000, a "Banana Consciousness-Raising Session" at the New Gallery in Calgary, and in 2001, *Banana Splitz*, a parody of a TV game show at the Banff Center. In 2003 was *Tie A Knot on Me* in Berlin, and in 2007, *Wrap*, with John Held, at the SOMArts Gallery in San Francisco.

*What large-scale artwork have you done?*

The Banana Olympics in San Francisco and Surrey, B.C. had over 100 contestants each, my Going Bananas Fashion Contest on CKVU's *Vancouver* show with fifty participants, and *Proof Positive Germany is Going Bananas* during which I interacted with over 375 people and getting 290 to complete my test forms.

*What other performance works have you done?*

I collaborated with Victoria Kirby to develop our performance *In the Red* at the Inter-Dada '84 Festival in San Francisco. For the 1991 *Condensed History of Performance Art* at the Aspects of Performance Festival in Owen Sound, I used the Futurist Sintesi format, creating a series of vignettes based on various styles of performance such as Carolee Schneemann's *Meat Joy* or Chris Burden crawling through broken glass, which were done on a tabletop using dolls and ketchup! Everything condensed, Futurist style. I classified performance art into styles such as "the boring school," and "the spiritual ritual," etc. The text that accompanied these actions aimed at informing the audience of the sorts of things done in the name of performance art.

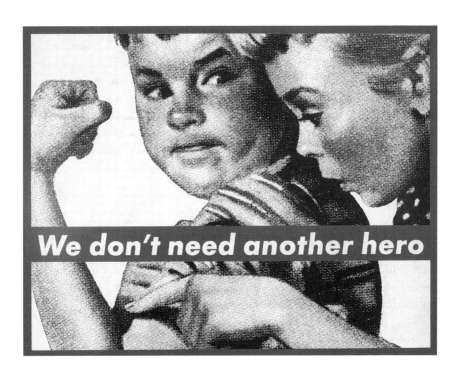

# Barbara Kruger

Barbara Kruger (born 1945; Newark, New Jersey) is a conceptual collage and installation artist whose art has been a form of social commentary and activism for more than four decades. Some of her most recognized work emerged in the 1980s, which consisted of text on random media cut-ups and photographic images in black, red, and white. These images directly addressed the viewer with satirical statements and questions on issues of sexism, classism, ideology, consumerism, autonomy, sexuality, identity, power struggles, control issues within society, and the dynamics of male and female roles. Her work is presented in the guise of an advertisement, with slogans like 'Who Do You Think You Are', 'How Dare You Not Be Me', 'Look Like Us', and 'I Shop Therefore I Am'. Her prolific work is found not only in galleries and museums internationally but in numerous public displays such as billboards, buses, posters, parks, buildings, train stations, and t-shirts. After attending Syracuse University, she moved to New York in 1965 to study at Parsons School of Design. She began working at Conde Nast Publications in 1966. Since then, she has worked at magazines like *Mademoiselle* as head designer, *House & Garden, Harper's Bazaar*, and *Aperture* as a graphic designer, art director, and photo editor. With her art, she creates "mock propaganda" works that capture the viewer's attention on both conscious and subconscious levels. She says one aspect of her work is to "welcome the female spectator into the audience of men." In 1977, she began working in black-and-white photography, which is cited as influencing her later work. In the 1980s, she started working in collage art with found images from print media, superimposing text. Since the early 1990s, she has created magazine covers for publications including *Newsweek, Ms., Esquire*, and *the New Republic*. Along with iconic graphic art, her works in video, audio, film, and sculpture have resulted in many large-scale installations. She has taught at the California Institute of Art, the Art Institute of Chicago, and University of California, Berkeley, and is a professor at University of California, Los Angeles. She was one of the first female artists to be represented by the Mary Boone Gallery and is still working with them today. In 2001, she received the MOCA Award of Distinguished Women in the Arts, and in 2005 was presented with the Leone d'Oro (Golden Lion Award) for Lifetime Achievement at the 51st Venice Biennale. Many articles, essays, and books have been written about her work, some by the artist herself, including *Remote Control: Power, Cultures, and the World of Appearances* (1994), *Love for Sale* (1996), and *Barbara Kruger* (2010).

*Did any factors in your youth affect your decision to work in the arts?*

Well, I really didn't think when I was a kid that I would be an artist, not an art world artist. I didn't know anything about art. I come from a poor, working-class family in a poor neighborhood in Newark, New Jersey. We just weren't on the culture train. I'm the first person in my family to ever own property. I went to public schools that were very poor and neglected. I just have a different race consciousness than a lot of people I know in the art world. Less than twenty years ago, say in New York, the art world was twelve white guys; now it's a much better place because it's just full of diverse people. As with my upbringing, it is full of all these different kinds of people. It was one which made me very conscious of how much difference there is in the world, how people could be different and yet still share similarities. That kind of awareness of difference really did inform my work.

*Where did you attend school?*

I only went to school for a year and three-quarters, maybe two years. I went to Syracuse for a year and was terrible in the art department there. I think I was one of the few people there who didn't have facial surgery. I didn't belong there, classwise; we just didn't have that kind of money. Then I went to Parsons for a year. After I left, at nineteen, I started working. My teachers were designer Marvin Israel, and Diane Arbus was my photo teacher. They had worked in magazines, so I got into the magazine culture trying to get jobs designing book covers, doing editorial design. I also worked as a billing clerk and a telephone operator. I got a job at Conde Nast at *Mademoiselle* doing design work when I was still quite young. I worked there on and off for eleven years, so that's where I really learned a certain visual language. I did do some early design work for a few months at a magazine that started in San Francisco called *Rags*, which is now a collector's item. I designed some book covers freelance. I went straight to the fashion magazines after I did that. I mean, I had no money at all. Maybe I could have done some more interesting work if I had an inheritance and my parents could have helped me along but that wasn't the situation.

*Is your work subversive?*

I have trouble with the word "subversive." It's incredibly romantic. I think that sometimes when you're romantic about certain conventions you cease to be effective because you're so caught up in what the romance and the history of that is. To me, subversion is "oh, I'm getting away with something." I think the way you make change is not only subject to "getting away with something," it's

the incremental changes that can alter people lives, small changes and they don't have to be done sneaky. It's really possible to make important changes and to do important powerful work and not to have to think that you're a subversive. That's sort of from another time. I mean, there's such a more horizontal, broad way of making meaning now. It doesn't mean there aren't hierarchies or gatekeepers, there still are on many levels, but it's not the same. I just think hanging on to old terms is not as productive as it might be. It's so hard because what doesn't become a repetition or a cliché? The point is to keep your eye on how to be productive and as effective, and make as strong or as moving art as possible, regardless of whether you're a musician, or a visual artist, a writer or a filmmaker, or whatever. I always say I don't make any claims for my work except I try and make my work about how we are to one another. That's pretty broad but that's the world. You know, how we love one another, how we hate one another, what we look at, what we learn. So I really keep track on what kind of culture we look at and what we listen to because it's that kind of stuff that builds consensus and makes meaning.

*When did you decide to take your knowledge from the magazine work you were doing and use it to make art that utilized thought-provoking statements?*

I basically transformed my work as a designer into my work as an artist, with some big differences; the differences being that when you're a designer, you have a very close client relationship so you're constructing someone else's image of perfection and idealism. What I tried to do was take the tools and use that to make work within an art subculture, to make meaning through those fluencies that I had developed. That was sort of a big move for me to do. In the art world, when I was quite young, it was very intimidating; there were almost no women there. But I think I started coming up at a time when women all of a sudden became very prominent; it was the first time women had entered the market in terms of the art world, about 1983 or '84. I don't know, I don't think in decades. During this time, most of us were not making paintings, though some were; we were working with photographic or installation works. Things really changed because my colleagues were other women. We had understood what we had gone through and it really changed for us.

*Would you like to mention some of these women artists?*

Sure. Cindy Sherman, Jenny Holzer, and Shirley Lavine, who had entered a market situation because suddenly people had lots of disposable incomes and that was new. Artists never, ever thought—I certainly never thought—I would make a penny being an artist; things changed as the economy went up and

down. Basically there have been more women slowly coming into the arts subculture. And it's changed radically from the way it was thirty years ago. There are so many women showing in galleries of so many different colors and sexual preferences, coming from all over the world, it changed extraordinarily. The irony is that there are so many art schools here with many students thinking they have to get their master's and all that. Meanwhile, the visual arts are almost totally marginalized in America. Most people don't know the name of one artist if you stop them on the street. It's a strange contradiction.

*Is schooling unnecessary to develop an artistic technique or skill?*

I don't really think school is a guarantee of anything. I think it makes it easier. Sometimes when I think back how much easier it would have been for me if I had come up with a peer group and had those connections rather than being an isolated person trying to find my way.

*What were some of your early works and where were they placed?*

I used to do stuff on the streets but I wasn't into the fetish of being a street artist or anything like that, which has become so fashionable now. I did stuff on the streets, did sniping... you know, putting postings up on construction sites and posts. I did that for a while and also started doing stuff within so-called alternative spaces, and then started showing in galleries, too.

*Was it anonymous at first? When did you first become known?*

Even now I do billboards and videos, and nobody knows it's my work unless they're art school people. Most people don't know who I am or what my signature style is because it's just visual information to people when they see a billboard. Most people don't know what artist it was so I'm just interested in making meaning in public to promote doubt, to ask questions, to make art about how we are to one another, whether we treat each other with kindness or with cruelty, and how that changes from the bedroom to the boardroom or to the war room. It's the same mechanisms that work on a certain level. Also, for the past sixteen years, I've been doing installation, working in video and in audio work. That's mainly what I've been involved with.

*When you started doing your art, were you still working at the magazine?*

In part I was there, but after I had left it, I took all these visiting girl jobs. I couldn't get a teaching job. I had no degrees but I'd get these little jobs for

one quarter or one semester and live in different places. I actually taught at Berkeley for a semester, and went from place to place to just figure out what it meant to call myself an artist.

*Did people feel your work was too confrontational? How did they react?*

It depends on who your audience is, everybody constructs different meanings. Are you talking about my work that's black, white, and red? A lot of that work is very different. It still has the same thread in that it talks about how we are to each other, different pronouns and direct address, which I've always used in my work even if it's a talking head. I have a video now that's on Sunset [in L.A.] on the top of a few buildings that addresses certain issues of consumerism and road rage. I still do the work that most people know of mine, there's a cover of *New York* magazine that I did, addressing Governor Spitzer. I think making art, regardless of the medium, is about creating commentary, about what it means to be alive, to live another day. And that's what I try do with my pictures and my words, whether it's photographically, moving images, still images, or through sound, installation, or 2-D images. You just figure out a way to engage those meanings.

*Are any pieces important regarding success in what you wanted to convey?*

No, I think it changes in site. It's different making work in a gallery, a museum, or on the side of a department store like I did in Germany. There was a show at a museum there called *Shopping* and I put these huge images on the front of this department store, which was basically questions about what consumerism means. I can't see stores doing that here. It is a question one asks. I don't exist in an ivory tower but I don't exist outside the market. My parents traded their labor for wages so it's not like I think I'm impure if I talk about the market, or come into the vicinity of money, because you can't live without it. You have to pay rent, you have to buy food, and you have to take care of your health in a country that doesn't grant healthcare. So I have no utopian ideas that there's a pure space or impure space, I think that we all struggle to live in the best ways possible. For certain people, it's a huge struggle, and for those who've been more fortunate, it becomes less so.

*Do you have specific placements from which you get the best response?*

You get different kinds of responses according to the context, and one context can fuel the other. I remember thirty years ago when I tried to get a billboard and nobody wanted to give it to me because they wanted to know, "Well, what

are you selling?" There were no arts organizations like the Public Arts Fund. That was a struggle, but once I started to get known in the art subculture, then there were arts organizations that could help fund a public project so I could have someone help me do a billboard. On my own, it was so hard because people weren't doing that at the time so that's why it was good to just do postings, random postings. But I wasn't very romantic about it. I think today there's this huge romance about being a street artist. I find it funny. I hope people continue to do that work though. I simply wanted to reach people. I didn't think I was building a career by doing it.

*Is the art created based on where it will be shown, or is the work created first?*

It's six of one and half-dozen of the other. Obviously, if I'm doing something more site-specific, I try to engage in that space. I'm very into architecture. I might have an idea in my head but in order to make it effective and powerful, it has to work within that space, so you figure out ways to engage a space as effectively as possible.

*Is your work a success? Is there a certain demographic you're trying to reach?*

Most people don't know who many artists are. Sometimes art students will know, but that's not the only group I'm speaking to. In fact, it's usually not the group I'm speaking to. It depends on the site, whether you're showing work in a gallery, or if you're fortunate enough to show your work in a museum, you get different people and audiences. That's great to be engaging as many contexts as possible.

*Do you express your artistic thoughts in other media, such as writing?*

I did write poetry for a while and I actually wrote criticisms. I used to write for *Art Forum* about film and television. I did a short thing on Kara Walker for *Newsweek* when she was picked as one of the "100 Most Important Americans." I still do some interviews for magazines with other artists. But I think when I was young, coming up, an important influence on me was someone like Patti Smith, she did really important work. So was Yvonne Rainer, who's a terrific dancer and filmmaker, and Chantal Akerman's early films. They're very important figures.

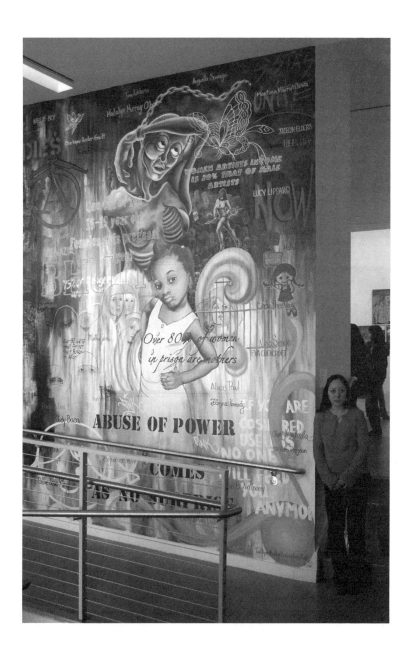

# Lady Pink

Lady Pink (born Sandra Fabara,1964; Ecuador, raised in Queens, New York) is an internationally known graffiti artist, muralist, and activist based in New York. She has been producing her art since the 1970s, and her work strongly supports freedom of expression, feminism, and social awareness. She was the only female to work within, and emerge from, the challenging early years of graffiti art. Lady Pink became known as a graffiti writer in 1979. While still in high school, her art was already being shown in galleries and exhibitions. Her work has been presented at venues including the Whitney Museum, the Metropolitan Museum of Art, the Brooklyn Museum, and the Groninger Museum of Holland. According to Lady Pink, her graffiti was an expression and form of communication in an unorthodox way. In 1980, her art was exhibited in the show *GAS: Graffiti Art Success* at New York's Fashion Moda and the New Museum of Contemporary Art. While still a youth, she had her first solo art show called *Femme-Fatales* at the Moore College of Art and Design in Philadelphia. Though she doesn't consider herself hip-hop, she became a hip-hop icon when she appeared in the cult classic film, *Wild Style* (1983). The film portrayed the early days of street art culture that included rap, breakdancing, and graffiti, in a fictional drama starring real characters. She joined the crew again for the film's twenty-fifth anniversary which was presented at the Hip Hop Honors, sponsored by cable television's VH1. As a staunch activist for justice and equality, Pink began collaborating with visual and conceptual artist Jenny Holzer in the 1980s by providing art to accompany Jenny Holzer's Truisms. Along with her graffiti art, she also creates illustrations and commissioned murals on walls, buildings, bridges, public transportation, and businesses around New York. She's been involved in many historical and community-based art projects like *42nd Street Art Project* (1993), *When Women Pursue Justice* organized by Artmakers Inc. (2005), the *Marc Ecko Block Party* (2005), and the *Wall of Fame Project* in New York City (2004). Her work can be seen in the books *Graffiti World: Street Art from Five Continents* (2004), *Graffiti Women* (2006), as well as *Subway Art* (1988) by Henry Chalfant and Martha Cooper. She can also be seen in the 1983 definitive documentary on graffiti art, *Style Wars*, by Henry Chalfant and Tony Silver. With her husband, Lady Pink currently runs a mural company, PinkSmith Designs, and continues to teach workshops at many schools and universities.

*How did growing up in New York influence to your artistic interests?*

My artistic interests went all throughout school, primary school and secondary school. By high school I met up with all the other graffiti writers, so I took a big interest in artwork there but it was maybe more vandalism. So being exposed to artists from all over New York City, a big metropolis, definitely contributed.

*Who or what first introduced you to the art of graffiti writing?*

I started at the age of fifteen in 1979, writing my boyfriend's name. He'd been arrested for graffiti and sent to go live in Puerto Rico. I was heartbroken and started writing his name all over the junior high school. By the time I went to high school, I had fallen in love with the romance, the adventure, the thrill and excitement of doing graffiti, and I was intent on going and getting some subways. So by 1980, I finally convinced the guys to take me to the train yards, the subway tunnels, and actually paint the big boys. That was the primary focus of that era, to get the subway trains. Eventually I was taught by many different people: my high school friends Seen, Doze, and Ernie. I also met an older, more elite group of writers who become my teachers: Lee, Crash, and Daze.

*How did your school experience influence you?*

Yes, the High School of Art and Design. I wasn't attending many classes, so that wasn't a factor. It was just a meeting point of many graffiti writers. The art classes that I took didn't have much to do with what I was trying to do. I started to major in architecture, I barely attended that; it was extremely tedious and boring, although I thought I should follow in my family's footsteps. My dad and my brothers in Ecuador are architectural engineers and I would have a knack for that but it wasn't what I wanted to do at the age of sixteen. I wanted to paint large, colorful, free and unhindered by any kind of rules of mathematics or precise codes. I just wanted to run wild, run amuck with color. High school started off with about four periods of lunch, which was as many hours as they kept the lunchroom open, followed by about an hour of ladies room, and that was my school day. It really was much more a meeting point for going to day-spots to paint or to go acquiring paint outside of the city. You had to make a day mission, get somebody with wheels and drive up to Connecticut, New Jersey, or Long Island, someplace outside of New York so that you could acquire paint, fill up a car, make a whole day out of it. So I didn't really attend classes much.

*What made writing graffiti so appealing?*

Well, the excitement, thrill, adventure, the fame, power, the friends, being in the popular crowd, being cool. When you start being a graffiti writer, you have a few successful missions, get a little fame, get known, you get power and that is a heavy thing for teenagers. And at the same time, when I was sixteen, I started exhibiting in galleries when it was all just blossoming. Guys were exhibiting and they needed a female, so I was their token female. But I learned fast and I got good fast. Immediately, paintings started to sell and then there was money. Money is also very seductive and appealing but initially it was just the thrill, excitement, the adventure, knowing that you've successfully conquered something and gotten away with it, if you didn't get arrested or killed. All of those things are very seductive for teenagers. If you want to sow some oats, break a few laws, and be considered cool, then that's what kids do. We weren't hurting anyone; we were just playing with paint and running from authorities. Kids could have been doing a lot worse than just playing with some spray paint.

*How did the writing groups come about when they did?*

We call ourselves crews, painting crews. It started off in the 1970s with groups of guys. If they called themselves The Crazy 5, there were five of them. They went specifically with their small groups. They came up with a crew name and it was all about trust, being comfortable painting with each other, collaborating and trusting each other when things got gnarly and the cops busted someone. Are they friend enough that they're not going to rat you out? That's what crews started out to be; guys that trusted each other and painting. And over the years it became more of a status symbol and a social thing, to be down with crews. When I started off, I got down with a lot of important crews. Which tells people all over the city that I'm friends with this guy and I know so and so and these people have my back so don't mess with me. When you have a lot of back, then you get a lot of respect, and if you're known and down, liked in social circles just like any other social situation, with that also comes some kind of trust but it's certainly not foolproof. It's still all up in the air sometimes. Now I've been down with TC 5 since around 1981 but that crew dates back to 1973. I can't even name all the originators. It's that far back. Now there's a new generation of TC 5, different guys, older dudes, but they paint very well. The status of that crew has always been quality artwork. Only people who get up a lot, do beautiful work, and are very cool can be down with that crew. It's all selective, it's all by invitation. There's always a president and maybe a vice president of a crew. These people have power to put other folks down and not just anybody could do that.

*Within the crews that you were a part of, were you the only female?*

I was always the only female in all of New York City from 1980 through at least the early '90s when some other females started to appear. So for a decade I held it together. I was like the only female in Graffitidom New York City, and pretty much around the world. Not until the late '80s, early '90s, did other females start to pop up. There were some girls that did a little work, painting here and there. But I stuck with it, did larger work. Then other girls appeared in New York City: bombers, painters, females from around the world.

*What was it like to be the only female in that scene? Did you have issues with other writers taking you seriously?*

Yes, all levels of sexism. Not being taken seriously, not being included in certain things to full right out lack of approval, support and encouragement from guys. It came in all sizes, shapes, and ages. Guys reacted in all different ways. A lot of jealousy, jealousy I still have to deal with. When you do real good work and projects, and sell your stuff for money and do well, folks are jealous. People just get jealous and they want to bring you down to their level. They're like, "Why did that person do it, why didn't I get it? I should have been that." Then they badmouth you and try to drag you down, play childish games. The graffiti community in New York has gotten smaller over the years but is still a community. We're a big family, we don't all like each other, we don't all get along but we are all stuck with each other.

*What did it take to break through those biases against you as a female?*

Well, I got accepted pretty early on, I think because I have a big mouth. Make myself heard. I'm very outspoken, made the right friends. Young women now have a hard time getting noticed, being taken seriously. It's a matter of not just what you do but who you know and how you present yourself, how you speak, speaking up for yourself. It was very difficult but I have my ways.

*How did you get your name?*

My friends in high school decided I needed a female name and Pink is about as female as you get. It wasn't my favorite color or anything but it says female and the letters work together. We do our fonts, our stylized letters, and how they worked well together, it was cool. I titled myself Lady after the European aristocracy, the nobility: Dukes, Duchesses, Marquise, Lady. I was a big fan of historical romances as a kid.

*How did you develop your style of writing?*

Usually I prepared a sketch beforehand. Most people did. The lettering was quite elaborate; you had to draw it out and memorize it. And you didn't really take the sketch with you. Once in a while I improvised and made stuff up on the spot. It takes years of studying lettering that developed in the early 1970s. It morphed into a kind of wild style through the mid-'70s and was well established by the time I came along. You had to study letters and learn how to draw them, link them together creatively and come up with your own original style, yet keeping to the guidelines of New York style, where fonts are very specific. It takes the kids a lot of time to figure out how to shape the letters yet originate your own individual style. Over the years it's gotten so wild, it's almost illegible. It's a bit of an effort even for me to read some of the current things that kids are doing. The letters have gotten so wild that they've excluded the casual viewer and we're only communicating to each other. Through the late '70s, when tags and pieces became so elaborate, folks just saw it as a big, abstract splash of color and had no idea that those are letters and it says a name. We teach master to apprentice, and it really just takes someone to teach you and tell you correctly, give you some kind of feedback. You cannot learn this just by looking at books. You really need feedback from other artists, that's how we become a community. It's rare that you can just isolate and do your own stuff like most street artists. It takes persistence, which I think is a key word to our world and our culture; long persistence.

*What is the writing process once you've got a location?*

You could stay all night or do something in five or ten minutes. Way back when we did subway trains, you had to go with people who knew where to go, how to get in, the times and schedules. You sent out a scout, you snuck in shadows, hopefully without making noise. Most all the subway cars were already covered by graffiti. You had to pick and choose where you could paint, who you can go over, and you did your thing. That could take anywhere from twenty minutes to six hours but you had to be done by sun up. And you got into these places in all kinds of ways: climbing walls and fences, running through tunnels, playing with live trains. They parked the trains all over New York City. We have over twenty train yards, I believe, and hundreds of lay-ups, where they just park them in the middle of the train tracks. They have a lot of winter lay-ups, too, which was our favorite time to paint. They park them indoors to protect them from the weather. It was very scary stuff. Sometimes you didn't find the right trains, other people were in there, you couldn't even get into where you were going, or one of your friends has to leave in an ambulance.

*What precautions did you take to protect yourself while writing?*

I didn't travel alone. I tried not to do any missions alone. I always had a group of young men with me. And I would dress as a boy because some of the young men I traveled with were very young. They were teenagers like myself, not very large. So you do encounter big groups of other graffiti writers in tunnels and yards, larger guys in their twenties with sticks and chains. So when you're underground, no matter if you're boy or a girl, if you're smaller, you can be robbed. They'll take your paint, sneakers, jacket, whatever they can, and send you home crying to Mama. Worse things could happen to a girl. So I would take precautions by dressing as a boy and trying not to travel alone.

*What is the meaning of a person's personal tag aside from signing one's work?*

Well, people chose their names by the way letters look good together, not necessarily by what it meant. There are a lot of names that mean absolutely nothing. It's just the letters look good together. So sometimes names sound silly, outrageous, funny, and absolutely meaningless. It's more what you're comfortable doing. Sometimes you pick a silly name as a teenager and you're stuck with it forever like Stay High, he can't be happy with that. He's from the very early '70s. But he's an old geezer now and he's stuck with that name for the rest of his life. So you have to choose carefully.

*What was it like when you were first writing at the Ghost Yard?*

That's one of the particular yards we would go into. It was a sweet place because you could go there in the daytime also. I would go there instead of high school. They parked the trains in all kinds of ghetto neighborhoods all over New York. So I got to see some very interesting, colorful neighborhoods I never imagined, got lost in some, wandered around all kinds of dark alleys and creepy places, the rocks by a river, crazy dark tunnels. The environment in the early 1980s was still kind of dangerous and crime-ridden as New York fell apart during the '70s. It was not very safe for a tiny, young woman to be out at three in the morning. I had to take guys with me and when I lost the guys I was very terrified. You'd get separated, you'd get chased, and I'd wind up going home by myself pretty damn scared. I did carry a knife early on. I used it just to scare people off. Like when guys start to get too friendly and say, "Hey, sweetheart, what are you doing here all by your little self?" So you take out a knife and you start cleaning your nails with it.

*How were the large-scale murals created in such dangerous environments?*

It all depends on the sweet spot you go to. You can do whole cars easier if you go to a spot where there's a platform and you don't have to actually scale the bloody thing. Or you can go to a safe spot where you know you can be there four, five, six hours without being disturbed. Only then is it successful, otherwise you have to paint much shorter, window down pieces. It was difficult but it does just take physical strength. It's hard manual labor. If you can keep that up and you're not scared, you know you can do it. I was able to do some top-to-bottom whole cars.

*How did you do this at night and then go to school and also fit in the missions?*

Well, the missions were mainly on weekends. During the week, the train yards are much more active than on weekends. So it was really more a matter of balancing whether you wanted to go get dirty doing hard manual labor in a some scary tunnel, or you wanted to get all dolled up and go to a nightclub with all kinds of interesting people like Keith Haring and [Jean-Michel] Basquiat. So that was the difficult part. School during the week wasn't too much of problem since I could get up and wander in when I wanted to, right for the lunchroom.

*So a certain amount of weekend fun was sacrificed to do what you wanted?*

Yeah. It still had to be done and that was a whole different kind of fun than going clubbing and partying.

*How do you feel about the laws that made your artform a crime?*

Well, there's always been some kind of law trying to maintain control. The authorities saw it as a visual pollution, as a big slap in the face, that there's loss of control. So some of the laws were a misdemeanor and such, but it's kind of the fun that kids wanted to play cops and robbers. You know, "I break the law, you chase me," and without that it wouldn't have been nearly as much fun, without the element of danger of being discovered, being grabbed. You know, Prohibition was a riot with people bootlegging and running around like that. You took away that law and folks were just drinking. So it's a little bit of that. Kids wanted to be outlaws, would need to be chased and potentially arrested. There's got to be that element. Nowadays, the laws do not fit the crime. They are much too severe. They can charge you with felonies. I just heard of one young man, I don't even think he's twenty yet. He's looking at eighty-two felonies for graffiti. And we've never even seen his name up. I mean what kind of damage

did he do? They want to ruin this kid's life forever? The penalties don't fit the crime. You could kill a family of four with your car and do two or three years, yet you do graffiti and you can spend decades in jail.

*When and how did those laws change?*

Over the years, they've changed it little by little, and then it depends on where you do the graffiti. If you paint subway trains, it's a felony; if you do it on walls, it all depends on the kind of damage. The Vandal Squad [the graffiti police], they've been around since the mid-1970s or so. They keep tabs on who's who and who's done what. They have spies and they infiltrate the shows and galleries, always filming people and taking photos. They can read most of the stuff and they have rats [snitches] in their pockets. It's all a big I Spy kind of a game. There are known rats, there are people who go down. Most folks who've always been very cautious and careful about what they do, take a fall because of a rat. When I appeared into the scene, some guys accused me of being a spy for the Vandal Squad, you know, send the pretty girl in there to sweet talk all the information out of the guys. So they were reluctant to give me information. It isn't a game though because people do go to jail, people have gotten killed, and folks' lives have been ruined. They have different laws in different countries but we are protected by the First Amendment. Most folks don't have that, where you don't need a warrant to kick in someone's door and steal their shit and take away everybody. In some countries, people have endured some severe penalties but the spirit of rebellion is what's important. Folks are willing to take these kinds of risks to continue rebelling. It is art but it is the spirit of free speech, self expression, freedom of expression, all of that. I don't think it can be crushed. So it is important that it continues despite the penalties and the consequences.

*Do you consider yourself a pioneer of hip hop culture?*

I don't consider myself a pioneer of hip hop. That phrase wasn't coined until the early 1980s. Before then, there was no such thing as hip hop yet, there was more than a decade of graffiti. Then this music started to happen all around us, kids were dancing. But we certainly didn't have anything to do with the creation of that. It wasn't until the media and corporation marketing got a hold of this hip new style that they coined this phrase "hip hop." They lumped us all in with that. The artwork, the dance, the music, it's all the same thing to them. But it's not, because a lot of graffiti writers do not listen to rap music and do not have anything to do with the breakdancing. That really pigeonholed us and categorized us as a minority subculture. They stereotyped us. The music

has absolutely no effect on what we do art-wise. There are a lot of folks that listen to alternative music, rock music, or punk. Most of us were very focused on our artwork and succeeding at doing our graffiti. I liked rap music early on. Then the hip hop fashion came along and you had to dress just so to be hip hop. Graffiti writers didn't do that. We dressed like bums, we get paint on everything, we don't pay attention to fashion.

*Does the work of early graffiti artists and the culture that emerged from it get the acknowledgement it deserves today?*

I think early artists are appreciated in the memorabilia sort of a way as a collector's item but as fine art, not that much. The art from the '80s is appreciated more because it's elaborate. It's appreciated in different markets. Now that it has gone international, kids go crazy for old school stuff; they want to buy old spray cans, old drawings, subway signs with old tags on them from the originators of the early '70s. They spend a ton of money on it on eBay. You'll find art from the early '80s, like with myself, has continued to gain value into the six digits if you want to put a monetary value to show how it's appreciated. Our style is copied by Madison Avenue, Valentino, Chanel, the advertising world and corporations, by everyone and on everything. Yeah, I think we are appreciated well enough.

*Have you had a feminist attitude in your writing?*

Early on I really didn't know what a feminist was, I just knew that the Women's Movement was going strong through the 1970s. I was a teenager. But it was everywhere, especially in the big city, women were showing their fangs. At the time, I was just standing up for myself against a bunch of stubborn guys. Through my early twenties I did become a feminist, aware of social, political, and world issues. With my fine art, my painting, I depict women in all kinds of situations from victims to heroines.

*After graffiti became a felony, has the transition to indoor galleries been difficult?*

The transition really happened around 1981 with some of the first exhibits in galleries in New York including museums, places like that. It wasn't a very difficult transition at all. You know, you're painting in the dark with your heart in your throat, then you're painting in the quiet of your backyard of your parents' home and stuff is now being exhibited. I come from a good family. I was a well-spoken kid and the transition from the underground ghetto kids to the aboveground media circus of the cultured white people wasn't that difficult

for me. A handful of the other guys had a very easy time moving up to the aboveground world, speaking for themselves and representing, and then there was a handful of idiots who couldn't make the transition, who couldn't speak, couldn't face up to white people, the media, all that money, all that pressure, and come with a big chip on their shoulders and just couldn't adapt. I was a chatty kid so they put me in front of the TV cameras all the time, the shyer guys hung back a little. It wasn't that difficult. Folks paying you hundreds of dollars for the same thing you were doing on the weekends in the dark.

*What was it like seeing your finished art?*

That's pretty much the biggest rush and the reason why it's all done. You get a huge thrill, a major rush. Nothing else equals to it, seeing your name roll by on a big subway.

*Why do you think graffiti became so popular when it did?*

I have no clue why society took that turn. It was grasping for something rebellious and underground. That is always very wanted and sought after: the new underground culture that hasn't been corrupted by the masses. I think it's the romance of the outlaw status.

*Was there conflict between the crews?*

Out of hundreds and hundreds of graffiti crews, it's difficult to answer that question. There are grown-up crews and kiddy crews, and they all resolve things differently. Back in the day, there used to be a code of ethics. That was thrown out during the 1980s and people just started going over each other willy-nilly. The stakes were raised during the '80s. In the '90s, it became popular to be a hoodie and a gangster. So the scene changed and people resolved their differences with a bit more bloodshed than there used to be. Not only did you have to watch out for the police but now you have to watch out for writer gangsters, who just sought to be infamous by destroying your work. The quality of graffiti suffered. No one wanted to take time to do something beautiful if it was going to be destroyed by some idiot.

*How realistic was the movie* Wild Style? *How did you get involved?*

Well, the movie is pretty true to some aspects. The dialogue is a bit made up and some of the situations that were written in the plot are completely true: the love story, the art dealers, the rappers, the breakdancers doing the same

thing—folk art—just inventing their own thing. The director of the movie used to chill with us and was just like part of the gang. He was writing a story about things he saw around him. He didn't know anything about breakdancers. As soon as he met them, he wrote them in. He went to the Bronx in those dingy little clubs with all those rappers competing and all that energy and creativity and wrote that into the movie. We made the movie hugely low budget; the only people who couldn't be replaced got paid. Anybody else that was expendable, don't even ask for money. I was about sixteen or seventeen, so I have very little memory of it. We didn't think his film would go anywhere, and it turned into a cult movie that still haunts us. He wrote me into the story and Lee, who really was my boyfriend at the time. Lee, he's considered the king of graffiti. He knew a lot of the people in the movie like Fab 5 Freddy, who introduced him to all sorts of interesting shit. The better movie was the documentary that came out around the same time, *Style Wars*. It was the video bible of New York subway graffiti. It was done by Henry Chalfant, the photographer who put out the very first book, *Subway Art*. Those books from the early '80s, they went worldwide. Compared to *Wild Style*'s combining of graffiti, music, and dancing, what we did, we really did it in quiet with no dancing and music. The music was all in our heads and the dancing only happened if you were trying to avoid the third rail when you were running from the police.

*When did you start using your art as a social and political statement?*

I think I started that in my early twenties. I was described by the media as a coming-of-age artist, becoming aware of social and political issues in things that affected me directly. Things that I felt deeply about is what I painted; protesting or bringing awareness, or just screaming about injustices like poverty and hunger, homelessness, and gay bashing. I started using my art as a voice. I try to tell a story with each of my paintings. Rarely do I do something just decorative for the sake of being decorative. Little by little over the years, I got involved after seeing more and more injustice, and started to understand what freedom of expression really means. So it was about things that would affect me, that infiltrate my life, like the government trying to put their finger on our artwork. How dare they?! I can understand they don't want vandalism and they want to arrest the graffiti writers who are vandalizing, but then we're aboveground in galleries and museums. Still the government is trying to crush us. The more I'm told, "You can't do that, you've got to stop, you've got to conform," the more we would battle against it. So I hooked up with different artists, different causes.

# Johanna Went

Johanna Went (born March 1, 1949; Seattle, Washington) is a performance artist and musician from Seattle, emerging out of the West Coast punk rock scenes of San Francisco and Los Angeles in the late 1970s. She first began working in Seattle with Tom Murrin and was touring nationally with him performing absurdist street theater. She moved to Los Angeles and took up solo performance art but soon after began combining her art with music in 1979 as a vocalist with Z'EV playing percussion. In 1980, Johanna's performances had a full instrumental backing with musicians like K.K. Barrett from the Screamers and Brock and Mark Wheaton. It became a loose conglomeration of improvisational, unrehearsed presentations, which has been described as punk rock, new wave, experimental, jazz, and noise. In the mid-1980s, she toured the United States at music venues and festivals, performing with bands like the Dead Kennedys, the Germs, and the Mutants. She was known for performing in surreal costumes created from found objects, incorporating bizarre or terrifying props. Her props consisted of fake blood, giant doll heads, body fluids, raw meat, and heaps of fabric that were used in ceremonial or ritual type displays. Johanna's performances focused on monsters, and mythological and biblical characters, and were often referred to as chaotic, otherworldly, and nightmarish. Her music can be found on the single *Slave Beyond the Grave* (1981), the album *Hyena* (1982), as part of *Found Objects* (1985) and the compilation *Johanna Went: The Club Years 1987-1997* (2007). Johanna has performed at music venues and art spaces including the Whisky a Go Go, Club Lingerie, Hong Kong Café, Mabuhay Gardens, Magic Theater, New York's Franklin Furnace, and The Kitchen. Her work has been featured in Re/Search's *Industrial Culture Handbook* (1983) and Meiling Cheng's *In Other Los Angeleses* (2002). Johanna has appeared in several films, including Shirley Clarke's *The Box* (1983), Gregg Araki's *The Living End* (1992), *Ghosts of Grey Gardens* (2005), and *Hallelujah! Ron Athey: A Story of Deliverance* (1998). She's exhibited at many galleries, most notably at Track 16, with the shows *Twin, Travel, Terror* (1987), *Alchemy of Monsters* (1991), *Interview with Monkey Woman* (1998), *Possessed Possessions: An Installation of Performance Paraphernalia* (1998), *Forming: The Early Days of L.A. Punk* (1998), and *Last Spring at Grey Gardens* (2001). The exhibition *Absolutions of a Nefarious Nature: A Retrospective* (2007) was a collection of her performances displaying props, flyers, costumes, and more, from over thirty years of work. Her 2004 show, *Aggravated Resistentialism*, was a reunion with Z'EV. In 2011, her work was featured in group shows at LACE and the Museum of Contemporary Art, both in Los Angeles.

*When did you start performing? What got you interested?*

I first started doing what I consider performance art in the mid-1970s, in Seattle. I met a man named Tom Murrin, alias Alien Comic and Jack Bump, who was working with some Seattle performers, dancers, actors, and singers in a group called Para-Troupe. He was organizing some freeform, site specific, public performances and I joined in. This was before I had ever heard the term "performance art" but that term is best to describe the work. It was spontaneous, unscripted, and performed by persons whom on the surface seemed to be devoid of any theatrical skills or talent of any kind. It was the perfect setup for my sensibilities and still is.

*Which do you consider yourself foremost, a musician or a performance artist?*

I have to consider myself a performance artist first because I can't play any instrument except my voice. I have grown to realize that there are more people that hate my particular style of singing than are offended by my actions on stage. Also, even though I can acknowledge and enjoy the talent of others, I'm not invested in being applauded for possessing talent in the classical sense.

*Were your acts completely improvised or did you plan any with scripts?*

My scripts are mostly visual drawings, diagrams; not much in the way of actual dialogue or stage blocking. Mostly I draw rough sketches showing the sequence of costumes, characters, and paths for them to enter and exit on.

*Why did you decide to combine music with performance art?*

I've always been really interested in music and I started going around to clubs in L.A. thinking, I really have to have music, especially at the punk clubs because the music was so inspiring, so intense, exciting. So I kept trying to get booked at clubs and nobody would book me. I started going to the Hong Kong Café and I kept asking the guy to book me and told him I had a drummer. I didn't really have a drummer but I knew this guy who might drum for me. So I talked him into it, and he put me on a bill with The Plugs. It was great. I did the show and everybody liked it. After the show Z'EV comes up to me and says, "You were great, you have to get a good drummer though, get rid of that guy." He said, "I'm going to drum for you." So we started working together. He uses all kinds of percussion things he makes himself and was really into improvising, which was what I was doing. We performed a lot of shows together. Later, he moved to Amsterdam, so I started asking different people to perform with me—like

K.K. from the Screamers played drums. Then I met Mark Wheaton, who was with Chinas Comidas, but the band broke up so he decided to play with me. It's always been my feeling that because my work is spontaneous, I want my musicians to work the same way. I try to explain the parts of my shows to give an idea, the ambiance of what the show is about, because usually I do nine pieces or acts. I describe the costumes and what things in my mind would sound like. I started working with Mark Wheaton in 1980. He always understands what I tell him, like "I want this part to be watery or a storm." I'm very vague because I'm not that articulate; maybe that's why I do the performances I do. There's a lot of stuff that wants to come out but I don't have the words for it. Mark puts together the music, and we put voices to it and some noise. Then we go with it.

*Was there any message being conveyed, or was it just freeform expression?*

I am truly an advocate of free expression. Since I began performing, I have not been interested in voicing other people's words or expressing someone else's emotions or aping their actions. And I don't put down others who do. I just happen to enjoy entering a performance arena without the need to fully control what happens there.

*What is fascinating about mythological or biblical characters?*

I've always been interested in mythology since I was a child. I lived in the housing projects in Seattle in this area called White Center—they called it Rat City. My mom died when I was young and I had to take care of my brother and sister. There wasn't a lot of supervision but one of the things I'd like to do was take my brother and sister to the library, especially in the summertime. Because I really liked to read, I'd go every day. The librarian used to let me read adult books, so that's how I really got into mythology. I read a lot about it. It entered my consciousness in a very profound way, especially since I was brought up Catholic. There are very similar symbols and stories. I hated going to church but I liked the creatures, the scary stories, anything frightening. I incorporate it into my shows by building it into costumes, anything religious. Any kind of religious belief I put into mythology. I'm not a person who believes religion is a good thing. I think religion is a dangerous thing for many people. My idea is not to inform. The thing I hate most is preaching to the choir. I hate going to see something with a message because usually it's either a message I'm aware of or know about already. It annoys me. I consider the audience smart enough. I like my performances to be entertaining; I don't believe performance art shouldn't be entertaining. I think art should be funny and humorous and encompass all elements of life. My idea is to create a performance that has a dreamlike

quality. I want to give members of the audience a personal experience. A lot of times the imagery comes out of me and I don't know what it is at the time. It's never rational. It's always blurred into each part. Hopefully there's a flow and you can ride that through the show. The little amount of structure in my shows is because of the messy cleanup. I want to make sure they're done at a certain time. I make little scripts but they're not solid. I make the art as I go along, though the costumes are pre-made, there's a continuation of the process during the performance, during the building up or the tearing down.

*What is the meaning of the grotesque element in your work?*

I fell in love with monsters at a young age. I was more fascinated with the concept of the devil than, say, the saints and the angels, although I was really into the martyrs; they were gory and very intense. The ritual process of my performances has to do with going to Catholic church when I was kid where rituals were constantly performed. There was a visual sense and timing to it. I like all types of rituals though, especially primitive. Any kind of primitive rites I think are fascinating. I really think there's a need for the primitive in our society, to have a mythology that's not so cut-and-dried, one where you need to use your imagination to work with it, as opposed to most religion where it's so rigid and defined.

*How do you use the found objects for costuming?*

Finding things is part of me; it's in my DNA. I also feel like they find me. There's a calling out. This object is asking me to use it; it was made for me to use, to destroy, and to change. Sometimes I adapt objects. Lately I've been using paintings from thrift stores; these are pieces of art that are disowned. I've been sewing the canvasses onto the costumes. It feels like magic to me. I work on instinct. A lot of times the costumes turn into characters; my costumes are very alive to me. I always have this sense in the middle of a show that a certain prop or piece really wants to be seen. I feel like I'm not alone on the stage, that they're as much a part of the show as I am.

*How do you respond to people's interpretations of your work?*

In the same way that I seek freedom within my performance, I also offer the audience the same freedom in interpreting my work. When I experience a situation where someone is trying to shove a message at me, I rebel even if I happen to agree with them. I hate being preached at. Surprise, intrigue, suspense, and mystery are more important to me than stories, definitions,

and information. I use color, form, light, sound, and movement along with a symbology indicated by the combining and placement of things, including vague vocalizations and ambiguous creatures to build a playground which dramatically bridges the unconscious plane between language and understanding.

*Was it difficult singing while using elaborate scenarios in your performances?*

Singing during shows has always been a challenge, especially since I don't have a strong voice and have no formal vocal training. Usually I strain my voice and I am hoarse for a couple of days after shows. Also since the musicians and I don't rehearse, my voice often gets swallowed up in the noise.

*How long does it take to prepare for shows?*

The last show I did took me two years because I'm older now. When I was young I could put together a show in a couple of days, maybe a week. My style has changed. My props and costumes are more elaborate, more work intensive, more handwork. I always have two or three things I'm working on at a time so I can change it later, or cannibalize costumes and props. I feel like I've kind of done cycles. There's so much involved, it's a 24-hour process.

*Have you ever been injured during any of your shows?*

No, but I broke my ankle and leg at home falling down stairs in 1990 and had a few operations on the ankle. Recently I had to have the ankle fused, so now I limp a bit but I'm no longer in pain. The injury has been the main reason that I perform so infrequently now.

*Was it your intention to join the punk scene, or did you just fall into that genre?*

I was lucky enough to fall into that genre probably because of the aggressive nature of my show. I was an adult at the time and even though there were many non-youths like myself participating, the punk scene was a genuine product of the youth culture.

*What were the messiest, most outrageous, or elaborate shows you remember?*

In my 1988 performance entitled *Passion Container*, I am in a headless costume with a large soft sculpture prop called The Head. The Head was tossed out into the audience during the performance and thrown around by audience

members throughout the show. Also, the first performance from the Monkey Woman Trilogy, called *Interview with Monkey Woman*, where I am wearing the costume at Don Preston's loft. And at Club Lingerie, there was the performance on Halloween in 1981 and the Whisky a Go Go show in 1982. The *Aggravated Resistentialism* at Track 16 show, June 2004, is another.

*What were your most memorable shows?*

That's hard. Honestly, my best work was when I was younger. My work now is bigger and I hope it's still exciting. When I was performing in clubs, it's really hard to remember a whole show. A lot of them weren't videotaped; sometimes I have photos. Maybe my show at the Whisky a Go Go in 1988, one of the last big club shows that I did. The costumes were bigger and the ideas came quicker. There was *Knifeboxing* at Club Lingerie. I was very excited because someone was going to videotape it. That night I felt the energy of the audience and a psychic connection, a melding of the consciousness. When I feel that, it's very powerful. The music venues are rowdier, higher energy, more excited. It's different than performing in a performance space where people are just thinking. I encourage them not to think and to just feel and experience.

*Are there any women performers who influenced your work?*

I love women with strange voices. When I was in high school I had a friend that loved Buffy Sainte-Marie and would go to her house and listen to her records. I liked Yoko Ono's voice and lyrics, too. My family was poor and we didn't have a stereo or records. Later, I got into Yma Sumac, Patti Smith, Diamanda Galás, and L.A.'s own Exene [Cervenka].

*Was there any show that ended in the venue being shut down or with your arrest?*

No, but I have had shows canceled. I was hired to do a performance for an event that was being presented at MOCA [Museum of Contemporary Art]. It was being produced by a special effects production company, and I was called four days before the show and told that I would not be allowed to perform on the property. The person at the museum wouldn't tell me why but the person from the effects company who hired me told me that they thought that I would destroy something.

*Who were some of the most unique bands or performers of the punk era?*

The Dead Kennedys, Inflatable Boy Clams, Z'EV. The Minutemen, The Germs, X, the Circle Jerks, DNA. Some of my favorite local bands were less known: The

Fibonaccis, Ella and the Blacks, Catholic Discipline, Strong Silent Types, and Mood of Defiance.

*Do you engage in any other art medium aside from performance and music?*

I take photographs but I haven't ever shown them. Also, I try to video some of my other friends' performances or artwork.

*What are some of your most memorable recent shows?*

A couple of years ago I did an installation and two performances at a place in Santa Monica called Crazy Space. It was a collaboration with Lily Greenfield Sanders called *Last Spring at Grey Gardens*. It was inspired by the film *Grey Gardens*. It was a time-based piece that lasted two hours. The installation was our interpretation of the gardens and the dilapidated mansion. The audience was allowed to walk though the performance space and could stand or sit on the same furniture that was a part on the set. It was the most elaborate set that I have built and the space was completely packed with things. We improvised the dialogue not intending to imitate the two women in the film, but instead we etched out an emotional response to the ties that bind place, family, and time. In June 2004, I performed *Aggravated Resistentialism*. Resistentialism is the theory that inanimate objects can demonstrate hostile behavior.

*Will you talk about your big retrospective show?*

For my show at Track 16, I was really honored because they wanted to present photographs from my early days through now. It was a big process trying to put it together. The curator, Laurie Steelink, was really amazing helping me do this. Performance art is so ephemeral, it's here one minute and gone the next, and documentation gives you a sense of what happened. Video leaves a lot to be desired; photos capture a moment and little piece of time in a way that video doesn't. The way we watch video, you always have a filter on. It also doesn't include some of the things that are most important, which is the energy of the house—the space, the people, the performers—there's so many subtleties that are not there, the colors are never the same, it's never an exact experience. All these different photographers that have given me photos over the years, I'm just so happy to display all this work. In another room, there's a display case of different items like records, magazines that I was in, old props and costumes. I have a lot of new costumes, probably thirty. A lot of them were destroyed when I had them in a garage during a rainstorm, it leaked badly, so whatever I had left I showed some of those. The new costumes came from the last couple of years. It's been an amazing show.

## Tessa Hughes-Freeland

Tessa Hughes-Freeland (born 1958; England) is an experimental independent filmmaker and conceptual artist. After moving to New York's Lower East Side in 1981, she emerged as part of the Cinema of Transgression filmmakers. Some of her most infamous films, mainly consisting of shorts, are *Play Boy* (1981), *Baby Doll* (1982), *Rhonda Goes to Hollywood* (1985), *Rat Trap* (1986), *Jane Gone* (1987), *Dirty* (1993), and *Nymphomania* (1994). In collaboration with Ela Troyano, she created *Playboy Voodoo* (1991) and *Elegy, for Jean Genet* (1994). As a filmmaker, her peers included Nick Zedd, Casandra Stark, Beth B, and Richard Kern. Many of her films are intellectual parodies of pornography and sexuality in film, confronting the viewer's personal concepts and subjectivity. She uses a complex layering technique in her films of projecting images onto one another until they oversaturate each other, creating subtexts and metatexts. Her unique style can also be seen in her works of expanded cinema, often in collaboration with Ela Troyano. A best-known work was the presentation of Jean-Luc Godard's film *Contempt* (1963), accompanied by John Zorn's composition *Godard*. In the 1980s, Tessa and Ela Troyano began showing their films in New York nightclubs like Danceteria, Club 57, and the Limbo Lounge. Tessa became a film theorist and commentator on the East Village art scene, writing for papers like the *Underground Film Bulletin* and the *East Village Eye*. She worked with Richard Kern on the cult classic film, *Fingered* (1986), and on *Red Spirit Lake* (1993) by Charles Pinion. Tessa, with Ela Troyano, founded the New York Film Festival Downtown (1984-1990). She also curates with MM Serra for the Film-Makers' Cooperative, also known as the New American Cinema Group, which was founded by Jonas Mekas in 1962. The organization's board of directors focuses on the preservation and archival of experimental and avant-garde films, along with the promotion, funding and distribution of films considered too radical, offensive or taboo to be released into the public by any other means. The New American Cinema Group has an open membership, with a strong principle of anti-censorship. Tessa's work is documented in the books *Deathtripping: The Cinema of Transgression* (1999), *Captured: A Film/Video History of the Lower East Side* (2005), and *No Focus: Punk on Film* (2006). She curated the films for *East Village USA*, an archival display of the East Village cultural scene from 1980-1990. She continues to work in film and expanded cinema. Her recent work has been shown at Exit Art and Deitch Projects of New York, and she has created the films *Watch Out!* (2007), *Instinct* (2009), and *Gift* (2010).

*When did you start working with film and what was the motivating factor?*

I was a teenager and I did it for fun. I was surprised at how people would act in front of a camera.

*What is New York's Cinema of Transgression and how did it affect independent and underground film?*

It's interesting how history works. In the early '80s there were lots of filmmakers who were remaking films and showing them in clubs. There was also a certain degree of creative synchronicity amongst a number of them. It was a time with a strong creative zeitgeist whereby people were working in different disciplines yet in the same vein. The Cinema of Transgression was a catchphrase used to describe certain films, coined in the *Underground Film Bulletin* in 1984 or '85. The *UFB* was a Xerox film fanzine put out by Nick Zedd under the pseudonym of Orion Jeriko. Right after that, he started showing programs of films from the Cinema of Transgression. I think it was really a joke or a prank that eventually became taken seriously. It was synonymous with a certain intense energy; nobody was aware of its existence until it was gone.

*What was your best piece of work and why?*

That's a really hard question to answer. I like everything for a different reason. The ones where there was a deep involvement with the material and the creative process but where there was also an opportunity for pure spontaneity within that. *Rhonda Goes To Hollywood*, *Playboy Voodoo*, and *Elegy* were all that way. Dirty was really a fun film to make. Everybody who was in it was great. Marti has a great sense of humor. We shot in the Chelsea Hotel and it was actually quite a complicated film to shoot. I always appreciate the simplicity of structure in *Nymphomania* and the economy in *Baby Doll*, where only three frames were cut out. I'm pretty excited about what I've been doing recently. I don't think I've made my best piece of work yet, so I suppose that's partially why I keep going. But at the same time all my work is like one endless piece. Parts keep being reused, themes and parts of films revisited. It's all a part of one great whole. Well, at least that's the way I see it.

*Has humor always been important in relaying your works' message and intent?*

Yes, definitely, it's often tongue-in-cheek.

*Did any of your art or performances not get recorded?*

Probably 90 percent of them have not been recorded. It's a shame that some weren't, especially the large-scale collaborative performance between Ela Troyano, Andy Soma, Stephen Holman, and myself which was presented over several days at The Kitchen as a part of 8BC nights. Though rarely do records of these performances do them justice, as they are so experiential. In the '80s I saw a lot of performances that nowadays would be recorded and should have been recorded. Back then, it just wasn't something which was automatically done.

*What about Richard Kern and Nick Zedd's work, and their artistic personalities?*

I've always liked Richard's work. His aesthetic is very elegant, whatever form he works with. He has a great sense of humor and is also really supportive of other people. Nick's more political than he gives the impression of being. He's always been slightly awkward and difficult.

*How was your work and the focus in its early years as opposed to now?*

My older work? I would describe it as poetic, expressive, and romantic. Now? I hope it still possesses those qualities but is a little more analytical and evolved.

*Are the reoccurring themes of sexuality and parody regarding sexual exploitation and objectification in your films reflective of your views on pornography?*

I should hope that, by this point in time, we're all aware of the absolute absurdity of the concept of how women are viewed in general. I like exploring that absurdity.

*What are some films you've worked on since those acclaimed pieces?*

Well, there is *Elegy, for Jean Genet* and *Godard*, which are both collaborations with Ela Troyano, and also *The Bug: A Lost Movie*, a film that I'm finishing; I've lived with it for a long time now. There's a double projection piece called *Instinct*; it has a witches' side and a bitches' side. It's made completely from reworked found footage. Also, I made a short piece called *Watch Out!* which is sort of related to *Instinct*. There are also several expanded cinema pieces which Ela and I have performed.

*Do you still prefer creating short films? Which type and length of film suits your work best?*

I like short films or endless projections. Short films suit my needs. They can be very dense. I've never made a full-length piece, only full depth.

*When and why did you start doing collaborative work with Ela Troyano?*

I can't remember exactly when it was, but I think it was late one night at the Chandelier. Someone had some hallucinogenics, so we started creating visuals using whatever equipment and film was around or we could lay our hands on. We were projecting for hours on a makeshift screen and on the other side sat a complicit audience. We have done innumerable multiple projection performances together. We have been collaborating on and off for twenty years. *Playboy Voodoo* is one of the few projections we made as a film, yet *Elegy, for Jean Genet* is probably the one we have actually performed the most. We have done so many performances and their names are so often spontaneously chosen, it's hard to remember them all. In fact, the titles are the least important part of the performances. For , it's their life, although fleeting, which is important.

*Which artists have you collaborated with during your career and why?*

I've collaborated with many different people in different capacities. I've rarely sought anybody out. We rather ended up together, it seems. Usually somebody mentions that they have an idea that I get excited about or inspired by, and then we'll make a film. If an idea doesn't excite me, I probably wouldn't even notice one had come up.

*Is there anyone you would have liked to work with? Who are some of your valued contemporaries?*

It usually happens so spontaneously, it's hard to say what's going to come up. I'd like to work with a child sometime. Otherwise I mostly think of musicians whom I'd like to work with. I recently had the pleasure of working with music by Manorexia, which is one of J.G. Thirlwell's incarnations. I'd like to work with Gibby Haynes sometime.

*What is the best environment for you to work in?*

When I shoot a film, I try to find a place that suits the mood I want to convey. An object I see on the street can inspire me to make a film. It's quite primitive really, finding a fetish object as a muse. When it's a performance, a large white

space with huge walls and no windows and preferably with a balcony is ideal. This is a rare find. I've shown work in a wide range of places. In tiny seedy bars, museums, alternative spaces, jazz clubs, outdoors, and in cinemas.

*Will you talk about the awards created for the New York Film Festival Downtown?*

When we produced the New York Film Festival Downtown, we used to buy these figure candles from the local botanica to present as awards at the end of the Festival. It was a last-minute idea, partially intended as parody, since the figures looked like Oscars. This was before every town in America had an underground film festival. I still see these awards from our festival appearing on filmmakers' bios.

*How long have you been curating festivals?*

Since 1981. Initially, I was putting together film screenings in clubs downtown. Then in 1984, we started the New York Film Festival Downtown. I've continued to put shows together. For a while I was chairperson on the Board of Directors of the Film-Makers' Cooperative; I continued on the Board until I had my child. I also curated a number of film programs with MM Serra, who runs the whole thing. A couple of years ago I put together the film part of a show at the New Museum called *East Village USA*.

*Is funding an issue for your filmmaking?*

Some of my best ideas have come from moments where I have wanted to make a film but was totally broke. Having a budget is a luxury but it's never determined whether or not I make something if I feel like it.

*If you could create a piece that had limitless funding and access to all necessary materials, what would this film or performance be?*

An interactive film where people could choose the direction in which the film goes through multiple-choice options. That could be fun.

*What was the process of making* Nymphomania? *What was that movie's intent?*

Holly Adams came to me with a story of a sexual experience she'd had. She was a dancer and was talking about how she'd like to be an elf since she had pointy ears. I kind of freely interpreted all of this. We shot it one afternoon in the Bronx. We didn't have a storyboard. With a bunch of great people I had some

shots in mind, and I just decided what to do as we went along, which is usually the way I work.

*Will you talk about the making of* Play Boy?

I wanted to make a film but I didn't have any money. I went along 42nd Street and asked in all the stores if they had any films that they didn't want. This was right at the time when they were switching from film to video. So I was given a lot of films. I'd also been buying films on the street and in thrift stores. I asked some friends who ran Piezo Electric Gallery if I could shoot in their space one day when they were closed. So that's what I did. That film is pretty spontaneous. I had no idea how it was going to turn out. I did have a plan for it to be displayed in a machine, which you would put a quarter in to view a part of the film. That was my idea of a way to make some money, as well as echoing the old seaside stereopticons and other antique nudie arcade machines.

*Which filmmakers inspired you, historically and among your peers?*

Maya Deren, Kenneth Anger, Bruce Conner, Jean Cocteau, Roger Corman, Russ Meyer, [Rainer] Fassbinder, Dario Argento, Orson Welles, and the cheesy Hammer horror films I watched on TV when I was a child.

*What prompted you to make* Baby Doll? *Was it scripted?*

I was living in a storefront with about nine other people. There was a music rehearsal studio in the basement. One day, these two girls decided to turn our kitchen into a café, called the Café Always. This meant it was always open. All of a sudden you had to order breakfast rather than going to the fridge yourself. These two girls are the girls in the film, Ferne and Irene. They were working as strippers and I thought that it would be fun to ask them some questions and make a film. We shot in the attic at PS1 Contemporary Art Center. I asked them questions to prompt them and cut them out, so you only hear their answers, which I thought was more interesting.

*Why was there was an explosion of underground, creative filmmakers in the '80s East Village?*

Cheap rents, small cameras, and lots of crazy people willing to go as far as they could creatively. Life was an experiment and nobody thought about the future.

*What have you been working on lately?*

I've been working on several films. One is called *Instinct* and it is a double projection piece about women's psychic abilities as a natural gift. Another short film I made, *Watch Out!*, is related and is about voyeurism and impressionability. I've also been editing this film which I shot a long time ago. It was called *The Bug*, but now it's also acquired the title *Lost Movie*.

## Litsa Spathi

Litsa Spathi (born 1958) is a Greek painter, Fluxus artist, teacher, and archivist based in Heidelberg, Germany and Breda, Netherlands. For the last three decades, she's created collage art, object books, Fluxus poetry, mail art, video, acrylic paintings, and multimedia performance art. Litsa Spathi's work is considered Fluxus art and a form of fantastic realism. In 2003, she co-founded with collaborator Ruud Janssen the Fluxus Heidelberg Center, at which she also teaches. The Fluxus Heidelberg Center was created not only to archive the history of the Fluxus movement, but to celebrate its spirit with documentation of Fluxus performances, Fluxus-related publications, numerous interviews with Fluxus artists, and a large collection of the art itself. Included in the Center's archives is work by Fluxus artists Yoko Ono, Ken Friedman, Ben Vautier, Geoffrey Hendricks, Alison Knowles, Nam June Paik, Larry Miller, and John M. Bennett, among others. Spathi has been a contributor to several magazines like the Dutch *Elsevier* and the *IUOMA* (International Union of Mail Artists) magazine. Her work has been included in many international exhibits, with a notable participation in the group show *Fluxhibition #3: Thinking Inside The Box–Boxes, Cases, Kits and Containers*, which consisted of artists from seventeen countries around the world, presented by the Fluxmuseum and the International Museum of Collage, Assemblage, and Construction. In 2009, her piece, *31 Secret Truths*, was added to the permanent collection of the E.H. Hereford University Center gallery at the University of Texas in Arlington. Her work was also featured in the 2010 exhibit, *Visual Poetry and Mail Art*, at the Skylab Gallery in Columbus, Ohio. Spathi's work appears in the Fluxus journal, *Visible Language*, in Volume 39, *Fluxus and Legacy*, and Volume 40, *Fluxus after Fluxus*. In 2007, Spathi founded Fluxlist Europe, a digital platform for Fluxus artists and visual poets to publish their work and to create a discussion forum for the art. Interview translated by Ruud Janssen.

*What was your introduction to surrealistic art?*

It must have been in Athens, 1972. The political system was a dictatorship. The art education was based on this. They forced upon me an aesthetical system which wasn't mine. It was tragic because already at the age of three, I had decided to become a painter. On one of those days, I came across a bookshop in the Center. And as chance wanted, I found myself holding a book dealing with surrealistic art. I knew instantly: there it is, the art the teacher at the Gymnasium didn't want me to paint. One year later, I emigrated to Germany and wanted to study art. Starting from spring 1974, I began to visit the museums. There I was, seeing Otto Dix and Francis Bacon.

*What is the main difference between Surrealist Art and Fantastic Realism?*

I myself hardly see any difference. The fantastic realism is, in my opinion, a variation of Surrealistic Art, maybe its child. But let me think. The Surrealists wanted to grasp the unconsciousness. For them, the real outside world wasn't important but rather the inner reality. The world of imagination is seen as the only reality. Reality and unreality didn't conflict in the surrealism, but rather embraced each other. The Fantastic Realism came up in the '60s, and precisely there in 1966. [Andre] Breton died and, with his death, the chapter of Surrealism should actually have been closed. But there were already new artists who claim to be Surrealistic painters. Of course, they don't duplicate the old art. But they too show works with a realistic-fantasy view of the world around them with cosmic and apocalyptic visions. These trans-real worlds also report of the human search for the other, and original life that will be created in every new generation.

*What is fantastic and what is realism?*

Well, for me, realism means the presentation of objects and items in a real life, real way, without any additions or alterations. When that is done, I would speak of transposing on the first level, the transportation of direct information. When it stays on this level, the picture would bore me after five seconds. In the principle: see it, absorb it, decipher it, get it, and forget it. Why? I miss the vision, the utopia. Fantastic are the things we have to discover and imagine. Only then they start to exist. Fantastic as second component creates another distorted reality. Only on this level things can change and metamorphoses can take place. That also creates the secret atmosphere that questions the reality and makes the observer wonder. For example, I see a statue on a painting that bleeds. Statues normally don't bleed. However, why shouldn't a statue bleed?

*How many years have you been a Fluxus artist?*

To be precise, twenty years. It began in 1984. The place was Frankfurt and the location an international book fair.

*What is Fluxus Art?*

First, I should explain something about the history of Fluxus. Mental Father of Fluxus was John Cage. Through every day sounds and theater actions, he widened the borders of music. Students at his courses at the New York School for Social Research were artists who later would be the heart of the original Fluxus group: George Brecht, Al Hansen, Dick Higgins, Alison Knowles, Allan Kaprow, and others. In 1958, John Cage came to Germany and worked as a professor of New Music at Darmstadt. Then the spark went further to Eric Andersen, Henning Christiansen, Nam June Paik. Only later, people like Joseph Beuys, Ben Vautier, Daniel Spoerri, Robert Filliou, and Willem de Ridder came to this group. George Maciunas founded the Fluxus as a group. That was in the year 1961, when he came to Germany. The Fluxus Movement as such has much to do with non-sense, asks provocative questions in its time, removes the borders between the different areas in art, and demands an active part of the audience. Annoying smells and sounds fit perfectly with these art events; Fluxus Eat Art Happenings and the whole spectrum of this revolting and unleashed action-art. Beside these actions, Fluxus also brought a flood of printed materials and a gigantic amount of absurd and provocative objects in the spirit of Dada. Almost always there is provocation involved that doesn't exclude sex, religion, or even pornography. The aesthetics of the painted pictures one denounced. Therefore, consequently, one also rejected the concept of the museums. As chef d'ecole/ideologist George Maciunas said, "Fluxus can't be found in the museums." Yes, of course. Fluxus is an anti-museum movement, one that revolts against the bourgeois culture.

The new utopia was a symbiosis of art and life. John Cage, for example, cooked in one of his concerts to demonstrate that this is possible. Others included animals in their performances, or it smelled like honey, dead fish, or a dead rabbit. The first performances of the group members were inter-media actions, always with different members. They called them "concerts" or "festivals" but they resulted in legendary happenings that might result in the complete destruction of the piano. The theater for a performance could also be a tennis court, like the *Open Score* by Robert Rauschenberg. The players used tennis rackets that were installed with microphone and sender. Every time a player hit the ball, the audience heard a loud bang and, at the same time, one of the forty-

eight lights that were hung in the hall went out. With the shutting down of the last light, the play came to an end; the *Farewell Symphony* by Joseph Haydn in a different way. After that hundreds of people went on the court to look at what happened, they couldn't see anything because the court was dark but the events taking place there were registered with light-sensitive cameras and projected on large screens in the hall. So what the performers did and couldn't see themselves was made visible. The audience is taken out of its passive role and is given a chance to make experiences that he/she would make never before. In this project by Rauschenberg, the basis is the irritation, the conflict.

*Working within Fluxus Art, are you ever too vulnerable as an artist?*

Yes, of course, because I show which themes and conflicts touch me, which utopias are important to me. One has to be engaged and have the guts to do this, a daring working attitude, for which one does bear the sole responsibility. That is why one's own Achilles' heel becomes visible, that means one gets vulnerable.

*What motivated you to found the Fluxus Heidelberg Center?*

The idea came up spontaneously, which I mentioned in a conversation with Ruud Janssen, that both a real building and a digital Fluxus Center should be founded. I didn't need much time to convince him. He was very enthusiastic and arranged all the computer work, the design and realization of the website, and integrating it on the Internet. We are in the Fluxus tradition, also connected with the first generation of Fluxus artists, whom we have collaborated with. We practice our Fluxus not as duplication of the old form but in an evolutional form, with the help of tools and communication forms of our times, and that is mostly digital. We still are implementing these modern tools in our Fluxus works. An example: I write Fluxus poetry in a digital way which is published by Ruud Janssen on our website. Only afterwards they get printed on paper and are published on cards. Together with Ruud Janssen, I write performances that we realize and document, sometimes digitally. For one year now, I have been working on the *Calendar Performance*, a special performance for which we use both the traditional and the modern Fluxus tools. Every month I collect the most important events for the Center, make from that a large drawing, and integrate in text the events and connected names, persons that contacted me in Germany. After finishing the original, I send it to Ruud Janssen in the Netherlands. He scans the drawing and publishes it on the website and makes the connections to the online world. He also makes DIN-A3 sized copies of that specific calendar month drawing and sends them back to me. Only then

comes the final monthly part of the performance: every person or institute mentioned on this calendar paper gets a signed copy.

*Are you satisfied with the Center and its progress?*

Oh yes, very. The Center certainly brings a lot of work but also a great deal of satisfaction. Many visitors come, we have interesting discussions, and also requests for realizing contacts. At the moment, the Fluxus Heidelberg Center has become an important contact place and in such a short time.

*Why has Dada, Surrealist, and Fluxus been primarily a European phenomenon?*

The French Revolution in 1789 goes into the books as the revolt of the farmers. Liberty, Equality, Fraternity: Liberté, Egalité, Fraternité. The artists needed yet another 127 years longer to start their revolt, in 1916 with Dada. The art should not be owned by the upper-class or ordered products by society and should not exist in an absolute aesthetical way. All can be art. And nothing can be more art or less art than something else. But all this should be seen in a historical perspective. What Picasso once started with his collage is taken consequently further by Duchamp with his bottle holder, *Egouttoir or Herisson, Ready Made*. It finds its final and most extreme form in Dada. The artists emancipated, and in 1916 revolted, against the bourgeois society, against their rulers, against the political system, which all at the same time here in Europe failed and preceded the start of the first World War. A war that was unknown here in Europe in these dimensions, where people were sent to the front as food for the cannons. Social and historic conventions lead to a catastrophe, according the Dadaists, and that is precisely why they rejected all these conventions, all civil and idealistic art forms, including Expressionism. Dada stands for absolute senselessness, for anarchy. Breton later developed Dadaism further into Surrealism, and Fluxus has its roots in Dada.

*Are there any works of which you are most proud?*

To be honest, I never thought about that, and now nothing comes up of which I am most proud. I am proud of all. All the works have been necessary for me. They reflect my reactions to the world I live in. They show my thoughts, my life, my fears and visions. They belong to me like, for example, the fingers on my hand. All works are different, and yet all are essential and valuable for me.

*How do you react if your work is misunderstood? Is that a concern?*

The first time, I was irritated and unhappy. I saw the misinterpretation as a rejection of me and my work. Today I see it as a compliment because I know it has more to do with the observer than with me. When I first showed my art here in Heidelberg, people already knew me as an artist and an educator but they never had seen my work. This new side of me they didn't know, and what they saw made them afraid. The distance grew, even during the opening of the exhibition. It took some time before we could communicate in a normal way again. Another example is when I wanted to start a dialogue with artists, again here in Heidelberg. To be precise, with their Forum fur Kunst, an artist group run by artists themselves. Ideal, I thought, but first I had to go through the formal way of applying to become a member. Without telling me the reasons, my application was rejected. The colleagues had voted against me. That hurt. Their rejection, however, protected me from their provincial mentality.

*Will you talk about the many books you've created?*

Some books have my poetry in them. Others are artists' books with my own work that I published myself. There is also a large series of artists' books or books with visual poetry that have been made in collaboration with other Fluxus artists. Besides that, I work together on a regular basis with the Berlin publisher Hendrik Liersch. I illustrate texts by other writers which results in publications issued by his Corvinus Presse Friedrichshagen. These publications are mostly bibliophilic treasures, printed by hand in a limited and signed edition, and contain original linocut prints or other graphics, precisely in the tradition of Gutenberg.

*What is the most important expression a Fluxus artist can produce?*

Chaos. After that a new order can start.

*Will you give an example of one of your many elaborate performance art pieces?*

These are performances of different natures. They sometimes come up spontaneously, by coincidence, as a result of a specific situation, and sometimes, as a reaction to a social or political event. And it also could happen the performance is just done for pure enjoyment. But there are those performances that are planned long ahead, prepared in full detail with rehearsals. Some years ago, at the University in Heidelberg, the Medical Director of the Psychosomatic Clinic celebrated his forty-nineth birthday. At the party, in one of the official rooms at the clinic, guests were specialists on the subject of psychoanalysis from Heidelberg and far away. At this party I performed 7 times 7. For the action,

I had prepared a special artist book with the content of forty-nine perforated coupons for very special hot themes. Seven coupons were for one kiss, seven coupons for one quickie, etc. Every coupon title caused the audience to have wild expectations, which contradicted the words I spoke. Because of this, the emotions of the public went from excitement to disillusion.

*Do you prefer working solo or in collaboration?*

Normally I like to work alone, like most artists. Reason being, one is responsible for the work oneself, the creation process and the result. One can control every step in realization and modification as one likes. Secondly, the copyright issue isn't a problem. It solely lies with one person. One example of my most memorable collaborative work was *The Blue Book*. For that I invited Robin Crozier from England to work with me on two books that went back and forth by mail from December 1995 until July 1996. In them visual poetry was created by me, on which Robin would interact. The final result was a set of two object books, as well as a printed edition of 200 copies that was published by Nobody Press, Heidelberg. This publication is mentioned in the *Anthology on Visual Poetry*, published in 1998 by Dmitry Bulatov. An example of how the copyright issue can go wrong: there it is mentioned as Robin's publication with copyright by Nobody Press, England. The *Say Cheese Performance* is another collaborative work I did for the Fluxus Heidelberg Center. The idea was to ask tourists to take photos of Ruud Janssen and me in front of the Old Castle in Heidelberg, taken from the Old Bridge. The Rhein-Neckar-Zeitung in Heidelberg wrote a large article about the event and our resulting photos were exhibited. The performance confirmed the idea that tourists are more interested in dead stones of a city than the living persons within that city. *A Third Performance* is memorable because of its complexity: three persons from three countries, and a timeframe where one communicates between two years. Fluxus artist Ken Friedman from Norway does this performance every year, and at the end of 2003, Fluxus Heidelberg was invited to take part.

*How does one go about the process of melding oneself with the viewer?*

Very complexly, but mostly it is a natural process that one has in one's mind when creating the idea of a performance. When I think of a specific performance, I already know what kind of audience there is and I will keep that in mind while conceiving the performance. It is like preparing for an exam. The theme, my knowledge, the audience, and that all mixed with a bit of psychology.

*What has been the focal point of a large portion of your work as a Fluxus artist?*

When one starts with the first steps in art, one is under the influence of the artists that one admires and has seen. That happens to all and one has to free oneself from that and search for their own ways of expression. So the focal point for me was to find a way to express my thoughts, my feelings, and my emotions in a form that fits me. The ways that I have chosen brought me to Fluxus, a platform that gives me the broadest basis for combining several things that normally don't go together or aren't brought together.

*Of all the media you've worked within, which is preferred?*

It isn't drawing. Drawing is just like a disease for me, I constantly feel the need to draw. The medium I would prefer is most likely painting, and the object book. Funny enough, one of my latest works was a combination of both. The British Council in London invited me to send in a work for an exhibition held in February, 2005. The envelope for the object book I designed for them was an original painting on canvas.

*Is it necessary to be educated to be a Fluxus artist?*

What one needs is the ability to see things, recognize things, analyze things, and to play with them. For that, one doesn't need some degree of art, rather a degree of creation. There isn't a college for that yet.

*What is the single most important expression an artist can relay to another?*

The first word that comes up in my mind is "credibility." An artist I admire a lot is Vincent van Gogh. The paintings he made in his last years are so bright, emotional, and ingeniously made. His whole life he worked to reach this, even if he had only so little time. He always searched further to capture the essence of his search, an idealistic search for beauty and truth in relation to man and nature. Because of the intensity of this search the works of Vincent van Gogh show credibility. Thinking of that, another expression an artist can relay is consequence.

*What medium should be explored further, or has yet to be discovered?*

Often I have heard that all has been done in art. Throw away all your tools, brushes, paint, etc. That would be the natural consequence. It is subjective to think that all has been already done. New times and new media will emerge and artists will discover them and start to use them. We have seen the birth

of video, digital media, and lots of artists have now their own website. What I think is interesting is the exploration of the digital media and how they affect our lives. The new digital media alone doesn't give the sensual satisfaction that we look for in traditional art.

*What are your plans with the Fluxus Center in the future?*

Lots of things already have been started and the plans are new performances being created, new Fluxus poetry will go online. Building plans have started for a new place for the Fluxus Heidelberg Center and that includes my new atelier. So one of the future performances will be a move to another building, another city, and another country. That is the real Fluxus life.

*As a professor, what classes do you teach?*

I teach two subjects: languages and art. The students are always adults. Some classes want to learn a new language. The other classes want to learn to paint in large scale with acrylics on canvas. I try to show students how to find one's own way in painting. Create, instead of copying the art that is already there.

*Should an artist try to embrace all types of media?*

For God's sake, no. Imagine you would enter a store with clothes, and you would buy all clothes that are modern for all generations in all colors. If you would wear them and go out of the store, how would you then look?

# Christina Augello

Christina Augello is a stage actress who has been performing for more than thirty years in experimental and progressive theater. In 1983, she founded the EXIT Theatre in San Francisco and acts as its artistic director. The theater is dedicated to showcasing alternative, progressive, and uncensored theater, at a grassroots level. The theater has allowed her the freedom to portray unconventional, daring and controversial characters, who would otherwise continue to be overlooked. One of her portrayals was of Baroness Elsa von Freytag-Loringhoven, the Dadaist rebel, feminist artist, and poet, in the play *Last of the Red Hot Dadas* by Kerry Reid. She also portrayed Bertha Thompson, the Depression era hobo grifter, feminist, and anarchist, in *Boxcar Bertha.* In 2010, Christina portrayed the sixteenth century Gaelic pirate queen Grace "Grania" O'Malley in *A Most Notorious Woman.* A nonprofit organization funded entirely by donations and volunteer work, the EXIT Theatre is home to many festivals which Christina has created and hosted, like DIVAfest (since 2001), dedicated to presenting new plays and works by women artists. It is also home to the Labor Festival, as well as the annual Fringe Festival, which allows performers to keep 100 percent of their profits. Christina has presented many of Eugene Ionesco's plays and continues on with other works in the tradition of the Theatre of the Absurd. Many independent theater companies have also performed at EXIT Theatre, including Killing My Lobster, Lunatique Fantastique, and Crowded Fire. EXIT Theatre has won numerous awards, including Best Off-Broadway Theater (1999), Best Local Venue, Best Offbeat Theater (2005), and Best Producer (2007). The theater remains one of the few in world to represent so many independent artists, nontraditional playwrights and unique performances.

*What first interested you in the theater arts?*

I love the theater for its intimate, risk-taking, live possibilities and the immediate connection to the audience. I started performing in grammar school. My father had a bar and restaurant that catered to touring and local performers. I spent a lot of time seeing shows and meeting performers from the time I was about four. I've continued to work in theater all my life, refining my skills as I go along.

*Why has the history of many female characters whom you've portrayed been disregarded?*

I think history is notorious for not including women in a broader sense, in all avenues of life. I am glad to say, however, that I have been able to discover several stories of awesome women, so they are out there but not as accessible or well known as their male counterparts. They are strong women who are willing to follow their dream rather than someone else's; they see themselves as equals. They have lived their lives creatively and bravely trusting their own instincts and sharing what they believe. I hope I have done the same and love being able to portray them.

*Do you identify with the women you portray in their rebelliousness, their creative forces, and their liberated spirits?*

Most definitely! How else would you choose to live?

*How do you feel about Baroness Elsa von Freytag-Loringhoven as an artist and a woman?*

I miss playing the Baroness and look forward to bringing her story to many more audiences. I think she was a committed artist, to the point where it consumed her. Her willingness to give up everything for her art is an inspiration.

*Are you satisfied with acknowledgments received for* Last of the Red Hot Dadas?

I've had the opportunity to perform the show close to eighty times in San Francisco, Montreal, Toronto, Winnipeg, Chicago, Los Angeles, Edinburgh, and Prague. I think she is a hard sell and really is a cult figure that needs to find her cult audience. Those who loved her, really loved her, and those who hated her, really hated her.

*Would von Freytag-Loringhoven's sanity have been questioned if she was male?*

I believe the Baroness chose to be mad and then lived it thoroughly. She constantly challenged the artists around her, as well as herself. She was outrageous, and I think sex had no influence on how people perceived her. It was her behavior that they observed, not her sex. The Baroness transcends all oppression by her lifestyle choices. It's known she was constantly hounded by the police for her appearance and outspoken actions which were sometimes questionable, though there were many men at this time who behaved the same way and were respected as genius.

*Do you feel the threats and encounters against her fueled her work?*

I think she was pleased that she had an effect on those around her. She definitely had an agenda and would not accept anything less. A true heroine!

*Had you been faced with censorship in your own work, how would this have influenced it?*

I hope I will always be willing and able to do what I believe in. The theater and the arts in general is a rich and fertile place to challenge, reflect and influence the world.

*Do you choose to perform these characters based on your interests or to bring attention to these women's work?*

It starts with a personal affinity and then I'm both proud and pleased to tell their stories to as many people as I can. These women are important to our history and our future. Without them, life would have been a little duller.

*Is your work a type of feminism, acting as activist or historical archivist? Are you inspired to expose women's suppressed history?*

I consider myself a woman and an artist who has had the exceptional opportunity to work in the theater all my life and tell stories that I believe are important and relevant. I have never felt oppressed, although I am aware there are people and thinking that would like to oppress me. One of the strongest draws I have had to the women I had portrayed is their innate sense that they are not victims but participants in life on equal terms with all human beings.

*Who have you not portrayed historically that you would like to?*

I know there are thousands, if not hundreds of thousands, of stories of women I will never have the opportunity to discover. I'm always looking for someone new and hope to portray a few more before I'm done.

*What audience did you initially hope to reach?*

Since I've always worked in small experimental theater, my audience has usually been those who seek out this particular type of work. However, touring to festivals has brought a new and curious audience and I hope to continue to develop audiences for my work.

*What research helped you prepare for your role as the Baroness?*

The Baroness was brought to me by the author, Kerry Reid. She made me aware of her and then I went on to do research on my own. It was very fortuitous that Irene Gammel published a biography on the Baroness the same spring we premiered the show. Her star is still rising as there are more and more articles about her, and her poetry has just been published in Berlin with an exhibit of her art work touring as well.

*How did you discover Boxcar Bertha? How did you develop the stage presence of such a complicated woman?*

I discovered Bertha in a travel bookstore when I picked up *Sister of the Road: The Autobiography of Boxcar Bertha*. After discovering her, I contacted Kerry Reid, and she did a lot of research as well as me and we proceeded to work together on the final script. John Warren, who directed the Baroness piece, came on board once more to help me discover all of Bertha's colors. Having spent a lot of time on the road myself back in the '60s and '70s, I felt a special kinship to Bertha and her experiences.

*How do you decide who will write the scripts for your performances?*

I don't necessarily choose who will write my scripts, but as I go along I meet people who either have an idea for me or I want to work with and ask them to write something for us. I am now beginning a new solo piece I will write myself, based on my experiences, as well as a character play about five middle-aged women titled, presently, Liberation.

*Have you always performed one-woman acts?*

I've only come to solo work recently. It was something new to try and I love it. I also like performing in an ensemble way as well. Solo shows are easier to take on tour, however, so it's good to have a few you can shop around.

*What was the motivating factor for founding the EXIT Theatre? What are your proudest moments regarding the performances presented?*

Founding EXIT Theatre was another step in spending my life in the theater. The first time I performed *Last of the Red Hot Dadas* was perhaps my proudest, but then came *Boxcar Bertha* and I was proud and pleased to play her. Having finished the Mandala Olive Project and recognizing how proud I felt on stage with my fellow ensemble members barefoot in the dirt during our curtain call was another proud moment. I guess I am equally proud of all my performances and the opportunity to bring creativity to the stage.

*Which of your performances are your most memorable pieces?*

There are lots of single moments, like standing on Sixth Street in my costume from *The Connection* by Jack Gelber, in which I played Sister Salvation. I was approached by a drunk during intermission asking for forgiveness. Being Elsa, being Bertha, playing Helen in George Walker's *Problem Child* are all memorable. I still remember playing the grandmother in a CYO religious competition play in grammar school, too. So there are lots of moments that make up a lifetime.

*What made you decide to do biographical material? Have you ever indulged in fictional work?*

I don't do strictly biographical material, and, yes, I have indulged in lots of fictional work. I have since played a mother of a methedrine [addicted] teenage daughter in *Crystal Daze*, and several characters, including myself, in a farce, *Her Majesty*. I have also played the maid in Eugene Ionesco's *The Bald Soprano*, and Gertrude in Charles Marowitz's *Hamlet*. As an actor, I am always looking for a role and enjoy fictional work as well.

*Why did you choose to open EXIT Theatre in the neighborhood you did?*

I chose to open EXIT Theatre on Eddy Street because the universe provided the right circumstance, and it is in downtown San Francisco, the traditional theater district.

*What do you consider fringe theater?*

I think fringe theater is risky theater, usually new theater, and most always experimental and innovative. It usually occurs in small intimate venues. Back in the '70s, I thought of Sam Shepherd as a fringe artist when he was doing his shows at the Magic Theatre.

*Will you talk about some of the venues and festivals EXIT Theatre presents?*

EXIT Theatre has four venues, and produced the San Francisco Fringe Festival, an open-access, non-juried festival, and DIVAfest, a festival dedicated to developing women writers.

*What are some of the regular, reoccurring venues you present?*

A lot of companies have worked with us over the past twenty-five years. The Cutting Ball Theater and RIPE Theatre are now companies in residence at the EXIT.

*What influence on theater do you feel you and the EXIT Theatre have had?*

I think running a venue for twenty-five years and working with hundreds of artists has made an impact on the Bay Area theater landscape. Our mission is to provide opportunities for artists to work and develop an audience for that work, and we have succeeded in doing both for over a quarter of a century.

*Did you work with Eugene Ionesco?*

I have never had the opportunity to work with Ionesco but had the opportunity to correspond with him in the '80s when we were producing a lot of his work.

*What kinds of themes does EXIT Theatre prefer to work with?*

EXIT Theatre has a long history of doing Absurdist work and for the past fifteen years we have been primarily committed to new work. I find myself drawn to those who are passionately committed to creating the New American Theatre and do so in a professional and creative way.

*How has EXIT Theatre progressed over the years?*

EXIT Theatre has gone from a single 49-seat black box theater to a four-venue

theater-plex that commissions, develops, produces, co-produces, and presents work as well as the annual seventeen-year-old Fringe Festival and the seven-year-old DIVAfest.

*Growing up, who were actors you admired? What plays or literature influenced the type of theater you do today?*

The biggest influence on my theatrical choices is Theatre of the Absurd, including Ionesco's plays. I have always been attracted to theater that opens new ways of thinking. I love plays about people and their relationships, plays that include strong women and take a look at human behavior. The shows that I remember from my earliest years include *Marat/Sade, Oh, What a Lovely War!, After the Fall, A Moon for the Misbegotten*. Then I discovered Ionesco, Beckett, [Michel] de Ghelderode, and Gertrude Stein.

*What is lacking in theater today? How has it changed over the years?*

In the smaller theaters, we have the opportunity to be more open to new artists. The theater is ever changing and that is good for a creative art.

*Before EXIT Theatre, where were you performing?*

Before EXIT Theatre, I performed with the San Francisco Free Theatre and we are the first production at Project Artaud, with the San Francisco Poverty Theatre and the Oakland Ensemble Theatre.

## Michelle Handelman

Michelle Handelman (born 1960; Chicago, Illinois) is a performance artist who also works in photography, video, and digital media. Her work explores various forms of excess and nothingness, bordering between personal endurance and public spectacle. Her films have been shown internationally at the Georges Pompidou Centre; Paris Institute of Contemporary Arts; London American Film Institute; Los Angeles; Roxie Cinema, San Francisco ; Pacific Film Archive, Berkeley; and the Museum of Fine Arts in Boston. Her first film short, *Catscan* (1989), is a nine-minute piece co-directed with Monte Cazazza, which documents a series of guerrilla actions at anti-censorship rallies. Her early film work includes *Sexual Techniques in the Age of Mechanical Reproduction* (1989), *Homophobia is Known to Cause Nightmares* (1991), *A History of Pain* (1992), and *BloodSisters* (1996). In 2000, she created the shorts *Ponygal, Blowjob, Candyland, Aliendreamcord, I.C.U.,* and *La Suture.* In 2002, she released *Jump, I Hate You,* and *DJ Spooky vs. WebSpinstress M.* The films *Folly & Error, Waterfall,* and *This Delicate Monster* were released in 2004. She has appeared in *Virtual Love* (1993), *Cut Piece* (1993), and *Twists in the Chord* (1994). Some of her exhibits have shown at Performa05 Biennial of New Visual Art Performance, New York City; Exit Art, New York; Rx Gallery and The Lab in San Francisco; Jack the Pelican and Museum of Contemporary Art in Brooklyn; and the Bologna Cultural Center, Italy. Her exhibits have included *The Illustrated Woman Conference* (1994), *Reframing Exposure: Photo Technology and Body Memory* (1995), *Scared Stiff, Body Parts: Medical Imagery and Experimental Cinema* (1997), *Fragmented Bodies: Identity or Violence* (1998), and *Future Species* (2003). Performances include *The Adventures of Lucky M: AIM* (2001), *This Delicate Monster* (2004-06), and *Passerby: Ghost Sites* (2004). In 2007, her art was chosen by Bloomingdale's for their Fall Art Campaign. Her writing appears in the books *Inappropriate Behavior* (2001), *Coming Up: The World's Best Erotic Writing* (1995), *Herotica 3* (1994), and *Apocalypse Culture 2* (2000). She won the Bravo Award in 1999 for her feature documentary, *BloodSisters,* an exploration of the San Francisco leather dyke scene. Articles about her work can be found in *Filmmaker, Art Forum,* and *Art in America.* She currently teaches in the Media Studies graduate department at the New School, New York City. She says her current work redefines cinema and pop imagery through a radical feminist lens. In 2011, she was featured in a group show, *Unseen,* at the Torrance Art Museum with Kembra Pfahler and Breyer P-Orridge, among others. In 2011, she was awarded a Guggenheim Fellowship.

*What was your first art medium and how were you introduced to it?*

It was definitely all about the camera. I never liked to draw or paint, and I was always in motion, so naturally the camera became my tool. It didn't require you to stay in one place; in fact, it insists on movement. The black and white film still, the light and shadow of classic horror films, these were my mentors. I never had any actual living mentors. My mentors were dead poets, dead rock stars, and dead film directors. I've always hated the elitist attitude of the art world and so for a long time I just didn't care to participate in an economy that favored bullshit over honesty.

*Which medium do you prefer working in and which best conveys your message?*

As John Waters says, "The best part about making a film is the first five minutes you get the idea, everything after that is pure drudgery!" I agree. Honestly, I've felt this way for the past fifteen years, but lately, I'm learning to enjoy the process more. Medium is content and I'm attracted to materials for both their physical and social properties. First it was photography, which led to performance, which led to film, which led to video, which led to animation. I'd say my approach to material is in a constant state of flux dependent on the needs of a project. Most of my decisions are rooted in a subconscious processes. But while the media may change, my obsessive commitment to a personal exploration of excessive desire is constant. I don't try to present a literal message with my work. I'm interested in creating psychological spaces and visceral experiences.

*What was your most profound work? Did the audience understand the piece?*

I definitely think what I'm working on now is going to be my most profound work yet, but looking back, I would have to say the first 16mm film I ever made, Sexual Techniques in the Age of Mechanical Reproduction, and This Delicate Monster, my multiscreen performance installation. Most people don't understand my work. Honestly, half the time I don't truly understand it, but the ones who get it, get it deep.

*What is your message, as your art investigates sexual or sociological dualities?*

Working with dualities is one way of putting it, but I think more than anything, I'm interested in the space of the abject, the place where meaning and language just completely fall apart. In some ways, I think my work is so loaded with the symbolic that it loses meaning altogether. There's no message, it's a revolt of meaning, a constant regurgitation of logic. I've always been drawn to the

grotesque and the idea of the ugly beautiful, the physics of attraction and repulsion, how too much of a good thing can make you sick. Yeah, those are dualities that play out in my work. Also, I like having the loud and brash bang up against the still and quiet. Silence can be as painful as the roar because it forces you to confront yourself, your own inner void. And most people don't want to do that. When you present something right next to its polar opposite, the greatest fullness of that difference can be experienced. It moves your insides around. I'm not interested in giving the viewer an easy narrative that lets them remain static as a passive voyeur. I want to destabilize my viewer so they are constantly questioning the ground they inhabit, and hopefully they will then develop a psychological agility that allows them to find pleasure in the unknown. As a kid I always loved those moments in movies, like that famous scene in Hitchcock's *Spellbound* where the gun turns and faces the viewer, moments that flip the script and actually implicate the viewer into the fiction. When an artist challenges the medium, it forces the viewer to challenge how they process and absorb information. And that's the most you can hope for, that people learn to be actively critical-thinking human beings. As Hans Bellmer, one of my dead mentors, said, "Opposition is necessary in order for things to exist and to form a third reality."

*Do you prefer working with modern themes or with historical references?*

Past, present, future, it's all happening at once. I work with iconic images that haunt all our myths and culture, and I'm specifically drawn to them because I think all historic themes are modern. People really haven't evolved much. My work is all about the shadow side of being human. Poetry has always been my starting point: Pasolini, Baudelaire, Blake, Artaud. I identify with the unknown, the collective unconscious, the ugly, and the supernatural.

*Do your ideas develop over time or do they come to you spontaneously?*

I'd say some of my best ideas come to me spontaneously. I guess it's like meditation in a way. Sometimes when I'm stuck, I'll just close my eyes and look at my inner screen and within a few minutes a fully visualized idea appears. Sometimes an idea will come to me just walking down the street. Like this recent sound piece I did for the DUMBO Arts Festival in Brooklyn. The festival takes place in this industrial neighborhood full of artist studios that is now being gentrified into multimillion-dollar lofts. DUMBO stands for Down Under the Manhattan Bridge Overpass and the realtors are putting up all these cute banners with pictures of elephants on them. I was asked to do a project for the festival, and as my boyfriend, Vincent Baker, and I walked under the bridge,

it immediately hit me. I said, "Wouldn't it be cool if there were hundreds of elephants trapped under this bridge pounding and screaming to get out, wild animals, like the wild artists here who are being wrangled by the real estate developers?" Then Vincent said, "Better yet, what if it's a recording of elephants and people think that they're really behind the gate." Vincent is a sound designer and a programmer. He works on a lot of stuff with me. So, bam! The idea came fully realized at that moment. Vincent made this incredible composition of angry elephants banging on metal, ready to stampede at any moment. We played it over a concert sound system and it reverberated throughout the neighborhood the entire weekend. I love doing public projects because they're not defined by the art world; it's the locals, random strangers, that complete the equation. Then there are projects that I started several years ago that are now sitting on a shelf and an opportunity will present itself and suddenly it's ripe for picking. There are always images, inspirations, impossible ideas competing for attention in my mind. The mysterious part is finding that moment when all the elements line up to favor one project over the other. That's something you can't predict.

*Has your work ever been so taboo, you've had to deal with censorship issues?*

Of course, the biggest censorship battle I incurred was during the distribution of my documentary on the San Francisco leather dyke scene, *BloodSisters*. In 1997, the NEA was up for ratification and several right-wing Christian zealots, led by Donald Wildmon of the American Family Association, decided to wage war against the art world again. *BloodSisters* never received any NEA money, they would never fund a documentary on leather dykes! But my distributor at the time, Women Make Movies, did receive NEA monies. So Donald Wildmon led this campaign against Women Make Movies and assembled a videotape with clips from their "disgusting and sordid" films and played it on the floor of Congress. Clips from *BloodSisters* were on the tape along with clips from Cheryl Dunye's *Watermelon Woman* and Barbara Hammer's *Nitrate Kisses*. When I found out about it, I immediately called Barbara Boxer and Nancy Pelosi. Eric Bock, my assistant at the time, and I sent out a mailing to every member of Congress stating how my work was unfairly taken out of context and offered to send them the full version if they were interested. Funny enough, the only people who responded to me were Strom Thurmond, Newt Gingrich, and Jesse Helms. It's depressing to see how well organized the media machine is within the right-wing sector. No Democrats responded to my needs. Nancy Pelosi told me she remembered when they showed the videotape throughout Congress and it was very hush-hush, only men were allowed to view the material behind locked doors. How about that! I envisioned all those uptight

males sitting there talking about these "disgusting films" while riveted to the screen watching two big leather dykes spanking the shit out of someone. What an image! Censorship is a smokescreen for political posturing and religious pandering. I have no time for religious fanatics, and I greatly resent the fact that in this country, which is supposedly based on the separation of church and state, I have to deal with religion infringing upon my quality of life and freedom of expression.

*When did you work with Monte Cazazza and what was his influence?*

Monte and I started working together in 1989. We were a couple very much in love and we started to create work together. At the time we met, I had already been developing a body of work similar to what I do now; projections, photography, and performance. So while we worked together, we also maintained autonomy working on our individual projects. The first body of work we did together was called *The Torture Series.* It was a series of photos using Monte's slide collection of Japanese bondage magazine covers and medieval medical imagery projected on both our naked bodies and re-photographed. They were very creepy, and elegant. Monte's vast knowledge of all things weird and dark influenced me greatly. The biggest influence Monte had was that through him I had access to all these amazing people. His friends and collaborators are some of the most radical artists of our time. I mean, incredibly powerful artists, an underground stream of activists and culture makers who consistently challenged aesthetic mediocrity and the political mainstream. All of these people were a big inspiration.

*What work did you do with Survival Research Laboratories?*

I never worked with SRL but I did work with Eric Werner, one of the founding members, along with Matt Heckert and Mark Pauline of SRL. This was in the late 1990s. I was becoming obsessed with sewing needles and Eric made me these eight-foot-long sewing needles, which I used in a few performances and exhibitions. They are amazing. Eric is a genius machinist. He designed, polished, and built them by hand from a solid piece of aluminum.

*What was it like working with Jon Moritsugu on his film* Terminal USA?

I loved *Terminal USA.* What a brilliant satire and what a shame it never got a larger release. That job came about because of Monte. Jon approached him for some specialized sounds and Monte brought me in. We were in charge of doing blood gurgles, explosions, screeching guitars, and screams. Jon's one of

those people who just does what he wants. He's not on a career trajectory, a capitalist construction, he's in the moment, and I admire that. I think I live my life the same way.

*Is there anyone with whom you'd like to collaborate?*

It would be great fun to collaborate with Paul McCarthy and Mike Kelley. They're a perfect combo of the ridiculous, the spectacular, the abject, and the intellectual. Also, Amon Tobin, The Boredoms, Matmos.

*Do you consider yourself and your work as part of a movement?*

Most cultural movements are borne in hindsight. I think most artists coexist with their environment in varying degrees of instigator, reactor, mediator, and erasure. Wickie Stamps, an amazing writer I had interviewed for my documentary, *BloodSisters*, once told me, "You're here because you want to find out something, and when you find that out, you'll leave. You'll be on to the next thing." I find that I'm constantly moving in and out of information pools and picking up cultural memes along the way. I've always been wary of aligning myself too closely with any one movement because history will trap you there forever. Wasn't it Kierkegaard who said, "Once you label me, you negate me"?

*What is the meaning of the piece* Passerby: Ghost Sites *and the idea behind it?*

*Ghost Sites* was commissioned by Michele Thursz and Anne Ellegood for *public.exe: Public Execution*, an exhibition of public art that used the public as material, as opposed to public art that just exists as immoveable sculpture. I came to that piece from the outside in, which is how I make a lot of my work. Spring was approaching and I knew I wanted to be outside, so I looked for a location. I picked Bryant Park because of its complicated history. It was once a grand park which fell into disrepute during the 1980s when it became a haven for junkies; only recently has it been cleaned up into the place it now is. I liked the idea of working in midtown, since it's really a foreign place to me and it also had wi-fi capabilities that I wanted to use. So I started thinking about all the people who travel through the park, how they're constantly under surveillance, how every park has a monument to a dead person, and how we're constantly walking through a city of ghosts. Somehow the ideas all coalesced into a project based on surveillance and homage: *the Doppelganger*. Quin Charity and I spent three weeks in the park clandestinely photographing and recording people's conversations. Then I picked five scenarios to re-create. I rerecorded the conversations with actors and then edited the audio into repetitive fragments

reminiscent of the snippets of conversation one catches as they pass by, and also incorporating the idea that when talking to another, we only hear what we want to hear. My performers were dressed exactly as the original subjects, but covered with white powder, like zombie statues, with conversations emanating from hidden ipods/speakers imbedded in their costumes. They sat in the park for four hours during lunchtime. There was also a blog that had stories and photographs of the original people I found in the park. So anyone in the park with their laptop could read the stories and hunt out the performers. It was like bringing the past into the present while knowing the future was being created as we spoke, as the park is under constant surveillance.

*How did Baudelaire's* Flowers of Evil *influence* This Delicate Monster?

*This Delicate Monster* was one of those pieces that was living inside my brain for a long time but I had no idea what it would look like until I finally just opened the door. This was right after the *Ghost Sites* performance and I was looking for a sign, a direction. I was thinking about how Baudelaire's writing has been such a big influence in my life, especially the *Flowers of Evil*, which I've been reading since I was in my teens. I have several first editions of the book with various translations and illustrations and all of a sudden I realized it was time to move it from the back of my world and deal with it directly. I worked with couture fetish designer Garo Sparo to create these crazy masks that were a cross between S&M and Mexican wrestling masks. Then I went up to my farm in the Catskills, which is surrounded by these amazing evil sunflowers, and with a group of performers, we spent two weekends shooting the video. This Delicate Monster isn't a literal translation in any way. I just took parts of the text that moved me for some reason or another, like the lines, "condemned to an eternal laugh because I know not how to smile," and "swallow up existence with a yawn," and created actions for my characters riffing off these ideas. For instance, in the introduction Baudelaire states, "To know nothing, to teach nothing, to feel nothing, to sleep and still sleep. This is my only wish. A base and loathsome wish but sincere." I just love that. I'm a big escapist. So I took that line as inspiration for the exhibition and built a Plexiglas box out of two-way mirror where I was encased and sleeping throughout the entire opening. It was perfect because I hate my own openings. You stand around in front of your work looking so desperate while people come up and congratulate you. It's so artificial. So I thought this is perfect. I'll just sleep through my opening! I also had the characters from the video sitting on chairs placed high on the gallery walls, like gargoyles, spitting and hissing on the crowd as they protected me sleeping in the box. The whole thing was like a cross between a pagan ritual and a fashion shoot gone terribly wrong. I think Baudelaire would have liked it. It was a haven for misanthropes.

*How did your writing come to be included in* Apocalypse Culture 2?

Adam Parfrey approached Monte and me to write a piece for *Apocalypse Culture* so we decided to look at the beginnings of our social pollution, how advertising destroys personal economy and targets children to develop them into fast-track consumers. We wrote a piece about cereal box design and how it manipulates the minds of children. We had a massive collection of cereal boxes and every week we'd go to the supermarket and find more. We looked at the marketing from its Freudian aspect, the magical allure and how capitalism has devolved into brainwashing. I mean, children's cereal is really just pure crap and especially evil since children's bodies are in their developmental phase and require specific vitamins and minerals to build a strong immune system to support them for the rest of their lives. It's one of the most insidious forms of corporate child abuse.

*What inspires your erotic writing?*

I'm a product of the sex business. My father ran a massage parlor in Los Angeles during the '70s, and those pimps and hookers were a great influence on me. I mean, in some ways, I was brought up in a very sexually excessive environment and I wasn't afraid to flaunt my own sexuality. I never got that thing about how women were supposed to be demure. I've always loved to talk dirty, talk sex, like a truck driver. In looking for material, I just always found that my strongest force was my own sexual desire, and erotic writing became a natural outlet for that. Also, in 1989, Charles Gatewood and I became fast friends, and Charles introduced me to people like Michael Perkins and Willem de Ridder, who were editing books and working for magazines like *Penthouse* and *Screw*. So I got job offers from them.

*Where did the concept of the character Lucky M come from?*

Lucky M is like a cartoon character without a book, part hyper-fantasy, part bumbling human. She's a homage to all female superheros. Her first performance was inspired by Niki de Saint Phalle's shooting performances in the '60s. Niki was this French sculptor who designed these massive pop art installations. One project was a building designed as a woman's body where the viewers had to enter through a door in the figure's vagina. She became quite famous for these shooting performances where she would fabricate these thick canvases imbedded with cans of paint, then shoot the canvas with a shotgun and the paint would come pouring out, bleeding onto the canvas. Funny enough, Jane Fonda, at the height of her *Barbarella* fame, brought her to California

and staged a shooting performance in Malibu. So Lucky M's first performance, *The Adventures of Lucky M: AIM*, was a shooting performance using paintball guns as her weapon of choice, riffing on the male-dominated world of action painting and using the guns for their power of creation as opposed to their power of destruction. Yes, that's the duality. Lucky M has many sides. She's kind of a failed superhero, someone who has great power and yet can succumb to great weakness. Like Barbarella, she was this great empowering image for female sexuality but she is also a symbol of failed female power. So I use Lucky M as a transforming female icon who encompasses both the positive and the negative powers of sexuality and violence. And I'm talking about violence as natural phenomena, an untamed force. She's about taking risks, going out on a limb, standing up for what you believe. I named her Lucky M because here I was alive, healthy, and pretty goddamned lucky to have the luxury of pursuing my dreams, while most of the world struggles for survival.

*How are you adapting Oscar Wilde's novel,* The Picture of Dorian Gray*?*

Like *This Delicate Monster*, my Baudelaire project, Dorian is a fragmented narrative that riffs off of Wilde's themes of youth, beauty, and the meaning of art. I'm working with performers who are true to their characters, actually are their characters in real life, so there's an authenticity to the piece alongside the theatricality. For instance, Armen Ra, drag diva and renowned Theremin player, is playing Lord Henry. Sequinette, a young New York bio-fem drag performer, is playing Dorian, and K8 Hardy, artist and co-founder of the queer collective LTTR, is playing Sibyl. The end result will be an installation with five freestanding video screens the viewer can walk among. I'm drawn to Wilde because in his own bourgeois way he was a rebel, and even as he reaped the rewards of high society, he always held up the mirror. He was not afraid to bite the hand. But Wilde was full of contradictions and the thing about Dorian is that though he is decadent and wild, he is not a free thinker, he is stuck in a shame cycle repeating someone else's idea of freedom. He is truly tragic. To quote Kierkegaard again, "People demand freedom of speech as a compensation for the freedom of thought which they seldom use."

*How would you sum up the meaning of your work, and how you would best like to be remembered as an artist?*

"Wow, what the fuck was that?" followed by, "I don't know, but I want to see more!"

138

# The Guerilla Girls

The Guerrilla Girls have been a tour de force of feminist and art activism since 1985. They claim to be reinventing the "F word": feminism. Their work and members have grown vastly over the years. They are a group of women artists, most of whom are already successful in the art world, who work as activists in anonymity by wearing gorilla masks and adopting the names of important women artists throughout history. Some of these historical women artists are Rosalba Carriera, Georgia O'Keeffe, Frida Kahlo, Alma Thomas, Lee Krasner, Eva Hesse, Gertrude Stein, Anais Nin, Emily Carr, Paula Modersohn-Becker, Romaine Brooks, Alice Neel, Violette Leduc, Ana Mendieta, Rosa Bonheur, Angelica Kauffmann, and Sofonisba Anguissola. They perform while wearing the gorilla masks in overtly sexy attire to destroy the idea that feminists need to seem masculine to be taken seriously. There are currently so many members that many just take on the numbered monikers of GG1, GG2, et al. Their work is intent on exposing the sexism and racism that still exists in politics, the art world, film, and many other cultural forums. They use satire and, most importantly, thoroughly researched information and historical facts regarding women artists and the art world to convey their messages about gender inequality. They provoke with informative ideas and slogans to elicit critical thinking and to counter the ingrained docile acceptance of injustice. They claim to be "the much needed conscience of corporate run art programs and art culture." The Guerrilla Girls not only work in performances and actions, but also present their messages in posters, billboards, stickers, and books. Their acclaimed books are *Bitches, Bimbos, and Ball Breakers: The Guerrilla Girls' Illustrated Guide to Female Stereotypes* (2003), *The Guerrilla Girls' Art Museum Activity Book* (2004), *The Guerrilla Girls' Bedside Companion to the History of Western Art* (1998), and *Confessions of the Guerrilla Girls* (1995). *The Guerrilla Girls' Hysterical Herstory and How It Was Cured, from Ancient Times Until Now* is forthcoming. In 2005, they exhibited *Always A Little Further* at the Venice Biennale with enormous posters that addressed the Biennale itself, the museums of Venice, politics, the art world, and Hollywood. They have conducted many lectures and workshops, and presented exhibits in schools, museums, and various institutions. In 2012, the exhibit *Not Ready to Make Nice: Guerrilla Girls in the Art World and Beyond* displayed ten years of their work in the Glass Curtain Gallery and A+D Gallery in Chicago. This interview was primarily conducted with the Guerrilla Girl Kathe Kollwitz.

*How long have you been active as a group? Do you prefer the title of artists or activists?*

We began in 1985. We are artists and activists.

*How much fun do you have in this endeavor as compared to the stress involved?*

We have a lot of fun thinking up this stuff.

*Which forum or medium has been most potent and influential in getting your message across?*

We like them all: posters, books, and billboards. Posters because they're down and dirty; you can do them quick and put them up right away. Books because they allow us to go deeper into the issues, and billboards because they're big and they reach thousands of people a day.

*What are the most offensive descriptive terms used in the arts community?*

We hate the masculine terms that are used to describe art like "seminal," "potent," and "masterpiece."

*What is the power of anonymity?*

In the beginning, we decided to be anonymous for purely self-serving reasons: the art world was a small place and we were afraid our careers would suffer. But we quickly realized that anonymity was an important ingredient to our success. First, it keeps the focus on the issues, not on our work or personalities. Second, the mystery surrounding our identities has attracted attention, which is helpful to our cause. We could be anyone, and we are. Now that doesn't mean that everyone should be anonymous all the time. Many of us are also activists in our real lives under our real names, too. And, of course, most of us have other lives as artists, some very successful.

*How does an artist avoid becoming a commodity?*

We think there's a disconnect in the art world. There's the world of artists: people devoting their lives, against all odds, to making work. Then there's the system: manufacturing scarcity and shutting out most of the artists, especially women and artists of color.

*How do the Guerilla Girls define feminism?*

We believe feminism is a whole new way of looking at the world. All our work does two things: confounds the notion of what a feminist is, and at the same time promotes our feminist agenda.

*Your members are countless, but does the group have an active core?*

We wish we could tell all about the women who've been in the group over the years but masked avengers must have secrets or else they lose their power.

*What changes have you seen occur since the Guerrilla Girls began? Do you know the degree to which you've affected society?*

Things are better in the art world than they ever have been for women and artists of color, and we have helped affect that change but there's still a long way to go. We are still condemning the art world for its lack of ethics and tokenism. Also, bad behavior in other fields like film and theater lag way behind the rest of society in the number of women and people of color in positions of power. I guess we can't hang up our masks yet.

*Are your actions planned or improvised? Have any been completely misunderstood?*

The Guerrilla Girls fight discrimination with facts and humor, attempting to reveal the hypocrisy, conservatism, and corruption in cultural and political institutions. Humor helps us present issues in unexpected, intrusive ways. We believe that some discrimination is conscious and some is unconscious and that we can embarrass some of the perpetrators into changing their ways. We're brainstormers, not improvisers. We want to make sure our work has an effect. We don't simply point to something and say, "This is bad," as does a lot of political art. We try to use information in a surprising, transgressive manner to prove our case. We also test our posters on people to make sure we're communicating successfully. Sometimes you get so close to an issue that you do a poster that doesn't make sense to people who haven't been thinking about it day and night. Every one of our projects is probably misunderstood by some people, particularly people without a sense of humor. But we have gotten letters from a few right-wing white males saying they respect what we're doing, amazingly enough.

*Does your activism often result in confrontation with the spectator?*

We try to get past viewers' preconceived notions, so our work can be pretty extreme.

*How is animosity handled? Do you ever experience threats, or has anyone gone to great lengths to discover your identities?*

We get thousands of love letters and thousands of hate mails. We've been threatened by some angry white men and chased by the cops. We handle the threats by saying, "Thanks for expressing your opinion but we couldn't disagree more." An art critic once called up and said he knew our real identities. He named a bunch of names, most of them wrong. We told him that we had friends in high places and if he published any names, he could kiss his job goodbye. That's the last we heard of that.

*Will you describe one of your published works?*

*The Guerrilla Girls' Art Museum Activity Book* is an outrageous, humorous, fact-filled look at how museums discriminate. Why do they raise hundreds of millions for new buildings and then complain that they don't have enough money to buy art? Why do they blow a fortune on a single painting by a white male genius when they could acquire hundreds of great works by women and people of color instead? Why do museum store execs get paid more than curators? The book is a sixteen-page activity book, like the kind museums put out to teach kids to love high culture. It has quizzes, connect-the-dots museum floor plans, and lots of ideas for how you can bother, and maybe change, your favorite museum, just like we've been doing all these years.

*What has been the Guerilla Girls most intimidating or threatening act of feminist activism? What got the most reactions?*

Our anti-Hollywood billboard and sticker campaigns have gotten lots of reaction. Hollywood likes to think of itself as liberal and edgy and ahead of its time. They couldn't be more wrong. We're artists, we're activists, and we're humorists. But our work doesn't qualify us to be called terrorists. We just put up posters and run around in gorilla masks.

*When creating a project, do you have a goal in mind or expectations in regards to the type of targets or responses?*

We take on issues we are passionate about, but we don't always succeed. If we

don't come up with something we think is worth putting out there, we don't. We've never been systematic, we just go after one target after another and there are plenty to choose from.

# Liz McGrath

Elizabeth "Liz" McGrath (born 1971; Hollywood, California) is an artist and musician based in Los Angeles. She is known for her mixed media assemblages, installations, and dioramas, as well as for her band, Miss Derringer. She is also a painter in watercolor and acrylic, a sculptor, set designer, animator, doll and toy maker, and clothing designer. Her art is described as surreal taxidermy, consisting of large-scale animal forms and insects that she builds into characters of elaborate, mythical creatures. They are generally based on themes of horror, circuses, and carnivals. Liz's creations are given names and personalities which all carry a visual dialogue evoking terror, curiosity, and awe. Her work has been celebrated in underground and commercial forums, and at numerous gallery shows including *Everything That Creeps* (2002), *Illuminated Delusions* (2004), *Altarwise by Owl Light* (2005), *The Incurable Disorder* (2007), *The Secret Party* (2008) and *Tears of the Crocodile* (2008). Some of the anthologies containing her work are *Pop Surrealism: the Rise of Underground Art* (2004), *Vicious, Delicious, Ambitious: 20th Century Women Artists* (2002), and *Weirdo Deluxe: The Wild World of Pop Surrealism and Lowbrow Art* (2005). In 2005, a monograph of her work, *Everything That Creeps: The Art of Elizabeth McGrath*, was published. As a musician, Liz sings in her band, Miss Derringer. The music is considered indie, country, rockabilly, and gothic, with a vintage sound recalling the late 1950s and early 1960s. The albums she has released with Miss Derringer are *King James, Crown Royal and a Colt 45* (2004), *Lullabies* (2006), an EP called *Black Tears* (2007), and *Winter Hill* (2009). Her husband, Morgan Slade, who co-founded the band Miss Derringer, is now collaborating with Liz by detailing tattoo work on pieces of her art. In 2008, Liz won an award from the International Horror Guild for Outstanding Achievement in Horror and Dark Fantasy Art, for her show *Incurable Disorder.* She contributed a piece of her artwork to David Lynch's *Twin Peaks* 20th anniversary art exhibit, called *In the Trees*, at the historic Clifton's Brookdale Cafeteria in Los Angeles. A series of graphic shirts are planned in collaboration with designer Anna Sui. In 2011, she premiered *The Folly of St. Hubertus* at the Sloan Fine Arts Gallery in New York. This mixed media sculpture depicts a woodland creature decorated in gold-leaf and Swarovski crystals, inspired by the vision of the hunters' patron saint Hubertus. The 2011 documentary, *Bloodbath*, directed by Cecil B Feeder, documents Elizabeth McGrath's life and art as well as her musical career.

*How did your upbringing influence and affect your work?*

I was brought up in an upper middle class suburb of Los Angeles by a Singaporean mom and American dad, who both held jobs and were very strict Catholics. My parents bought a house that was above their means at the time, which left my sister and I home alone a lot with nothing but our imaginations. When it came to entertainment, we visited the library almost every other day and my mom took us to any community arts and crafts classes that were available, which I think was really a stepping stone to my current artistic endeavors. My aunt was also very artistic and had designed two restaurants that she owned, taking me along every step of the way, from fabric shopping to flower marts, to furniture showrooms and art supply stores. She even had me design signs, advertising specials. At a very early age, my sister and I were paid a nickel for every perfect black bow we could tie, to go around countless decoration props she used at the restaurant. Her eye for perfectionist detailing was another thing that has stuck with me. My step-grandfather was a cartoonist for a Long Beach paper, my real grandfather was a musician who toured the world with his band, playing out his last days as the pianist at an Oregon piano bar. All these things really influenced who I am today.

*How did growing up in a Catholic family and going to Baptist schools affect you?*

My Catholic family sent me to a Baptist school just as I started my teens. My family and I were at odds with just about everything. I hit a rebellious streak and my parents reacted by sending me away to a Baptist boarding school, which was a traumatic event in my life. Just before the Girls' Home, my parents sent me to Hawaii for a summer to stay with my aunt and cousin. Hardly believing my luck, I went along with it and by the end of summer my mom met me out there to take me to Singapore, where their plan was to leave me with relatives and send me to a Catholic school. They hoped I would become a nun! Both my mom and dad were nearly a nun and a priest. It didn't work out, but while in Singapore I was exposed to so many great visual stimuli, which has stuck with me today. One thing I will never forget was the Tiger Balm Gardens, a theme park dedicated to the Buddhist religion. In one of their attractions you walk through a tunnel-like cave and they have dioramas set into the caves of the thirteen (I think) Gates of Hell, with very expressionist and brightly painted sculptures of people climbing trees of swords or being boiled alive while demons ate their remains. I loved it. I had always loved miniatures but this was the first time I thought that they were cool.

*Do any current religious beliefs affect your work?*

I wouldn't say I really have religious beliefs per se. I subscribe to the theory that everything is connected and part of each other. Who knows, maybe we are all God.

*What arts education have you had, and has this helped your art?*

Well, actually I'm a seventh grade dropout. I almost have a degree in fashion. I took fashion [classes] at the community colleges and various art classes. I feel like they all helped me shape what I do today.

*You wanted to become a fashion designer?*

I took two years of fashion at Pasadena City College and was a top student until it came time to take my five sewing classes, I couldn't sew at all! I think that's a thing you learn at an early age by family members. There is no way I could have achieved the level of success I would have wanted with my feeble sewing skills.

*Will you talk about your first band and how it related to becoming an artist?*

I had a punk band called Tongue and around that we developed a fanzine, *Censor This*. The forum was for anyone who had anything to contribute to it and the catch was that we censored nothing. One day, while passing out flyers and 'zines, it got into the hands of a local music video director, Fred Stuhr, who was impressed with the artwork and hired me to work at his studios.

*Will you talk about your work in stop-motion animation?*

Working with Fred Stuhr Animation brought me back to my childhood days where you had to problem-solve with the items you had around you, working on slim budgets. I realized that a slick miniature elevator lift with robotic moving parts and scary creatures could be Popsicle sticks, cardboard, Gatorade bottles, and coat hangers! It really changed my perception about the mysterious and seemingly expensive materials I thought were needed to make art.

*What artists or peers have inspired your work?*

I was always a fan of the La Luz de Jesus Gallery and *Juxtapoz* magazine, where I found artists' works such as Joe Coleman, Robert Williams, Mark Ryden, Camille Rose Garcia, and many more! Before that, I was hugely inspired by children's book illustrators, whom I checked out from the library at an early age and tried to copy on spare sheets of paper. Some of these artists were Arthur

Rackham, Beatrix Potter, Jean Grandville. Also, the art of Aubrey Beardsley and Erté.

*Is your work more easily financed today, and does that change the work itself?*

I believe every artist sacrifices something for the sake of their art. I have been lucky enough to achieve some goals but it took many years of exploration and dedication. My gallery now has been very generous with me and I am able to create more work and experiment with more expensive materials.

*What are the materials you used in your earlier work as opposed to now?*

I still use wire but instead of coat hangers, I use armature wire. I use fabrics, wood, resin, clays, and paints. I also have the freedom to buy materials that inspire me, rather than work with only what I am given or find.

*Why did you create curio boxes and dioramas with insect characters?*

Insects have always fascinated me. Living close to a canyon, we encountered many kinds of insects that my mom would oftentimes say is a person reincarnated as a bug. "Leave Uncle alone, he's only trying to find a spot to have tea," she would say about them. So I've always had these images of insects who think they are people. I do still work with these I images, but insects are sometimes challenging subjects to recreate.

*Have you had any backlash from using taxidermy animals in your artwork?*

Actually, I never have used any taxidermy animals in my work. Everything is made from manmade, scratch materials. My initial sculptures were supposed to look like eighteenth-century toys. I liked the way the Skin Horse [from the Velveteen Rabbit] would be made from some kind of worn-out fabric but its face would be carved out of wood, with the colors not matching. I love porcelain or papier-maché faced animals with fabric-sewn bodies, those were my initial inspirations. People thought they were taxidermy. If you look at the faces of my sculptures, they are all made out of clay. I have adopted the use of foam taxidermy forms, and now, for easy explanations, I just say they are taxidermy-esque. As of 2007, I don't use any animal products in my work. Previously, I used to live next door to a factory which made leather clothing and they would give me bags of leather and fur scraps, which lasted me for years. After running out, I went to buy leather and fur hides and just couldn't, seeing the shapes of the bodies and also how cheap they were selling for. They are cheaper than

good fakes. It really resonated with me how what I was doing was just wrong. I don't wear fur or leather either now. People may say it's recycling using vintage pieces, but if enough people use or wear the vintage leather and fur goods then it creates a trend that new designers and artists will follow by buying more leather and fur and aging them to look vintage... well, you get the idea. So far I haven't received any backlash. In fact, people send me their taxidermy animals as gifts. I get boxes of old leather and fur jackets every year but I usually give them to friends or donate them.

*How do you get ideas for your art?*

I do a lot of research on things that pop out at me, like a picture, a poem, something I see in life. I will sit at night problem-solving, lying in bed thinking of what I'm going to do. At times, I know my subconscious is taking over my sleep because I will wake up with an idea.

*How long does it take to finish a piece? What is the process?*

Anywhere from a day to six months. It involves research, sketches, the constructing, painting and dressing the sculpture, and making a box to fit it. Then designing the interior of the box and painting the outside.

*What kind of message does your art convey? Is the dark humor intentional?*

I don't make art with the intention of spreading a message. I used to feel bad about not having a message. I sometimes feel like art is a silly luxury compared to the world's problems. Maybe that's where the dark humor comes from, my guilt in not being able to produce art with a message.

*What inspires the reoccurring themes of mutants and mythologies?*

I listen to a lot of audio books of all different themes, especially mythological themes. The stories always seep into my art. Creatures like Pegasus, unicorns, centaurs, minotaurs, Bigfoot, the Loch Ness Monster, the Chupacabra. Any Greek, Chinese, or Irish lore, and just about any kind of strange creature interest me!

*Is a piece created based on the materials on hand? Is the frame created first?*

Yes, often parts of a dollhouse will be enough inspiration to make a whole piece, and I make the insides first.

*How many different kinds of media are you working with now?*

I use a lot of different media. When I stopped using fur and leather, I wanted to work with a fabric that was just as strong, and was drawn to furniture upholstery. It got me thinking about how we infringe on animal territories every day, and fight for cohabitation, and how animals and humans have adapted themselves to their environments.

*Where do you work, and does your living environment affect your artwork?*

I have a studio workspace that is basically tables made of fridge doors and such, lots of paint and wood and fabric, all kept in about 100 plastic storage bins on long shelves in one of the rooms in my studio. It's not very fancy but functional. I used to work out of my home but my husband thankfully put a stop to that! I live in an artist loft in downtown L.A. I've been in this area for about thirteen years now and have watched it gentrify from literally being Skid Row to its recent emancipation as Gallery Row. There are fourteen units in my building and everyone has been there for years, so it's a pretty tightknit community. I've known some of my neighbors from when I was seventeen and our bass player lives upstairs.

*What was your first gallery show and one of your most memorable shows?*

It was at Copro Nason Fine Arts Gallery. I was in a three-person show. I was not the highlighted artist of the show but I worked really hard on it and surprised everyone by selling out on the first night. I knew I was on to something then. The last solo show I did was at Billy Shire Fine Arts. I worked really hard on it and I feel like I achieved what I set out to do and a lot of people came out to see it!

*Do you have a favorite piece? Do you prefer to work on a small-scale or large?*

I like everything I've created equally. I've come to think of them like children. I like to work large. It is hard for me to sculpt small with the medium that I use. The bigger pieces are always more challenging. Positioning pieces so they will stay for a long time is a process.

*What kind of music does Miss Derringer play?*

It's been called Goth Country, but Goth as in Gothic Americana. It was started by my husband, Morgan Slade, and came about because art collector Long

Gone John also has a record company called Sympathy for the Record Industry. He was at my house one day looking at art and we played him a song Morgan had written, he then gave us money to record an album. Now the band has achieved some great recognition.

*Which is a greater passion, music or art?*

I love being in a band. I've been in bands since I was a teenager. In the girls' home, I was in the choir and we traveled around to different churches singing. I don't know why—I have terrible stagefright and I'm not really a good singer—but there are a few moments on stage when everything is perfect, and it's addicting. You are always searching to play the perfect show. I think that art is definitely my greatest passion; it's way more personal. The band is a team effort.

*Did you ever imangine your art becoming so successful?*

Sure! Like any honest person out there, you secretly dream that you can be in the top of your game but I would be satisfied to be able to just make a decent living from what I am doing.

*What is your typical day like?*

I usually get up around 11 a.m., get some coffee at the local spots downstairs from me, do my emails, walk the dogs, then go into my studio, which is down the hall from my living loft, and work. Sometimes I have helpers, sometimes it's just me. I usually turn on an audio book. Then, around evening, we have band practice, which is upstairs in my bass player's loft. I usually work until about two in the morning. I do this almost seven days a week! Of course, I try to go to the gym, take meetings, play shows and such, and sometimes we go on tour, but it's a tight schedule; I am always working.

*Will you talk about the development of your book* Everything That Creeps?

It was like a dream come true. Billy [Shire] from La Luz [de Jesus Gallery] and Ron [Turner] from Last Gasp took me out to dinner and told me they wanted to publish a book. We then hired Debra Valencia, who laid out one of Mark Ryden's books, and it just all came together perfectly.

*What would you create if you had an unlimited budget?*

A theme park with an underground sea cave that had pirate ship cruises. Of course, the profits would be donated to good charitable causes.

## Lisa Petrucci

Lisa Petrucci (born 1963; raised in Massachusetts) is a painter, an art director, and a film historian. After art school, she became a curator and director of many progressive galleries in the Northeast, including the Pat Hearn Gallery and Bess Cutler Gallery in New York. In the early 1990s, she moved to Seattle and began working with Something Weird Video, which restores and distributes an extensive collection of taboo, out of print, banned, exploitation, and obscure films, mainly from the 1930s to 1970s. She works with the company as archivist and meticulously restores the films. She has a vast collection of adult-themed ephemera: pinups, vintage comic books, and children's toys, which she says all influence her art. Lisa's art mainly consists of acrylic paint on wood plaques, with the images as homage to pop culture and female portraiture of the 1950s through the early 1970s. Lisa says in creating these images from a female perspective, it takes the objectification out of this type of imagery. In her own words, her art is where the "kute meets the karnal" or Margaret Keane meets *Playboy*. She celebrates femininity, whether through the cuteness of childhood nostalgia or the sexually charged adult female form in provocative poses. Her art can be found on everything from clothing, jewelry, and stationery, to a line of vinyl figurine dolls based on her art, produced by Dark Horse Deluxe. Her work has been featured in many anthologies including *Pop Surrealism: The Rise of Underground Art* (2004), *Vicious, Delicious and Ambitious: 20th Century Women Artists* (2002), *Big Eye Art: Resurrected and Transformed* (2008), *EdgyCute: From Neo-Pop to Low Brow and Back Again* (2009), and *Garden of Eye Candy* (2009). Her paintings have been shown in dozens of gallery exhibits including *Ha Cha Cha! Pin-Up Art Past and Present* (1993), *Virgins, Whores, Witches and Goddesses* (1994), *Dangerous Dolls* (1999), *Precious; The Pathos and Pleasure of Kitsch* (2000), *Ladies of Lowbrow* (2002), *Pop: Surrealism* (2005), *Apocalypse Wow!* (2009), *Back from Black: Bright Pop to Dark Underground and Back* (2010), and the *Pop Surrealism Big Bang Group Show* (2011). Her designs are available as wearable art in the Lisa Petrucci jewelry collection produced by Classic Hardware. Her work continues to be exhibited internationally in solo and group shows, with a recent group show, *Death and The Maiden*, at Roq La Rue Gallery in Seattle. A monograph of her work, *Kickass Kuties: The Art of Lisa Petrucci* was published in 2009.

*How and why did you break away from Fine Art to pursue Lowbrow Art?*

I have a B.A. with a major in art history and minor in studio art. My formal education has so little to do with the art that I now make but I'm glad that I went to school and had the whole college experience. Majoring in art history gave me a strong foundation to draw from. I worked in art galleries in Boston and New York during the 1980s and became very familiar with current trends. But by the early 1990s, I was disenchanted with all the conceptual art that was being championed by galleries. I started to paint subjects that interested me and looking for other artists who were working outside the existing establishment. I was fortunate to get a job with the Bess Cutler Gallery and met a lot of underground artists like Robert Williams, Anthony Ausgang, Todd Schorr, and others who, although not recognized by the mainstream art world at the time, were the basis for the Lowbrow Art movement. Then I moved to the West Coast and felt at home amongst the pop artists I began showing with.

*What inspired the style of your artwork?*

During the late 1980s and early 1990s, I had been working in art galleries in New York City and was disenchanted by the art that was being shown at that time. So much of it seemed very esoteric and elitist. I had been tinkering around with female imagery in my art for years but decided to push it a little further by incorporating things that had a personal and nostalgic meaning for me. I began incorporating pop cultural references from my childhood: dolls, toys, cartoon characters, and cute kitschy imagery usually associated with girlhood and with pinups from old men's magazines from the 1950s and '60s. I got the idea of painting them on souvenir wood plaques after experimenting with some other arts and crafts surfaces, like plaster casts and found objects. The wood plaques seemed like the perfect format since the object in and of itself is the embodiment of kitsch and Americana. Most everyone is familiar with the souvenir wood plaque so often emblazoned with pictures of Jesus, the Virgin Mary, the Last Supper, or some inspirational religious quote, as well as pastoral landscapes and every sort of animal imaginable. Besides deer and horses, wolves and eagles, puppies and kittens, there is the occasional unicorn, rainbow, or other fantasy subject. This appealed to the collector in me and was yet another way to infuse another of my personal obsessions: thrift stores and flea markets. The wood plaque also references art for the masses and the Lowbrow. When I started using them, I was definitely thinking about them being an arts-and-crafts material, and the implied differences between female hobby crafts like decoupage and fine art. That was the genesis of my paintings.

154

*What are your paintings like and what are the images based on?*

I do brightly colored, pop-culturally influenced paintings on wood that incorporate vintage pinup girls with nostalgic girly imagery based on my various interests and collections. Vintage dolls, toys, comic books, children's books, greeting cards, fabric designs, and kitsch like big-eyed prints, tikis, circus and carnival ephemera, and way too many other things to list, intermingle to create a tableau that is cute and unsettling at the same time. I also reference low-budget exploitation films from time to time.

*Do specific images inspire the adult-themed pieces?*

I have been collecting vintage men's magazines from the 1950s to '60s for as long as I can remember. I like the obscure titles that feature mostly unknown, big-haired, cat-eyed she-devils in bullet bras, stockings, heels, and big panties. I am fascinated by them because being a men's magazine model was an unconventional career choice back in those days.

*What is the process for creating each piece?*

I find the discarded wood plaques at thrift stores and swap meets. In most cases, they already have something decoupaged on them that I have to remove in order to paint on them. But sometimes I buy blank wood slabs from a hobby craft store when I'm out of the old ones. I scrap off the varnish and paper image, then sand the surface down to bare wood, leaving the bark alone. Once the surface is clear, I apply a few coats of Gesso then hand-sand the surface until it's smooth. The wood plaque is ready to paint on. I usually have an idea in mind and have done some sketches and drawings on tracing paper. I transpose the images onto the wood with pencil, and then do the underpainting with liquid acrylics. From that point it's just a matter of painting. My technique entails applying thin layers of liquid acrylic to create depth and translucency. Once the painting is completed, I lay the painting flat and pour Envirotex, a two-part craft resin/varnish, over the surface and edges. This final step gives the painting a shiny jewel-like quality which collectors seem to appreciate. It takes a day or two for the varnish to dry, but it's well worth the effort.

*How long does it take to complete a piece? What is your ideal work environment?*

Gosh, it all depends! Since I have a full-time job with Something Weird Video, my paintings are done over a period of time. I don't usually just sit down and see a painting through completion. It can take anywhere between eight to forty

hours to finish a painting. I keep going back and forth between them, tweaking and fussing over areas, especially the eyes. Most are rather small but detailed. Some paintings just happen easily, whereas others are a struggle. As far as the perfect environment goes, that would be having the house to myself so I can play music loudly and focus on the work at hand. But that doesn't happen very often since I live with my husband Mike, who also works at home, and his two teenage kids. So it's always chaotic and noisy and I'm constantly interrupted.

*What are your various collections that inspire your artwork?*

My husband Mike and I are voracious collectors. Our entire house is like a pop-culture emporium. My primary collections are vintage dolls and toys from the 1960s and early 1970s, big-eyed art and ephemera, circus and carnival, tikis and Hawaii-ana, Wonder Woman, comics, movie and television memorabilia, monster and creepy stuff, you name it. Different rooms in the house are for designated collections. My office and painting studio are filled with dolls and all that is cute. It's inspiring being around these things. They make me happy.

*Who is the typical admirer of your work?*

That's hard to pin down. Naturally, many guys and gals of my generation recognize the references to the toys, dolls, and big-eyed art featured in the paintings, so they respond to them with nostalgia. Other people are into pinup and sexploitation, so they like the sexier aspects.

*Have you been confronted by viewers who find the artwork disturbing?*

On the rare occasion I have heard this. The most hilarious email I've gotten was from a doll collector who was horrified that I had defiled her beloved Liddle Kiddles by portraying them in such a sordid way. But most viewers get the irony and juxtaposition of combining the cute and carnal. It's very much a part of who I am—collecting vintage dolls and old girlie and pin-up magazines and working as a sexploitation film archivist—so it makes sense that I'd make art that addressed these subjects.

*What inspires the childlike images?*

Many of the little gals are loosely based on Liddle Kiddles dolls from the 1960s. I had these as a child. They were, and still are, my favorites. They were an important part of my childhood. I'm also inspired by Blythe, Furga dolls, Flatsy, mod era Barbie, Dawn, and many other obscure dolls from the 1960s and '70s.

I have a gigantic vintage doll collection in my office studio that is a constant source of inspiration and joy.

*What cartoons were your favorites as a child?*

My favorite cartoon was *Kimba the White Lion*. The *Lion King* was actually based on it. A lot of the cute critters that I paint have Kimba-like qualities, big eyes and small bodies. I also watched all of the Sid and Marty Krofft shows, *Josie and the Pussycats, Justice League of America,* and *Wacky Races.* As a child I liked cartoons that featured female characters like Wonder Woman and Penelope Pitstop. There were so many psychedelic cartoons in the late 1960s and early '70s. Definitely the Sid and Marty Krofft shows like *H.R. Pufnstuf, Bugaloos,* and *Lidsville.* They were way out there and a feast for the eyes with all the Day-Glo colors and trippy imagery. In retrospect, the Kroffts' claimed that the shows were not influenced by the hippie drug culture, but that's hard to believe.

*What are your favorite films from the 1950s and '60s?*

I have done a few paintings based on some of my favorite movies like *Faster Pussycat! Kill! Kill!*, *Straight-Jacket,* and *Spider Baby.* I also love John Waters' early movies and try to capture that colorful exuberance in my art.

*Do you ever run into copyright issues regarding the images you use?*

Since my images are reinterpretations and parodies of characters like Wonder Woman, Kimba, and the dolls and toys I collect, I think I'm okay. Artists like Mark Ryden, Isabel Samaras, Ron English, and many others often use recognizable pop cultural references in their art as a way to pay homage to their subject, which is what I'm doing.

*On how many different media and collectables does your artwork appear?*

Surprisingly, my art is showing up all over the place! On apparel, accessories, gift items, postcards, vending machine stickers, and soon wireless cell phone content. I'm happy that the imagery has found an affordable outlet for fans who wouldn't normally buy art.

*Would the adult content of your art cause a problem with younger viewers?*

The only adult aspect of my paintings would be some partial nudity, which I

personally don't find morally harmful to anyone. There's nothing obscene in my art that could hurt a young viewer's eyeball or psyches. You'd have to look really hard to find something that disturbing.

*When did you become interested in vintage films?*

Some of the first scary movies I saw were at the drive-in as a kid. I'd pretend to be asleep in the back seat and would peek in between the seats and watch films like *Night of the Living Dead, The Undertaker and His Pals*, and *Corpse Grinders*, which were totally inappropriate for any child. I also used to watch late night *Creature Double Feature* and saw all the Universal [Studios] horror classics, Toho [Studios] rubber-suit monster movies, and other schlocky offerings on television. During college I became nostalgic for the films I had seen as a kid and began looking for them on VHS and discovered a whole other world of obscure low-budget cinema.

*How did you start working as a film archivist?*

I began writing about pop culture and film during the early 1990s while I was living in New York City and still working as an art gallerist. I lived near Kim's Video and rented hundreds of exploitation and horror films, and became especially interested in 1960s sexploitation, a genre which was relatively unknown at the time. This genre includes the oeuvre of such luminaries as Doris Wishman, Joe Sarno, Michael and Roberta Findlay, Barry Mahon, Dale Berry, Lou Campa, William Rotsler, and others. The primary video company releasing these kinds of titles was Seattle-based Something Weird Video, so I made it my mission to get to know more about the company. I met Something Weird Video founder Mike Vraney, and the legendary godfathers of gore, David F. Friedman and Herschell Gordon Lewis, at the Chiller Theatre Convention in New Jersey in 1993, and interviewed them about sexploitation cinema. Mike was intrigued with my knowledge and enthusiasm for exploitation films and invited me to work with him. So we began a long personal and professional relationship that continues to this day.

*What is your role at Something Weird Video?*

We work as a team, along with the brilliant filmmaker and cinephile Frank Henenlotter, in putting out obscure, low-budget movies that have fallen through the cracks. I watch and review old movies. My area of expertise is sexploitation films from the 1960s. I tend to be drawn to the more gritty black-and-white ones with lots of big hair, liquid eyeliner, and lingerie. I also edit and

design our mail order catalogs and packaging. It's a full-time gig and pays our bills.

*What is your personal favorite piece of artwork created by a contemporary?*

Kirsten Easthope made me a fabulous Wonder Woman custom-painted bowling pin. It features a 1940s-era Wonder Woman surrounded by nine black cats, with her nemesis Cheetah looking down at her. It's amazing.

*Have you seen other artists' work that is reminiscent of yours?*

I would say Mitch O'Connell, Glenn Barr, and I are influenced by similar subjects. Although our styles are very different, it's apparent that we are coming from the same place: an obsession with kitsch, old-time stark naked gals, and trashy pop culture.

*What are some of your more memorable shows and why?*

Being asked to participate in the Margaret Keane and Keaneabilia Exhibition at the Laguna Art Museum was a big honor. I was showing alongside this cultural icon, as well as Mark Ryden, Dave Burke, and many of my peers. I also enjoyed curating the *Dangerous Dolls* show that toured in Scandinavia because it featured many of my favorite female artists like Isabel Samaras and Niagara.

*Has your work influenced popular culture, as well as art and/or kitsch?*

There wasn't a whole lot of cute or big-eyed stuff available in the early 1990s. I don't know what helped the Cult of Cute to catch on. Perhaps Hello Kitty, Japanese anime, and Lisa Frank infiltrated pop culture so much that it became part of the mainstream. I, along with artists like Fawn Gehweiler, Seonna Hong, and Junko Mizuno, were among the first females to make sweet girlie-girl art with an edge. Mark Ryden, the Gothic Lolita subculture, and the rediscovery of Blythe have definitely contributed to making this sort of imagery become more popular. I've noticed that contemporary toys, dolls, and products now have that retro big-eyed cuteness that we were aspiring to over a decade ago. As far as pinup art goes, it's also become commonplace. Vintage-style pinups appear in advertising and every other sort of media nowadays. But what still sets my art apart from that is the combination of super cuteness with old-time sexiness. I'm glad to have been a part of inspiring a new generation of female artists to make art that's personal and taps into expressing their femininity.

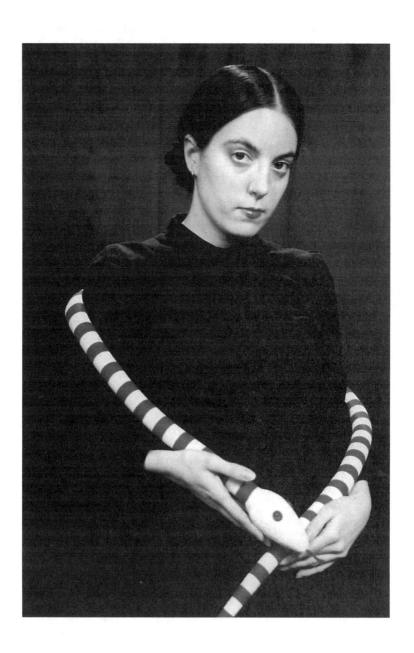

# Christiane Cegavske

Christiane Cegavske (born 1971; Tacoma, Washington) is a stop-motion filmmaker, animator, sculptor, and costume designer, who created the award-winning, full-length feature film *Blood Tea and Red String*. She is one of the few female artists to have a place among stop motion and animation film luminaries such as Bruce Bickford, Webster Colcord, Stephen and Timothy Quay, and their precursors Ladislaw Starewich, and Jan Svankmajer. She graduated in 1993 from the San Francisco Art Institute with a B.A., majoring in painting. She creates all of her work by hand on a miniscule budget. Her film, *Blood Tea and Red String*, took more than a decade to create as a completely self-produced work. Her work reveals a distinct aesthetic combining elements of Edwardian fashion and culture, fairy tales, and Gothic symbolism in black, white, and red images. The film has no dialogue with only the musical accompaniment of Mark Growden. *Blood Tea and Red String* was released on DVD in 2006. It has won awards for Best Director, Best Animation, and Best Animated Stop-Motion Film at film festivals including San Francisco Indiefest in 2006. Her films have been described as nightmarish Freudian tales about birds, dolls, and death. Her work has been described as David Lynch meets Beatrix Potter. The book, *Blood Tea Red String: Development and Storyboards*, detailing the making of the film, was released in 2006. Cegavske also creates books, paintings, drawings, illustrations, sculpture, puppets, costumes, dolls, and collectibles. She has contributed to film and television projects, most notably in the dream sequences for the Asia Argento film *The Heart is Deceitful Above All Things* (2004). Prior to *Blood Tea and Red String*, she made two film shorts, *Blood and Sunflowers* (1992) and *The Doll Maker* (2002). Her poetry, accompanied by her artwork, is available in the book *A Raven Went Out Walking* (2005). In 2010, she created animation for Mark Growden's "Coyote" music video. She is working on a series of paintings tentatively titled Little Red, which she plans to publish as an artist's book. In 2010, she released a second volume of poetry and art, *A Raven in the Looking Glass*. Christiane's art prints, dolls, and clothing can be found in her online shop, Little Miss Crow. She is also working on a sequel to *Blood Tea and Red String*, the second in a trilogy, called *Seed in the Sand*.

*Where do your ideas and inspirations come from?*

My subconscious. It leaks out when I sketch and dream. My ideas don't come directly from any outer source but I am probably influenced by the work of artists I admire and I tend to mythologize actual events from my life. All of my work, paintings, drawings, writing, and film function as a journal or diary if viewed chronologically. Everything is intricately related to everything else. New ideas build on old ones and old ones fade slowly, if at all.

*Do any of these come from dreams or nightmares?*

No. I do write [down] my dreams once in a while but those never really make it into drawings or storylines. My artistic inspiration comes from sketching, or just like a shock out of the blue. I let things come to me as I scribble. Also, I receive inspirations while in the shower or out for a walk or at other times when I let my mind wander and am not actively trying to come up with something.

*How much of your work is personal?*

All of it is personal. There is no way to separate the work from my life. Life is the inspiration.

*Where did the idea for the story line in your movie come from?*

It grew gradually, organically, from earlier ideas, sketches, and actions. It didn't just land in my head fully formed. The creatures showed up in a drawing one day and I started thinking about them a lot. The mice showed up in a sketch a few years before the creatures and resurfaced when I needed them. I just started working on the part I was most interested in and everything else fell into place in my mind and then my work table as I needed it.

*What is the significance of your female characters? Are you making a social statement about power, sex, or politics?*

The females in my work could be seen as vessels for something emerging, or as a shell protecting or releasing the truth inside. There is no intentional statement at work here. Many reviewers and other viewers have come up with answers for that question for themselves, but I am not trying to say any particular grand thing. These female forms come naturally to me. Perhaps they are symbolically autobiographical? I don't think it is my place to explain my work to everyone. It hits a spot underneath ego statements.

*Is there a pervasive underlying theme in your work?*

Transformation? Honestly, I just follow the inspiration I am following. If my work holds together thematically, I suppose it is just a reflection of my personal aesthetic taste and life journey.

*What reaction would you like your viewers to have?*

I evoke the imagery and feelings from my own experiences. My hope is for people who view my work to take time and let it strike a chord from their own experiences, rather than to impose a particular message on the viewer.

*Why did it take more than twelve years to complete* Blood Tea and Red String?

Twelve and a half years. It takes a long time to do something like this on your own without financing. I have had to work on a lot of jobs that are unrelated to anything I love, from retail and food service when I lived in San Francisco, to freelance animation jobs here in L.A. I was unwilling to compromise my vision and took time to execute it exactly as I imagined.

*Did any schooling contribute to the making of your film?*

I attended San Francisco Art Institute. My education there was more related to growth of vision rather than technical information. I learned a great deal about the mechanics of animation by doing it myself, by trial and error. I made it to an employable skill level and moved to Los Angeles where I worked on quite a few commercial projects. In this capacity, I learned a great deal that helped me to complete my film and improve my techniques for my current project.

*Will you describe the film's basic narrative?*

*Blood Tea and Red String* is a dialogue-free film that tells the tale of the struggle between the aristocratic White Mice and the rustic Creatures Who Dwell Under the Oak over the doll of their hearts' desire. The Mice commission the Oak Dwellers to create a beautiful doll for them but when she is complete the Creatures fall in love with her and refuse to give her up. Resorting to thievery, the Mice abscond with her in the middle of the night. They descend into debauchery as they become drunk on blood tea and force the lifeless doll to play their card game and dance with them as The Creatures Who Dwell Under the Oak journey through a mystical land to reclaim their love.

*Did the effort you put into this film create a sense of accomplishment more satisfying than if it hadn't taken as long to create?*

Well, certainly, it is a great feeling to complete something like this. But I see this as a link in the chain of my artistic expression and experience. All my work is satisfying to me. The act of creating it is more satisfying than the completion. It is really enjoyable to share my completed pieces, but I am always tinkering away on a new thing, which is what keeps me happy.

*During the years you worked on the film, how much time did you have to spend on it between jobs?*

If I had kept any records and could condense the actual time spent working on the film, it probably would add up to somewhere between five or six years.

*How did you keep up the dedication and perseverance despite all the setbacks and obstacles?*

I refuse to give up! My creatures wouldn't let me.

*What were some of the animation jobs you've worked on in Los Angeles?*

I have been the lead animator and sculptor working on projects for the Oxygen Network, the Disney Channel, and Fox at Space Bass Films, Inc. I was the creator of an animated project that was in development with Fox Kids. I worked as animator and sculptor on an Iron Kids bread commercial for Acme Filmworks. I created animated dream sequences for Asia Argento's *The Heart is Deceitful Above All Things*, which began its festival run at Cannes Film Festival, 2004.

*What was the process involved in making your film?*

I made all of the sets, characters, and costumes, and did all of the animation myself. I had few resources beyond my Bolex camera and my credit card to shoot my film. When all of the filming was complete, Mark Growden made the music and Salami Studios did the sound. I started in 1993 by making characters in my tiny studio apartment, and the story grew as I made them. I lived at a warehouse in 1995, where I built the sets next to the trash cans and motorcycles. I shot the first couple of rolls of film there. Then I moved and had a little garage to shoot in, then a bigger garage, and then just a tiny living room. I built some more sets outside under a tarp in my backyard during the November rains in 2001, in the evenings after my twelve-hour days at an animation job for Space

Bass Films. I got the flu from that one but when we finished that job, Corky Quakenbush let me shoot the last two minutes of my film in the studio.

*How do you acquire your props and supplies? Do you make them all yourself?*

I make everything with just a few exceptions. I purchased a miniature tea set, and I used store-bought silk flowers and leaves because it took too long to cut all of those out. I found the teapot in a thrift store and it was so perfect, I decided to use it, and I used real bones and bugs.

*How much of your work is sketched and planned out on paper before you begin?*

It is different all of the time. Some parts follow me around for a long time and show up in sketches for a while before I incorporate them into the film story line. I make a few characters and their existence further develops the story. I write out the script, make drawings, work on sets, and the story grows naturally from there. Even after I start shooting film, the script can shift and grow organically.

*What got you interested in this type of art?*

Jan Švankmajer's *Alice*, Hieronymus Bosch, Larry Jordan's animation class at the San Francisco Art Institute.

*Did you have any specific inspirations for this film?*

Jan Švankmajer's *Alice, Wind in the Willows, The Bloody Chamber, Alice in Wonderland, The Wizard of Oz*, ex-roommates, personal trauma, standing in a circle of trees staring at crows flying overhead, love letters, card games on a rainy day.

*Do people realize how much work is involved in stop-motion film and animation?*

Probably only a very few who have not actually done it themselves.

*Do you think some people are intimidated to work with this type of art?*

I don't know, probably. I suppose it would be less intimidating with an adequate budget and crew.

*Are there many women stop-motion film animators of note?*

My friend, Lara Allen, did a beautiful piece called *The Nightshade Family*. I've worked with an animator named Rebecca Stillman. Dame Darcy has done some stop-motion work with collaborators. I am not familiar with any others at this time but I sure would like to know of more.

*What inspires your work on an aesthetic level?*

Red stitching, white cloth, texture, blue sky, black feathers, reflections on water, and unexpected shadows.

*How was your film* Blood Tea and Red String *received by audiences and critics?*

I have been constantly amazed at the positive reception my film has received. I have had a lot of really wonderful reviews. Even reviewers who may be harshly critical of certain elements of my film still say wonderful things about it. I have only had one really horrible review that I have seen so far, and a few people express distaste for it in their blogs or on IMDb, but overall the response has been enthusiastic, loving, and inspired. The audiences have been widely varied. I have encountered all ages and styles of people at my screenings. The DVDs are selling well and it has played at festivals all over the world. A few people have even sent me photos of themselves in Halloween costumes inspired by my film. This sort of thing just leaves me speechless. While working on it, I figured on showing it to friends and at a festival or two. I had no idea it would get so far.

*How are the character pieces created? What kind of materials are used?*

I use wire armatures for my characters and a little Sculpey for beaks, in the past, for the ears and eyes. I use felt and hot glue, needle and thread, fur and fabric. My techniques have improved dramatically between the characters for *Blood Tea and Red String* and the new characters I'm working on for Part Two.

*Why did you decide to make* Seed in the Sand, *a sequel to the film?*

I am not so sure I decided to make more films. The ideas just descended on me and I am compelled. This second film takes place in the same world, but it is in a distant time and place from the land where *Blood Tea and Red String* took place. The creatures here are similar, but of another race. It opens where *Blood Tea and Red String* ends, in the live-action world inhabited by the masked woman.

*Is this second work easier to make, in regards to your experience and funding?*

I see it as easier in that I am more skilled, but scarier in that I have a better understanding of the enormous task ahead, and as for funding, we shall see what the future brings.

*What is the third film you wish to create?*

It will be part three of the trilogy, held in place in the stream of symbolism by the live-action world with the masked woman.

*What about your film do people really respond to, what do they most appreciate?*

There is no one thing that I can pinpoint. Some people admire the perseverance and the fact it was finished at all. Some people are captured by the symbology and some by the aesthetics. Everyone is different. What one person loves ends up being the thing another is most critical of.

*What would you like to see happen with your films once the trilogy is finished?*

I would like to see the films screened and released on DVD over and over again, all over the world.

*Do you wish to work on major films doing this type of animation or would your prefer to stay working solitary?*

To be able to do both would be my hope. I am most compelled by my own work, of course, and I like to putter away on my projects alone, but getting a fat paycheck to work on another person's vision can be a wonderful thing. Plus I really enjoy the camaraderie involved in working with other people on animation projects.

*What is the most fulfilling aspect of working in this type of art?*

The tactile experience of creating each little piece and then making it live.

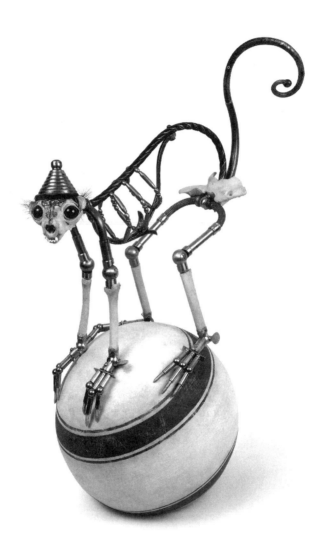

# Jessica Joslin

Jessica Joslin (born 1971; Boston, Massachusetts) is an artist who creates complex sculptured creatures, using mixed media and assemblage art based on science, mechanics, and anatomy. These creations are reconstructed animal forms, which she brings back to life in meticulous works of animal skeletons and components from her collection of antique mechanical parts. Jessica uses bone, brass, leather, taxidermy, and antique hardware to create her intricate sculptures. These sculptures she calls "beasts" consist of hundreds of parts, some of which have moving jointed legs, tails, and beaks. Her creations range from one inch to six feet tall. Her artwork is a menagerie of fantasy birds, cats, dogs, rabbits, and monkeys, many of which have personalities, presented as if entertaining the viewer in a cabinet of curiosities-style circus. Her work has been described as Baroque in its elaborate and detailed ornamental work and Victorian in its aesthetics and fine craftsmanship. Jessica's beasts all have distinct names derived from art and history, like Radian, Leopold, Egon, Avaline, Lautrec, and Figaro. With her knowledge and experience in biology, anatomy, mechanical engineering, taxidermy, machining, and model-making, she combines the natural world with that of the artificial and manufactured. She has studied at the Art Institute of Chicago, Parsons School of Design, New York; the Field Museum, Chicago; and Studio Art Centers International, Oxford, England, and Florence, Italy. Although she is an academic scholar, she calls herself "an intrigued autodidact," as she is largely self-taught in her passion for life sciences. Her collections have been shown in exhibits including *Strange Nature* (1998), *Bestiary* (2002), *Cabinet of Curiosities* (2003), *Aves and Mammalia* (2005), *Flights of Fancy* (2006), *Brass Menagerie* (2006), *Curiosa* (2008), *Clockwork Circus* (2009), *Hybrids* (2010), *Brass and Bone* (2010), and *Gilded Beasts* (2012). In 2011, she contributed a piece to the *In the Trees*, *Twin Peaks* 20th Anniversary Art Exhibition in Los Angeles and *Twin Peaks: Fire Walk With Me* at Copro Gallery in Santa Monica, California. Her art has appeared in many publications, including *Bizarre* magazine, *Juxtapoz*, *High Fructose*, *Huffington Post*, the art blog *Wurzeltod*, and *Brass Goggles*. Jessica has worked as a skilled trade professional for over twenty years, making large-scale models, prototypes, film sets, and sculptures. A monograph of her work, *Strange Nature*, was published in 2008, and depicts many of her pieces in full color plates. She currently lives in Chicago with her husband, painter Jared Joslin, and continues to create and exhibit her art internationally.

*How did your early environment and your relationship with your father influence your interests and your art?*

I grew up in Brookline, Massachusetts, just outside of Boston. Throughout the years, my father has been an artist, an artisan, a neurophysiologist, a nursery school teacher, a children's book author, an entrepreneur, and a commercial sculptor. When I was little, we were always making things, reading, and exploring. In that way, not much has changed. My father's eclectic, Renaissance-man background brought an interesting mix of art, literature, and science to everything that we did. Instead of the usual children's books, our bedtime stories were often Greek mythology or early translations of Grimm's *Fairy Tales.* When my younger sister and I asked questions like, "Why is the sky blue, Daddy?" he would answer us literally, describing light waves bouncing off gas molecules in the atmosphere. At the time, I was probably in nursery school, so I had no idea what he was talking about. Still, it made the world seem like a place of endless mysteries and possible discoveries. When I was little he would often bring my sister and I to visit the local museums. My favorites were the Natural History Museums at Harvard, particularly the Museum of Comparative Zoology. It was housed in an ornately detailed building surrounded by huge old trees. The labyrinthine halls were lined with row upon row of dark hardwood display cabinets, filled with Victorian-era taxidermy and articulated skeletons, identified with tiny brass plaques. There was a huge central atrium filled with hordes of elephant, ostrich, crocodile, and giraffe skeletons. This was surrounded by two levels of glass-fronted display cases, filled with a dizzying array of taxidermied and osteological animal specimens.

In another part of the museum, there was an extensive collection of glass models, made in Leopold and Rudolf Blaschka's Dresden studio in the late nineteenth century. These intricately detailed models were scale replicas of perishable items like fruit, flowers, and marine invertebrates. They were used as teaching aids in lieu of the traditional pickled specimens in jars. I was fascinated by the painstaking detail. Each hair on the stem of a poppy was individually rendered, along with perfect glass dew drops on the translucent petals. They seemed almost more real than real. When it was too nice to be indoors, we would go on excursions to the wildlife preserves outside the city: canoeing, hiking, and exploring. We would collect specimens of things like seedpods, wildflowers, seashells, bones, and insect casings to add to the nature collection, our cabinet of curiosities. With each new item found, we would look it up in reference books and discover tidbits about the nature and habits of the creatures that lived around us. It was an intoxicating way of exploring the world, one that made every walk through the woods seem like a treasure hunt. At the

time, I didn't have any sense that bones were considered macabre; I simply saw them as a beautiful clue to some mysterious animal that had once been there, the same as a seashell. Both are skeletons, of course, yet they obviously have very different cultural associations. Coming from a somewhat science-centric background, I was always encouraged to be curious about the inner workings of animals, as well as the exteriors. I recently found a series of drawings that I made when I was eight years old. They were careful illustrations of seedpods labeled with the species of tree. Each one was paired with a proposed project, for example, making a doll from a horse chestnut and a porcupine made from a sweet gum seed. It was titled Seed Ideas.

*What continued to fuel your interest in science as a young girl into your formative years?*

It was the aspect of discovery, of seeing that which is usually hidden. I was enraptured by the idea that the closer you look, the more there is to see. On my eighth birthday I got a microscope. From that moment on, I was utterly incorrigible. I would go out to the garden and hunt for dead insects to dissect, or store away in the tiny bottles filled with formaldehyde that came with the microscope. About that time, I decided that I wanted to be a marine biologist. Within a few years, I began to pursue my goal of studying Marine Biology with single-minded determination. I spent my summers at an oceanographic institute in Maine, instead of summer camp. It was amazing. We collected specimens, did core samples, and dredged the bottom of the Atlantic, pulling up strange and beautiful fish with seaweed-like protrusions. We went deep-sea fishing and I caught a shark. We later realized that it was pregnant and gave it an impromptu C-section. We kept the baby sharks, complete with dangling yolk sac placentas, in a tank in the lab until they could be released, then brought them back to sea.

*Do you consider yourself a metal sculptor more than an assemblage artist?*

I don't really try to categorize what I make but I suppose I'm both. Since my work incorporates so many disparate materials and techniques, mixed media is the easiest catchall. If I need to verbally sketch an image of what I make, I usually describe my work as Victorian Steampunk mechanical animals. That is not quite on point, but it's evocative enough to give someone a sense of whether they want to find out more. Generally speaking, I prefer to show rather than tell.

*What did you experience at the Field Museum in Chicago?*

When I was in college, I did an internship there. They put me to work restoring and repairing dinosaur bones. I got to sculpt a few missing vertebrae from an Apatosaurus, and make molds and casts of an Albertosaurus's feet. One of the best fringe benefits was having access to the back rooms, the storage and preparation facilities. There were thousands of drawers filled with study skins and unmounted, preserved bird skins. All were identified with handwritten labels in fine and tiny penmanship from naturalists, explorers, and collectors who lived hundreds of years ago. There was also a room filled with huge tanks of Dermestid beetles, which are used for cleaning bones. My husband, Jared, was also an intern there. One afternoon, he saw a huge pair of swans being cleaned in the tanks. I always wished that I could have seen them.

*How did you acquire metal-working skills? How much time is spent on each part of your process?*

I've learned a lot of skills through my professional work and developed certain specialist techniques over the years. I spent many years working in shops: model-making, rapid prototyping, mold-making, carpentry, sculpture, and exhibit building. In each new place, there has been a particular skill set that I've had to master. In each case I've found elements that translate back to how I make my own work. I think that building prototypes has probably been the most useful in terms of techniques. It requires a level of discipline and precision that agrees with me. If you are building a working prototype, whether of a toy or a machine, it has a specific function to accomplish within a set of rigid parameters. If the parts don't fit, it won't work. It's common to be working within .01 of an inch accuracy, the thickness of a sheet of paper. Doing that work taught me how to think in terms of engineering with regard to my sculptures. It ultimately made it possible to create sculptures in a wide range of scale that are freestanding and incorporate my favored materials and aesthetic.

There is actually no soldering or welding involved in my work. The heat would damage the beautiful patina on the antique metals, and in this case, welded seams would be far too noticeable. My pieces are assembled using mechanical connections, so parts are generally drilled, tapped, and threaded. Each angle has to be figured out in advance. If a single hole is off, one of the feet might not touch the ground, or it would be lopsided. There is a lot of engineering and finesse that goes into making them seem natural and effortless, as if they were meant to be. People often don't realize the complexity of the construction. For example, a single one of Ludwig's feet is made up of about thirty parts. As far as preparing the bones, the best way to clean them is using Dermestid beetles.

I live in Chicago, without a backyard or suitably rural area to stash corpses. As a result of this, I often work with osteological suppliers for acquiring my bone specimens. Several years ago, during a particularly hot Chicago summer, I found a partly sun-bleached deer skeleton in the woods just outside of the city. It was perfect for a project that I had planned, so I stashed it in the trunk and brought it home. For lack of a better setup, I cleaned it in the bathtub. I had to keep the windows open because of the smell; there was no air conditioning. After that experience, I promised that as long as we live in the city, I wouldn't bring home any more roadkill!

*What was your taxidermy experience before you had any schooling, and how did you begin to apply it to your art?*

When I was in college, I taught myself taxidermy from old books that I dug up in the library. I was drawn into this slightly unusual hobby because every day I would find beautiful dead birds floating in a fountain near my school. They looked like jewels and it made me sad to think that they would be thrown out with the garbage. Since I have a fondness for taxidermied specimens, it seemed a fitting tribute to those beautiful creatures. In my earliest pieces, there was a fair amount of parts like preserved bird feet and taxidermied wings integrated with metal elements. Over time, I've largely eliminated the taxidermied parts for both practical and aesthetic reasons. Once I decided that I wanted the creatures to be able to stand, I had to develop ways to construct feet. Preserved bird feet are fragile and you can't exactly balance a big metal sculpture on top of them. I still use feathers, but usually not as full wings, which are visually dense and difficult to integrate aesthetically. I also use scavenged parts, like fur from antique mink stoles and leather from opera gloves. Of course, I still make use of quite a few bones in my work. There is an amazing book about bones by R. McNeill Alexander, who examines animal anatomy from the perspective of a mechanical engineer. Partly, bones have stayed as an integral element in my work because they are both beautiful and structural.

*When did you first start creating the art you are known for today?*

The first of the beasts was *Marco*, made in 1992, while I was at the Art Institute of Chicago. There was a steady progression up until that point, though. I started off as a photographer. My first school was Parsons School of Design. While I was there, I made photos of mixed media constructions, which integrated natural and manmade elements. In part, what started me off on my current path was a package that my dad sent. It was filled with objects that we'd collected for our nature collection when I was little, an assortment of seedpods, shells, and

bones. I used those combined with objects that I'd collected on my own while wandering around the alleyways of the Lower East Side of New York. By the time I transferred to the Chicago Art Institute, the sculptures that I was making for my photos had become increasingly complex, and photographing them had started to seem secondary. Right around then, my apartment was robbed, two nights in a row. My photo equipment was all stolen. I took this as a sign and switched majors, using my insurance money to buy some basic hand tools and a drill press. That's when I got started in earnest. At the time that I made Marco, I was collecting old typewriters and adding machines and dismantling them. The precision of antique bolts is just amazing, they are so tightly machined! One day, I found a bag of Victorian millinery supplies, gorgeous black bird wings and a head and tail, mounted on delicate thread-wrapped wires. When I saw it, I knew that I had to make a body for those parts.

*Does your complex and thorough research affect the length of time it takes to create a piece?*

I suppose that nowadays, when so many contemporary artists choose to hire others to build their work for them, I'm a bit of a throwback. I've always enjoyed the technical challenges that come my way and have methodically addressed them through a sort of apprenticeship system. Throughout the years, I've pointedly chosen jobs that will hone my skills and broaden my base of knowledge. It is very important to me that my work be beautifully executed. I strive for precision and elegance in the details and a sense of integrity in craft. There is a painter's expression that I've always loved, "painting under the eaves." It refers to those craftsmen who take such pride in doing their job well, that they paint even the areas that no one else will ever see. I think of my work like that. There are details that no one but myself and the eventual collector will ever know about, but those are important to the integrity of the whole. When I make leather-covered shelves to display my work, I don't need to cover the underside with leather but it would bother me if I didn't. In my work, many of the details are hidden in plain sight. You have to look very closely to notice that some jaws are spring-loaded, so that the mouth can snap, or that the heads are often jointed, so that they can turn. From looking at a picture of a turtle, you can't tell that when you pick it up the legs and head are mobile and weighted so that it slowly shifts position in your hand as you turn it. However, you might be able to see the joints if you know what to look for. I think of these as being like an inscription on the inside of a ring, an intimate interaction with the owner.

*Where do acquire the artifacts for your work?*

I find parts in antique shops and flea markets, in specialty hardware stores, or in the woods. Over the years, I've found certain objects that I enjoy working with and seek out specifically. For example, the metal tips on antique parasols make wonderful finger or toe tips. There is a wonderful, old, dusty shoe repair supply shop in Chicago. I love to go poke around through the crumbling paper boxes of buckles, grommets, and tacks. I made a piece named Marcel, a small antelope perched atop a circus ball, who has hoofs made from shoe taps that I found there. There are also many parts that I regularly keep in stock: brass machine screws in many sizes, swivels, standoffs, universal joints, springs, nipples, balls, finials, couplings. Those come from various specialty suppliers all around the country. I deal with companies that specialize in electronic components, fly-tying supplies, upholstery supplies, woodworking materials, taxidermy equipment, parts for model trains, specialty pneumatic couplings, on and on. It's as if I've developed my own special version of the Erector Set.

*How do you fuse two extremes of material, for example, hard metal with the more delicate, brittle medium of bone?*

They need to complement each other. Bone can be supported by metal, in terms of structural reinforcement. Bones are also very different from species to species. Each has specific qualities, different strengths and weaknesses. Bird bones are hollow and light, so they tend to be fragile compared to most mammal bones. Large herbivores, like cows, have very dense, heavy bones, to support the weight of their flesh. Making an ostrich was an interesting challenge. They are very large but since they are birds, the bones are thin walled. To attach the legs to the pelvis, I didn't want to just screw into the bone that would not have been strong enough. I ended up finding two threaded, hollow brass balls that fit into the hip sockets perfectly and fashioned them into a compression fitting using a large threaded rod. That way, the pressure of the attachment was dispersed throughout both leg sockets evenly. Similar to the way it might be in a living animal.

*What type of environment do you work in?*

Jared and I share a studio, as we have for the past fifteen years or so. His easel is right behind me, which makes him a very brave man since little bits of metal are always flying over into his area. At the moment, he's working on a painting of the two of us, me in a gown and him with a falcon on his arm. There are several new oil paintings leaning around the room, including a 1920s chanteuse and a portrait of Anita Berber. He has a row of Irving Klaw photos above his desk, several of Bettie Page. His paintbrushes are in a clown-faced teapot. My corner

of the studio is lined with rows and rows of tiny drawers, labeled with things like mouse bones, fish scales, glass eyes, watch chains, pewter feet, and brass couplings. Larger objects are in wooden boxes on a shelf. Bones are sorted by type: leg bones, skulls, etc. Metal parts are sorted by shape and or type: rods, balls, musical instrument parts, drawer pulls, etc. I also have boxes of things like antique vestment trims, opera gloves, and fur collars. I love plants, so the windows are full of ivy and bromeliads in old brass and copper containers. I have a shelf filled with curiosities, things like bird skulls, porcupine quills, seashells, a goose egg, a seahorse, and a dried lizard. *Otto*, a monkey that I made for Jared for our tenth anniversary, is on another shelf nearby. Helmut is peering out of the window. My reference images are pinned to the wall, below a deer antler wall plaque. There is an anatomical illustration of a dog skeleton and a reproduction of a turn-of-the-century circus poster. There is always music in the air.

*Have you ever had help from assistants?*

No. I prefer to build them myself. When I do that, it feels like play. Assistants make it feel like work.

*How did you meet your husband at the Chicago Art Institute? Have his interests or art influenced your work?*

We like to joke that we are the one example of a stalker story with a happy ending. I didn't know until much later, but Jared was watching me for several years before he worked up the resolve to introduce himself. I, on the other hand, had the somewhat odd habit of not wearing my glasses unless I needed them, so I didn't ever notice him noticing me. The day we met, I was walking out of the foundry at school and saw a blurry form waving at me. I walked over, assuming that it was one of my friends. When I got closer and realized that it was a stranger. He introduced himself and within moments, we were talking about the dead birds floating in the fountain in front of us. There was a tall glass building above the fountain. Birds would often crash into the mirrored surface and break their necks, falling into the water. I would often wade in, collect the dead birds, and use them to practice taxidermy. We quickly realized that we both had freezers full of dead birds collected from the fountain, so I offered to give him taxidermy lessons. I gave him my phone number and, as they say, the rest is history. Having a partner in crime while navigating the crazy life of an artist has been invaluable! Since we've known each other for so long, there is a shared frame of reference, both visually and experientially. We can speak in shorthand to each other, whether it's about prior works, circus

freaks, contemporary art, exotic animal species, or Weimar Berlin. I don't think that either of us has made a piece, in all the time that we've known each other, without getting feedback from the other along the way. The circus has been an important influence for both of us through the years. We still make frequent trips to the Circus World Museum in Baraboo, Wisconsin, to look at their incredible archives of historical images and carny paraphernalia. I might find a delicious detail from a circus wagon or animal costume that I'll incorporate. It's an endless source of inspiration.

*Has anyone taken offense to your work because of your use of animal artifacts?*

Occasionally I'll get a rant, but usually it's when someone has made wild assumptions that I kill animals to make my work, for example. That couldn't be further from the truth. Generally speaking, I have received interested, supportive responses from the people who I've spoken with, including those who are involved in animal rights organizations. I have a very strong affinity for animals, and I think that comes across in my work. I take great care to ensure that any parts used in my work are both legally and ethically obtained.

*Has working with organic materials affected your relationships with living animals?*

I often think about their structure as I'm looking at them. I'll be sitting, cuddled up with a friend's dog, and I'll find myself thinking about where its bones are relative to its position, looking at the angles that the limbs form. Those angles are so critical for my work. If the pose isn't fluid, it doesn't have the feeling of being about to spring to life. Because of the type of work that I make, the animals that I meet are muses to me.

*Do you have a hard time parting with your creations? Where do their names come from?*

It's always hard to part with them but I do realize that I have to make room for the next ones. They would completely take over our home if I hoarded them! The names I collect, just like I do my other parts. When I find a beautiful name, I write it in a special book. Whenever I finish a piece I bring out the book and decide what suits it best. My mom is very interested in genealogy, so she sometimes sends me lists of names from our family tree. Some of the names are from books that I've read or from my big, old biographical dictionary.

*Do you have a favorite? Is there one "beast" that you have most enjoyed creating?*

I'm always the most besotted by the creature that is on my workbench at that moment.

*Will you give an example of how an idea for a piece comes together through inspiration?*

I made a Chihuahua riding on a tricycle several years ago after I found a marvelous circus poster image from the late 1800s. It depicted The Feline Marvels, a troupe of performing cats that traveled with the Ringling Bros. circus. One of the cats is riding a tricycle. I loved that idea but wasn't sure how it would be feasible, construction-wise, in terms of balance and strength. I found an antique metal tricycle on eBay and knew that it would be the perfect size. It was half the size of a typical tricycle. A few months ago, I traded a sculpture to the Director of Education at Skulls Unlimited, a wonderful osteological supplier. In exchange for the piece, he sent me several boxes of osteological specimens, including a Chihuahua skull. When I saw it, I brought the tricycle out and the two seemed like a good match in terms of scale, so I began.

*Are there any artists of your peers or in history that create similar works?*

There are artists who I have found along the way who feel kindred, but not similar. Frederik Ruysch was a Dutch artist and anatomist in the seventeenth century. He was a pioneer in techniques of preserving organs and tissue, and constructed elaborate dioramas using skeletons and foliage made of preserved artery and vein structures, and mountains made of gallstones. Truly a mad visionary! Most of his creations have not survived but are remembered through a series of marvelous engravings done by Cornelius Huyberts. I would also cite the forefathers of anthropomorphic taxidermy, Walter Potter and Hermann Ploucquet. They created supremely odd tableaux of taxidermied, costumed, and bewigged animals at teatime or garden parties. These have a delightfully grotesque yet charming sense of whimsy. I also feel a sense of kinship with the early inventors who created automatons like Pierre Jaquet-Droz and Jacques de Vaucanson. I think that, in a broad sense, I look at art that is very different from mine for inspiration. I'm just as likely to use a detail from a couture gown as a bondage harness. I often look at the images of Albertus Seba, Jaap Best, and Eadweard Muybridge when deciding what to make, and my old Funk and Wagnalls' wildlife encyclopedias are always at my fingertips. I have appropriated some tidbits from works by Helmut Newton. *Helmut*, 2005, was named after the late great man. The missing foot, replaced by a wheel, is a subtle nod to one of my favorite series by him of a woman wearing fetish heels

in a wheelchair. I also love photographers like Eugenio Recuenco, Erwin Olaf, and Pierre et Gilles. Images and anecdotes of Barnum's American Museum (1841-1865) have always set off many and varied sparks. Ultimately, if I felt that there was work similar to what I do, I wouldn't have been driven to create it. I make my beasts because they are what I dreamed of discovering but they didn't exist anywhere, so I had to make them myself.

## Kaia Selene

Kaia Selene (Arroyo Hondo, New Mexico) is a performance artist and Butoh dancer based in Olympia, Washington. She is among a limited group of Westerners keeping the essence and art of Butoh dance alive. She has studied with Katsura Kan, Yuko Kawamoto, Diego Piñon, Sheri Brown, Nishimura Haruko of Degenerate Art Ensemble, and Helen Thorsen of Dappin' Butoh. Kaia has performed with the group Death Posture, along with musical accompaniment by Port of the Sun, Mele Pele, Blind Physics, Xaxis Wye, and Soriah. She has performed solo and in collaboration with Butoh dancers in New Orleans, San Francisco, New York, Portland, and Seattle. Kaia also works as a costume designer, musician, painter, choreographer, assemblage artist, mask-maker, and in film. Butoh was considered scandalous when first performed in Japan in 1959. Butoh dance was meant to create a freedom of true primal expression in improvisation that tapped into the subconscious, breaking away from the constraints of choreographed traditional dance like Kabuki and Noh. Butoh combined traditional Japanese performing arts with German Expressionist Neue Tanz (new dance) of the 1920s. Tatsumi Hijikata and Kazuo Ohno, the founders of Butoh, were inspired by photographer Eikoh Hosoe and writer Yokio Mishima, progressive Japanese artists of the time. They also drew inspiration from European surrealists like Antonin Artaud and Jean Genet. Audiences and critics saw Butoh as provocative, grotesque, primal, shocking, irrational, and surreal. The dance was more than avant garde, it was revolutionary. Few Westerners have dedicated themselves so fully to the skill of Butoh as Kaia. Her performances have included *The Ebb of Lilies, into the White* (2008), *Viva! Flowers of Dissection, with Death Posture* (2007), *Denial of the Body* (2007), *Contempt for Beauty* (2002), *Our Lady of Dissociation* (2004), *Burning Silence* (2007), and *Mutation Dance* (2008). From 2002 to 2005, she contributed her dancing to the multimedia art shows of Cabaret ReVoltaire. Kaia is co-owner and creator of Nethereal Designs mask-making and costuming company. She continues performing solo or within collaborations, and is currently working on a Butoh-based aerial show entitled *Aer CaeoV*.

*What is performance art? Is it more of a personal expression or a reaction to society as a whole?*

Well, I believe performance art can be any artistic piece that isn't static and is shared with a group, but I don't believe a crowd has to see it for it to be a performance. The watchers may not even be predefined. It's subjective but I think, for most, it must be a combination of both personal expression and reaction to societal constructs. It definitely is for me. It's about trying to evolve and transform; it's a progressive, proactive endeavor. It's a very useful tool to make our selves and issues seen as, in so many ways, aspects of our existence as women remain invisible to society and in need of direct attention. All of our inner spirits are essentially invisible in this social dynamic and we need a medium for communicating the essence and experience we've no other means to share. I'm hoping to plant fruitful seeds.

*How were you introduced to Butoh? Were you performing any other dance before learning this artform?*

My first teachers were Vanessa Skantze and Alex Ruhe of Death Posture. I did have previous dance experience including doing some performances that were very close to Butoh in energy and involved very slow movement.

*What dance training did you have, and with Butoh in particular?*

I studied ballet and some modern dance when I was younger and learned folk dances with my parents. But I've always loved to dance my own way, far more than to be told. As for Butoh, I have gratefully been graced with a variety of teachers and other dancers to learn from. I've studied with Katsura Kan, Yuko Kawamoto, Diego Piñon, Vanessa Skantze and Alex Ruhe, Sheri Brown, Haruko Nishimura, Alan Sutherland, Douglas Ridings, and Helen Thorsen.

*Was it difficult to learn Butoh?*

I'll be learning for the rest of my life. But it's a wonderful thing that we all get to never stop learning it, for there are a lot of layers in this art. The emotive, the theatrical, the ephemeral, becoming forms in nature, calling out taboos, learning to leave one's ego behind and dance from a more universal space, which is the hardest and most fundamental, and then the physicality. Strengthening muscles you don't use much in other realms, working with strange balance points and inside of very unnatural postures. I have some strengths but I have a lot of growing to do physically and inside the process of removing the ego.

Sometimes it still shows up.

*Would you explain Butoh and how it differs from other dance forms?*

Butoh can be difficult to define and understand. I could say that it's dance, performance art, theater, spiritually based, and it's activism in the form of movement. It originated in Japan post-World War II, with a performance in 1959 by Tatsumi Hijikata that included a homosexual element and primal, violent energy. He was essentially banished from the dance world in Japan for his work and horrified the conservative modern dance audience. Kazuo Ohno is the other basic founder. They shared dance backgrounds but their styles are extremely different. The word "Butoh" itself translates to stamping dance/dance of darkness, which we take to mean dance of the earth, and the darkness is that which is unknown, either within our humanity or without. Hijikata's dances were often fierce and embodied many of the harsher aspects of the human condition. They included death and destruction, dark eroticism, and intense primal energy.

They called out taboos and were extremely provocative. He explored different ideals of beauty that weren't glamorous, that were rooted in nature and simple acts, which contained the full spectrum of age and status. Ohno is a much gentler and quieter dancer, whose movements are often very light and who finds ethereal inner spaces from which to move. Though also physically pushing the body to odd limits, he often seems very peaceful and is very graceful. He's over a hundred years old now and still dancing with only his hands while in bed. In years past, there's been many a splintering off in different directions so that there are now so many smatterings of Butoh, and its manifestations are calm, brutal, sweet, violent, theatrical, minimalist, slow, fast, based in story, improvised, choreographed, and more. I desire a kind of amalgam of these. It can be hard to find a common thread in actual performance. There are some physical elements that are nearly always present, such as full body white make-up and contorted postures.

What really makes Butoh what it is has more to do with the inner process of the dancers than anything else. We are taught to find an empty space, to leave our personal selves behind and try to tap into a greater experience of consciousness. Many things can then flow through us; we become a thousand forms in nature, animals, grains of sand, the wind and rain, an insect, a corpse. We emote taboos, are afflicted beings, find the calm undercurrent of life, and deal with brutal and violent states. We are danced by the essences of things. Instead of starting out with "dance like a body in a river!" we start out with becoming as empty as possible, and then the water is introduced and begins to move us. We are trying to tap into the deep and universal current that flows

through everything and everyone present on this earth. You don't have to have a dancer's body to do this work; the foundation is unconscious, improvised movement. So what you have to do is find your own dance, your real dance, to continually free yourself and really explore, go inward, find depth. You can see why this is a lifelong endeavor!

*Which dancers and performance artists have inspired you?*

Hijikata and Ohno, of course. Death Posture, Atsushi Takenouchi, Diego Piñon, Katsura Kan, Yuko Kawamoto, Yuko Kaseki, SU-EN, Yumiko Yoshioka, Sheri Brown, Alan Sutherland, Douglas Ridings, Ariel Denham.

*Do you have any environments that you prefer for performances?*

I love to perform outside, and also find strange, chaotic environments helpful in the growth process but it depends on the show. Some require real lighting and electricity for sound devices.

*What types of venues host your performances?*

All sorts of places: in galleries, theaters, warehouses, nightclubs, house gatherings, for outside festivals, and on the street.

*What type of audience attends your performances, and what kind of audience do you wish to attract?*

It's really varied. It seems to mostly depend on the venue and who's in it. I'd like to bring in as many people who've never been exposed to the dance as possible. It's a very vulnerable thing to do and watch and people need to see it, even if they hate it. Especially then, when they are really uncomfortable.

*What were your formative years like?*

I'm from a teeny town named Arroyo Hondo, New Mexico, which is near Taos. I was born to hippie-ish, very intelligent, and creatively inspired parents. Mental illness runs heavily in my family, if it really exists as such, and my childhood was both extremely supportive and traumatic. I still struggle with the corrosive lack of self-confidence that stems from severe emotional instability in those around you as you grow, but I was also greatly encouraged to create and given a lot of respect for nature, the arts, and cultural variety. My mother is a writer and she read to me a ton. My father is a wonderful photographer and woodworker.

They both also play many instruments so our house was full of music. I guess I chose painting and dancing as my main outlets. Nothing in particular inspired me to do them; it feels more like those things chose me. When I was really little, we were dirt poor and didn't really have modern luxuries like electricity, so my formative years were unique for the time. Living in the country and our lifestyle definitely contributed to a creative orientation. But I also think my imaginative internal world was and is necessary for me to exist here. It saved my life.

*In what other media do you work, aside from performance and painting?*

I'm all over the place. I write, do costuming and mask-making, sculpt, make assemblage art, jewelry, music, and do installations. I'm also currently making my first film.

*Do you see performance as a form of ritual, catharsis, or an empowerment?*

I see it as all three of those; the foundation being rooted in ritual, which encompasses the other two. The hope is that it affects the viewer by changing them in some way, if only planting a seed, and changes our selves as well, and thereby this world and culture that we cannot escape being part of. It moves me deeply, spiritually and psychically; it's a sacred journey for me. It moves me physically, even when not dancing. It changes my mind's perceptions, releases or creates new tensions in the body, and forms or destroys body memories and pathways. The empowerment aspect is tricky stuff. It's very important to remain really invested in helping others through your work in a collective growth, so it's hopefully an inclusive form of empowerment. When you perform ritualistically, that transformation is meant to last. It is an act meant to change you, the universe, and energetic structure of mass consciousness forever, breaking an innate process in someone's cyclical thought pattern, your own, and in the gut subconsciousness of the human race. For every action, there is a reaction.

*When you practice Butoh, do you experience trance possession, a state of unconscious awareness?*

When I practice straight improvisation, I'm almost always in a trance-like state. Sometimes a kind of possession also occurs. In Butoh, we can totally lose our identity. So, yes, I reach that place and a void. Catharsis and epiphanies abound during this transformation. Little and big ones both, for everyone who does this for any real amount of time.

*Have you found that American audiences can appreciate Butoh?*

I don't think a very large sphere of residents of the U.S. can appreciate the art form generally other than as spectacle, which sadly some people seem to be latching onto now. It might be practiced and understood more if people in our culture weren't so utterly afraid of and out of touch with the fact that they exist in a body, even have a body, and are part of the larger body of the world. It embraces all sides of existence. It isn't fluffy enough for most people here and it isn't normal entertainment. Sometimes even watching it seems like a kind of work, and actually is. Also, many, if not all, deep or dark emotions are shunned in our culture and kept behind closed doors, furled. I don't see it as growing much until other things within our culture change because the masses aren't ready to face the demons, respect, honesty, nakedness, patience, and transformation the dance carries within itself.

*While engaging in spontaneous improvising, have you experienced emotions that were frightening or overly difficult?*

I've found myself in some terrifying inner spaces during and after performing, yes. I've hit walls I could not pass, had reactions I didn't understand, felt overly exposed, insane, frenzied, broken down to bone. I've been given images or reached places in myself that then became physical that I could not shake. But I've never regretted what I've explored or the various forms of pain. I think everyone who does vulnerable performance must reach these places.

*Can pain correlate to a healing process by transposing from the physical to mental?*

Of course, and I think I usually don't regret the fear or pain brought to the surface, as they encompass fundamental lessons I wish to learn and are part of the gift we're trying to share. The work is definitely a kind of confrontation, both outward and inwardly, although in essence not a violent form, but maybe a little escapism, too. Escape from trying to control, which is very painful, but also from the personal physical pain I deal with from chronic muscle and joint issues. I don't feel it while I'm dancing, really. It's the only time. Without some kind of confrontation there is no growth, and my personal and universal goal is simply that. To never become unteachable. Trying to live this way hurts a lot, but it's worth it, and there's a difference between pain and suffering. Suffering is avoidable and unnecessary on the emotional plane with help and tools, but pain is a very useful part of life.

*What are some of your most memorable performances?*

Contempt for Beauty was a performance art piece I did in New Orleans around 2002. I was really sick in a lot of ways then. I was modeling for people but not creating enough myself and was sad about being a muse and not having one, even though I really appreciated the work I was vaguely contributing to. I was very close to having cervical cancer at the time, which has thankfully since been healed. I was angry at my body and the medical system. I felt betrayal all around me. I used the Leonard Cohen quote, "She holds a special contempt for the slaves of beauty, she lets them watch her die," inside a messy sculptural box. I put myself in the main pathway, was moving incredibly slowly, and people were really uncomfortable. So I guess that means it was kind of a success. The last couple of years, I haven't been doing pieces of my own. I've been immersed in learning from established dancers and doing their works. I did help with aspects of shows with Death Posture, but mostly I've been absorbing as much as possible, which is wonderful. One of the strongest performances I've done in the last couple of years was with them in June or July of 2007. We danced four states of the body, which were hatred, love, destruction, and denial. I was to embody denial, a new creature being born that does not yet know how to move, dragging itself forward trying to learn, and then coming into itself only to meet that feeling of wanting, reaching out, and denying one's self over and over. Finally even the wanting ceases and you just leave entirely. Absence. It's hard to share in words.

*Viva! The Flowers of Dissection* was another show I was part of last year that was worth sharing. It was based loosely on Shinya Tsukamoto's film, Vital, which tells the story of a medical student whose memory is damaged by a car accident. He goes back to school and into the lab, and, while dissecting his cadaver, his memories begin to return. He's dissecting his dead lover, who died in the crash, and with each layer, more of the past unfolds. Alongside there's this beautiful inner story. The film is shot in very cold light but in this inner world he is with her, and everything is warm and bright and in forests and on beaches, and she does these dances that are very rich with the vitality and exuberance of life. So we sort of danced that story; there were actual characters in it, and a dissection scene that included tame, small, surface cuts with scalpels. I hear they were enough for a few people to get up and leave. On September 11, 2006, Alex Ruhe, Vanessa Skantze, Ariel Denham, and I did a performance based around three sculptures by Michael McGrath, which were life-size and modeled off of images of Iraqis in torment. They were sculpted in clay, and then cast in salt, and put up in Occidental Square in Seattle to melt slowly in the rain. We danced for two hours during lunchtime, without music. And my first Butoh performance is memorable partially because I was so utterly unaware

of my surroundings. It was in a revolving installation that my partner at the time, B. Aubrey, and I collaborated on. We dumped 750 pounds of sand on the floor. I went so far away that I didn't know people came in and were sitting in the room all around me. My feet were so raw that it was hard to walk for days.

*Do you think Butoh helps women become self-aware and gain confidence?*

I hope I am doing something worthwhile, something that will help someone else as it helps myself. I believe that most of my work helps me heal. We need to be given a space to show how we are disgusted, tortured, and repressed by our culture's dehumanization of femininity and sexuality, as well as express joy and love towards ourselves, and hopefully in so doing, help other women do and/or feel the same things.

*In the context of Butoh advancing freedom from societal constraints, does the word "beauty" impose limitations for women?*

Beauty as it exists is an impossible goal. We waste our lives thinking we are not enough. That's a terrible situation. I've done a lot of wasting of life through insecurities and self-flagellation, so I know from experience. Beauty isn't defined by our bodies, that much I know. Unless we learn to love ourselves for all of who we are, it's an endless pathetic trap. But that's really hard. I find our cultural ideal of female beauty utterly disgusting. Although I basically have a runway model's body, I refused to do it [model] because of that. I didn't want to contribute to a crazy ideal. I didn't want my looks to be my focus. In the years when I was more active in those realms, I began to actually consider scarring my face in some way. Beauty is a sort of nasty idea to me because as a general rule it doesn't infer that it's an encompassing thing, not just about how our body parts are considered to be, but how amazing our minds and souls are, too. I also do a lot of performance semi-nude. I want to help desexualize the naked female body and I hope that doing vulnerable, uncomfortable, and sometimes grotesque work will aid in that shift. I hope so, as that idea is insidious and exists in every subculture as well as the masses. Our art about this is deemed feminist, a now dirty word, and often dismissed as reverse misogyny for being such. It's hard to create change when the door has been shut in your face but I know that we still can. Everybody should try Butoh! Everybody. It's been more liberating than I can say, to be exposed to Butoh and begin this course. I'm very grateful for this wonderful work. I wish I could give the freedom in it to everyone somehow.

*During and after the performances, do you find yourself residing in alternate realities?*

Yes. I work from a state of being lost when doing improvisation. I'm not calculated there. I just dance. I often haven't remembered what I've done in performance. I also often don't ask. Sometimes it's not important to know, just to do it and let yourself be in a pure moment, to be free of the tendency to analyze and to lash out at yourself and to try to perfect from an ego space, which just creates a sort of masturbatory work that is already being taken care of by plenty of people.

*What are some of your more recent projects?*

I've performed a few times in Portland recently and a few in Olympia, Washington. I'm working on two shows. One is entitled *The Ebb of Lilies, into the White,* which is a solo performance, a memorial for love. And *Aer CaeoV* with four other women, a ritual in reclamation of feminine energies and incorporates flesh hook suspension and trapeze (their respective other pursuits) into a Butoh-based show. In other realms, *The Adventures of P. Starlight* (a children's book), watercolor/ink paintings, and a short film entitled *Blood-slick Petals of the Wind,* in collaboration with Xaxis Wye Media.

*How does Butoh affect your life currently?*

Honestly, I'm holding onto to a new and extra fragile egg and trying to not grip too hard. I very nearly died six months ago. But Olympia does me good and I'm very inspired here. The Butoh dancers are still scattered from the loss of Doranne Crable but they're starting to peek out. I've been incredibly blessed in almost every way the past few months and wonderful shifts have occurred. Butoh is the most important thing in my life. I have no idea how to explain the depth of my gratitude. It's a chance to do something that really matters and it's the only thing I've ever done that involves other people, where we can share everything in ourselves and it's okay; in fact, it's useful. I can't think of anything more beautiful or worthwhile that I could do with my limited time in this world.

## Laurie Lipton

Laurie Lipton (New York) is an illustrator and graphic artist who has lived in numerous European countries, mainly the United Kingdom, and currently resides in Los Angeles. She creates large-scale, complex, and intricate drawings using a layered crosshatch technique. The themes of her work are often dark, containing satirical social commentary and macabre controversial subject matter. Working with charcoal, pencil, and paper, she creates works so meticulous, they appear as black-and-white photographs. Laurie Lipton graduated from Carnegie Mellon University in Pennsylvania with a fine arts degree in drawing. Though she graduated from art school, her own technique is so personalized, she considers herself to be self-taught. Her subject matter addresses family, religion, age, sexuality, society, illness, death, and politics. Her work presents a message about mortality and the naiveté of human frailty. She has won awards for her work, and was an honored artist at the annual exhibition of the Society for Art of Imagination. Laurie's work has been exhibited internationally since 1974, often at the Vorpal Gallery in San Francisco and New York. Her work has been featured in publications including *Metamorphosis: A Collection of 50 Contemporary Surreal, Fantastic and Visionary Artists* (2007) and the magazines *Inscape*, *Juxtapoz*, and *Arts and Letters: Journal of Contemporary Culture*. Some of her notable exhibits of both solo and group shows include *Remote Control* (1998), *Sleep of Reason* (2003), *Unquiet Voices* (2003), *Art of the Imagination* (2003), *Day of the Dead* (2005), *Salon Macabre* (2007), *Gone* (2007), *Transgressions* (2008) and *In the Land of Retinal Delights: The Juxtapoz School* (2008). Recent shows include the exhibits *Weapons of Mass Delusions* (2010), *Love Conquers All: Art For Equality* (2010), *Machine Punk* (2010), *La Luz de Jesus 25th Anniversary Masters Exhibition* (2011) and *Carnival of Death: Perceptions of Death in Europe & the Americas* (2011). Her art prints can be found on a special edition clothing line at All Saints Spitalfields. In 2010, the monograph, *Extraordinary Drawings of Laurie Lipton*, was released, surveying three decades of her art with more than seventy drawings.

*What were your early years like? Were you creatively inclined?*

I came from a nice, middle-class, suburban home. I drew since the age of four. When I was six, I was attacked and molested by a man who had escaped from a nearby asylum. That changed my life. I used my art to express all the fear, anger, and horror that I couldn't express in words or even allow myself to feel. They just didn't fit into the nice, proper, pruned environment I found myself in.

*Did you have any artistic educational experience or training that may have contributed to the skill of your work?*

I went to school at a time when conceptual art was all the rage and people were throwing paint at canvases or putting rocks on the floor. I wasn't interested in that kind of "ism". What fascinated me were the highly detailed and excruciatingly precise drawings and paintings from the sixteenth and seventeenth centuries, especially the Flemish School. I cut all my classes at Carnegie Mellon University and sat in the library and copied [Albrecht] Durer, [Jan] Van Eyck, [Hans] Memling, etc. until I understood form and composition. I graduated with a Bachelor of Fine Arts degree and was the first ever student to graduate with a major in drawing at that university.

*What were your other artistic influences? Which artists and media did you admire most growing up?*

My influences ranged from my tiny black-and-white TV, the Twilight Zone, old movies, to family photographs, to Sylvia Plath poems, to Carson McCullers' novels to Diane Arbus's photographs, to Aretha Franklin songs; anything and everything went into this vast threshing machine and inched me towards the kind of art I wanted to create. I didn't quite know what I wanted. I had never seen it before. I knew it was somewhere between [Francisco] Goya, [Pieter] Bruegel, [Hieronymus] Bosch, and my living room. The artists I currently admire are the new wave of the Pop Surrealists springing up all over. At least these guys are technically proficient.

*What was the appeal of the Flemish artists?*

What appealed to me was their superhuman ability to create detail. The pictures were real, yet unreal. They were totally realized worlds. They also used symbols as a kind of vocabulary, yet they were able to access something deeper, what Jung called the Collective Unconscious. I wanted to create something human, something about life and death, things that mattered to me. This seemed like

a way to do it.

*What technique is used in your art? What is the process involved?*

I wanted to paint like the Flemish Masters but no one could teach me. I was a student at one of the best art schools in the U.S., yet the only thing the teachers could tell me to do was express myself. I tried to teach myself how to paint using egg tempera from books but failed miserably. Then I was traveling around Europe as a student and could only afford pencil and paper. I developed a way of drawing that mimicked the painting strokes of egg tempera using tiny little lines to build up an area of tone. It took ages. It was insanely tedious but the effect was luminous and I was able to make every centimeter of the paper glow with detail.

*How long does it take to create a piece? What effect does this work have on your mental or physical health?*

It takes as long as it takes. If I sat down in front of a huge sheet of paper and said, "This will take me four months to do," I don't think I'd start. The drawings take me ages. That's all I know. As for its effect on my mental and physical health, drawing keeps me sane but my neck is killing me.

*What environment do you need to create? Is there a preparation or ritual to prepare for each work's inception?*

I work with headphones on in order to shut out the world. I sometimes also wear magnifying glasses, so I look like a reject alien from *Star Trek*. I usually go through a great deal of art books in order to get my juices flowing for a show, or I'll visit a lot of museums. Then I write out the drawings. I write them up, then sketch them, and then let them stew. I'm usually ten drawings ahead of myself, so they have plenty of time to cook.

*What inner dialogue do you have while doing this meticulous work? How do you stay focused?*

Music keeps me focused, also BBC Radio 7. I try to keep the work as challenging as possible in order to keep my interest. I have no inner dialogue. I'm not "there," which is why working is so addictive to me. It's a kind of drug. I'm actually in the drawing. I call it "sinking." It's like climbing into a lovely bath of soap bubbles, all relaxing and warm. I allow myself to sink down slowly and float.

*How do you choose a work's themes, which some say convey a brutal honesty, the harsh realities of society, and life's cruel ironies?*

I only draw what interests me. My drawings are me. They are bits and pieces of my thoughts and feelings. They just come to me, like breathing. I draw about what concerns me. Sometimes I feel like I was dumped on the wrong planet and have to try to interpret the odd behavior of the inhabitants. If it disturbs, perhaps it's because people are used to looking at Modern Art. You know, the vapid fields of color or splish-splashes or meaningless juxtapositions of objects. I draw what I am interested in or feel passionate about. I draw about what intersects my life and my emotions. Why waste huge amounts of time on a drawing unless it means something to me? However, I wouldn't define my work as brutal, harsh, or cruel. I think it's very amusing. Maybe I have a warped sense of humor?

*Did your environment growing up also influence your art?*

I come from a very close family and I was exposed to the arts at a very young age. My father used to take my brother and me to the museums on Sundays. My favorite was the Cloisters Museum and Gardens in New York City. There were many medieval works there, and the baby Jesuses used to frighten me because they looked deformed. However, I loved the tiny carved ivories and the paintings with the landscapes that went on forever into the distance. I used to stand in front of them for ages and try to burn them into my eyeballs.

*What was your religious upbringing? Has religion or spirituality had a great influence on your work?*

My parents were staunch atheists but I always had a sense of something. I have read a lot about religions from all over the world and even worked for a private library that had the largest collection of books on alchemy and mysticism in Europe. I did illuminated manuscripts for them. The spiritual has always held a fascination for me, though religion has always repelled me. I don't trust people or doctrines that declare they have all the answers. I respect the mystery of life and have a holy awe of the unknowable and the vastness of the cosmos.

*What motivated you to create the Day of the Dead series?*

I can only speak from my own experience. When my mother died it was very awkward for friends and family to approach my brother, father, and myself. They said very silly things like, "That's life!" and felt nervous and ashamed.

Death is never spoken about in my culture, just as sex was a forbidden topic in Victorian times. I visited Mexico and got a real shock. Everyone there treated death as if it were something natural or organic, as we say in commercials. They actually said the "D" word and celebrated it, had festivals and picnics, and made fun of it. It was wonderful to see death being embraced instead of swept under a carpet of pills, diets, liposuction, and denial.

*What do you think when your art is described as alarming, shocking, disturbing and, at times, frightening?*

I don't think this is criticism. I take it as a compliment. A lot of people don't want to think or be challenged. A lot of people sleepwalk through their lives and that's fine with me. Some people, however, "get" my work; the intelligent, sensitive people, obviously.

*What is the true intent of your work?*

If I could explain to you the true intention of my work in words, I'd be a writer.

*What kind of feedback have you had from your fans, peers, art world, and critics?*

My fans say, "Wow!" The art world and critics say, "Amazing technique, but too disturbing," and my best friends think a lot of my work is a riot.

*When did you move from themes of human experience at home, work, and church, in works including* Of What Will He Die, Love Bite, Giving Birth to Death, *and* Hunger, *to themes dealing with society as a whole and politics in works like* Delusion Dwellers, Watching, *and* Collateral Damage?

When that asshole, Bush Jr., in the White House went to war on terrorism, thereby creating a load of terrorists, and used the media to sell his insane ideas, it provoked me. I did a show called *Weapons of Mass Delusions*, which no one wanted to show because it was a bit too close to the bone at the time.

*What are some personal philosophies you live by?*

Try to take life one day at a time. It's impossible, of course, but I keep trying.

*How do the ideas inspiring each piece come to you?*

As I'm drawing, I get ideas. They just pop into my head. I think in images. I

thought this was normal, until my mother told me that people usually think in words.

*How do you decide on the size for each piece? What was your largest piece and how did the size affect the art?*

I long to do a really huge piece but I just don't have the time. The largest piece I've ever done was *Closed Circuit* of 170x130 centimeters. The image decides the size of the paper. I don't know how, it just does.

When and why did you decide to create your work as a triptych?

When a piece of paper wasn't enough. My favorite painting on earth is *The Lamb of God* by Jan van Eyck. It's in Ghent, Belgium. It's a huge triptych and you could lose yourself in its world. It is vast and luscious, like a field of ambrosia. I wish I could afford to do something that size.

*What other media do you work with?*

I only use pencil, charcoal, and paper. I'm a simple girl with simple needs.

*Will you talk about your alchemical art and what it means?*

Alchemy is the transmutation of base metals into gold and was the earliest form of chemistry. It could also be taken in a metaphorical sense; i.e., the transmutation of the human spirit from base instincts towards God. The iconography always fascinated me and seemed to be speaking of some subconscious Universal Truth. Jung thought so, too. I was delighted when I was commissioned to do the illuminated manuscripts for the private library. I had been familiar with the images since childhood. They spoke to me.

*Which are you favorite or most treasured works, and why?*

My favorite work is always the next one. I always think the one I just finished isn't good enough and the next one will be amazing. I guess it keeps me going. I do have special feelings for my *Haunted Doll's House*, however. It is a large triptych drawing and is quite impressive, if I do so say so myself.

*What kind of commissioned work have you done? What type of person usually collects your work?*

Very discerning people with good taste collect my work. Commissioned work can also be seen on my website. I've done a lot and very varied pieces. My favorite was the illuminated manuscripts. I did those in colored pencils. They were very challenging.

*What direction do you plan to go in with your work? Do you feel you've got the recognition you deserve for your art?*

I intend to be much more famous in the future. Of course I don't have the recognition that I deserve. Who does? Although my parents always told me that I was a genius, so I guess I shouldn't complain.

# Ionat Zurr

Ionat Zurr (born 1970; resides in Perth, Australia) is a progressive artist as a Wet Biology Art Practitioner, whose artistic disciplines involve life science, photography, and media studies. Since its inception, she has worked with SymbioticA, an artistic laboratory for undergraduate and postgraduate students, dedicated to the research and learning of life sciences as art. It is the first research laboratory that enables artists to engage in wet biology practices, tissue culture, tissue engineering, and biological technologies to create living art. SymbioticA was created in 2000 by professors Miranda Grounds and Stuart Bunt, along with artist Oron Catts, founders of the Tissue Culture and Art Project. The TC&A Project has a strong belief that "biologically related technologies are going to have a dramatic effect on human evolution and history in the near future, a biological revolution." Ionat Zurr had been artist and researcher in residence at the School of Anatomy and Human Biology, Western Australia, since 1996. She worked as a researcher at the Tissue Engineering and Organ Fabrication Lab, Massachusetts General Hospital and Harvard Medical School, Boston. Her research and development project uses tissue culture and tissue engineering as a medium for artistic expression. The vision of SymbioticA created an artist's studio/lab at the School of Anatomy and Human Biology, University of Western Australia, where its projects can explore links between the arts and neuroscience in a hands-on experience. Its creed is to support speculative work based on critical thought, with non-utilitarian, curiosity-based, and philosophically motivated research. Every few years, SymbioticA produces a major exhibition and conference, focusing on biological art. There are many SymbioticA symposiums like *Strange Attractors* in 2006 and *The Metaphors and Misunderstanding* symposium which addressed "issues that emerge in communication across disciplines, the intersection of the life sciences with the fine arts and the humanities." SymbioticA also conducts Biotech Art workshops internationally. Some of the art created has been *Victimless Leather*, the growing of leather-like garments with living tissue and displayed as it fully forms; the *Disembodied Cuisine*, an art project using the cells of animals to create a growing exhibit that will be displayed until it has reached full growth and then consumed as food, as a victimless meat. The *Extra Ear ¼ Scale* was a re-creation of Stelarc's ear, by growing a small-scale version using human animal cells; and the *Semi-Living Worry Dolls* is the formation of living tissue in a bioreactor, shaped like Worry Dolls, on which you can submit your worries to as part of the display. SymbioticA has had many historical exhibits and won the Golden Nica Award for Hybrid Arts in 2007. Ionat Zurr's work is featured in the documentary, *Tissue*, by Alethea Jones.

*Will you talk about the history and formation of SymbioticA? What was the inspiration?*

SymbioticA was established in 2000, stemming from the model of the Tissue Culture and Art Project. Oron Catts and I, from the Tissue Culture and Art Project, had been working as artists and researchers in residence in the School of Anatomy and Human Biology at the University of Western Australia and the Lions Eye Institute, since 1996. At the time we were working in what seems to be the more common ways of artists working with scientists, as independent artists, who through some connections acquire a temporary and conditional access to a laboratory and work there for a while in an ad hoc-ish way. After what seemed to be successful relationships between Oron, Professor Miranda Grounds, and Professor Stuart Bunt, there was the realization that there is a need for an improved model of collaboration that will be more stable, more equal, in which artistic research will be perceived as equal to any other research, scientific or otherwise, as well as enable other artists or non-biologists who are interested in life sciences and its applied technologies.

*What is the intent for the project?*

SymbioticA is a laboratory dedicated to the research, learning, and critique of life sciences. It is very unique and, as far as I know, the first in the world. It was established to enable the opportunity to explore, hands-on, the technologies and methods of modern biology. It is an artistic laboratory which is located within a science faculty. SymbioticA was established with the aim to provide a place where interdisciplinary research can take place. It provides an opportunity for researchers to explore, free of the demands and constraints associated with the current culture of scientific research, while still complying with regulations. SymbioticA also provides a new means of artistic inquiry, where artists can learn and engage with technologies and knowledge of the life sciences.

*What type of degree would one need to work with SymbioticA? Are the artists educated in both science and art?*

SymbioticA offers different programs, a residency program as well as an academic program. The idea is to foster interdisciplinary research and generate an informed yet critical view of the respective disciplines. For both programs, previous experience in science is not needed, or respectively, people from the sciences do not need a background in the arts. And people who come as residents are not necessarily artists. We have had politics professors, science fiction writers, art historians, and currently a geographer undertaking

residencies at SymbioticA. In the Master of Science Biological Arts, the student who has a scientific background needs to take some basic units in the humanities and arts, while a student in the arts will complete science units. All students also take units concerning with philosophy, ethics, etc. The second year of the master's is dedicated to the student's own project, which must include an element that involves the act of life manipulation. Not necessarily cutting edge or invasive, just observing living beings and changing elements in their environment is considered life manipulation.

We are also running a couple of units which are open to any student from any discipline; we love and encourage a variety of disciplines. We had students who were studying degrees in Anthropology, English, and Commerce, etc. Art and Life Manipulation introduces students to issues, concepts, and techniques relating to contemporary arts practices dealing with the manipulation of living forms. The students learn and critique the issues concerning the use of life manipulation for artistic and aesthetic means. Students are also learning basic techniques in biotechnology such as DNA isolation and printing, tissue culture and tissue engineering, and more. Aesthetic Crossovers of Art and Science is a practical and theoretical investigation through critical engagement of the nexus and differences of the art and sciences cultures by the use of technologies of life sciences and biotechnology as an art form. Students and residents are working closely with the health and safety, as well as human and animal ethics, committees and in many cases challenging their boundaries and premises.

*Will you describe the laboratory the artists use and what types of equipment can be utilized for the experimental creations?*

In the School of Anatomy and Human Biology there are shared laboratories and facilities. This is of great advantage for our residents, as they have to physically work alongside the other scientists. Residents are working on a wide array of interests, technologies, and the life continuum. The projects undertaken by residents range from working with viruses with Tagny Duff; tissue culture and tissue engineering (which is my specialty); plant tissue culture, slime molds microscopy with Phil Ross; and molecular biology or working with a whole organism with Verena Kaminiarz. Basically, interacting with the animal and its environment. As a result, artists are working alongside or together with scientists on projects which do not necessarily follow scientific methodology, i.e., cannot be repeatable, are performative, etc., and do not follow a utilitarian agenda, creating many interesting situations. In many respects the laboratories themselves become a place of cross-contamination and cross-fertilization, with deliberate or accidental acts of intervention, and predominantly constructive, provocations. This is not to say that the atmosphere is always collaborative and

harmonious. There are frictions and tensions, and we welcome them. As much as we encourage interdisciplinary research, we have also learnt to appreciate and maintain the disciplines' integrity. Frictions can be very fruitful and a knowledge provider, as long as they can be handled with mutual respect.

*How is the work funded if the work is considered both science and art?*

The projects undertaken are funded through art bodies, and SymbioticA itself is funded through yhe University of Western Australia, and the School of Anatomy and Human Biology provide in-kind support through our being able to use the facilities and space to research. We have a policy to avoid funding from the biotech industry and other interest groups in order to maintain our independence and critical edge. The research coming out of SymbioticA is predominantly artistic and experimental.

*Will you describe what "wet biology" is, and what is considered living art?*

When we say "wet biology," we mean that the residence in SymbioticA has to experience the act of life manipulation, as mundane as it may be. The idea is that the resident won't just talk about the act of life manipulation and its larger implications but also will experience it in the most literal sense. The reasoning is that usually there are unrealistic expectations in regard to the possibilities involved with biotechnologies. This has created utopian and dystopian views concerning its future and effect on us as individuals and as a society. By engaging hands-on with some of these technologies, one realizes its limitations, its mundanity, as it is repeated on a daily basis in the lab and hopefully one can experience the uneasiness involved in the act of life manipulation. We hope that such an experience will enable not only a better understanding of the technologies, which will lead to a better informed argument or critique, but also this will position any person who is engaged with manipulating life (and we are all implicated with the act of life manipulation either directly or less directly), in a less self-righteous position. We are practicing a level of hypocrisy in our relations with the living environment and the Other. Oron and I, in our roles as artists within the Tissue Culture and Art Project, advocate for what we refer to as "informed hypocrisy." And while some other resident artists might also recognize this position, others do not. Living Art can be seen, as far as I see it, as art which has a living component beside the spectators. This is a very encompassing definition, as it can include environmental art, performance art, and any art that involves organisms and/or part of organism which needs care to sustain them alive. It may be a bit morbid of me to say that Living Art can be seen as an art that consists of an element that can literally die.

*What is your role at SymbioticA? How are you currently involved, as compared to when you started?*

Currently, I am a core researcher in SymbioticA, as well as the academic coordinator. I have been one of the core people to form SymbioticA, which stemmed from my collaborative artistic project together with Oron Catts, who is the director of SymbioticA. I have been developing the postgraduate program in SymbioticA and am currently running the program. My area of expertise is also within tissue culturing, so with artists and researchers interested in this discourse, I teach them the technique in the labs.

*What is an example of living art created within the lab and where it is exhibited?*

My own practice is concerned with growing *Semi-Living Sculptures* made out of living cells from complex organisms. In order to show the living *Semi-Livings*, we have to use special equipment that we either construct ourselves, or use a ready-made. This equipment is like a surrogate body that provides the conditions for the fragments of bodies—cells and tissue—to stay alive and grow in the gallery. Since 2000, in some installations, we specifically designed a laboratory within the gallery where we could care for our sculptures during the exhibition period. We had to feed our sculptures and therefore devised the Feeding Ritual. At the end of every installation, we are faced with the ultimate challenge of an artist: we have to literally kill our creations. The works have to be terminated by the end of the show for both practical and conceptual reasons. For that, we devised the *Killing Ritual*. The killing is done by taking the *Semi-Living* sculptures out of their containment and letting the audience touch and be touched by the sculptures. The fungi and bacteria which exist in the air and on our hands are much more potent than the cells. As a result the cells are contaminated and die, some instantly and some over time. The *Killing Ritual* enhances the idea of the temporary nature of life and living art, and our responsibility as manipulators to the new forms of life. The *Killing Ritual* can be seen as either transforming the Semi-Livings back to a sticky mess of lifeless bits of meat, or as an essential show of compassion: euthanasia of a living being that has no one to care for it.

Artists who are using different materials and methods are Donna Franklin, who researched the techniques of ancient and new technologies through exploring the growth and staining of fungi on textiles. She has made a living fungi dress called *Fibre Reactive* in 2004, made out of the mycelium and fruiting bodies of the fungus Pycnoporus coccineus, or Orange Bracket Fungus, and is presented inside a sealed Perspex box. Although Donna provides the fungi

with nutrients prior to the exhibition, if she will not furbish the dress, every few months or so, it will die. The fungi dress, once on exhibition outside of Western Australia, could never return back home due to the quarantine rules of this state. Verena Kaminiarz is now completing her Master's project titled *May the mice bite me if it is not true*. In this piece, which is currently on display in the Animal Research Facility at the University of Western Australia, Verena is taking care of four genetically modified mice designed to be living models for human diseases. Verena designed and built special dwellings for the mice she adopted. She named them after her favorite artists and is creating their personal portraits. In many respects, Verena is doing the opposite than the scientists around her: she is personalizing these animals rather than treating them strictly as tools. Verena's audience are the researchers working in the animal facility, as well as the other mice living there. And the subjects are as much the researchers as the mice. In general, artists are either creating the situation in which they can show living art, or resorting to documentation of the process and showing relics of the work produced in the lab.

*What inspires the ideas for the artwork?*

In SymbioticA we have different researchers with different views, aims, methodologies, and personalities. In general, the majority of projects are concerned with cultural, social, and political discussions, aesthetical and ethical inquiries, or philosophical questions concerning what life is. We are not producing new technologies for science in SymbioticA, though it may happen as a secondary act, but rather using and subverting scientific methods and the technologies of mainly the life sciences to create evocative objects, situations, or performances about life.

*Would you consider the work scientific research? Have the art projects affected scientific or medical advancement and benefit?*

No, I would not consider the art as a form of scientific research, but rather a form of research. Scientific research has its own methodologies, constructs, and aims. I do not see the point in artists doing scientific research unless to study to become a scientist and follow this path. We also never ask or imply that the artists' role is to advance scientific or medical research. This is not the role of the artist. Artists have different roles and a different contract with society. This dialogue is explored in depth with an undergrad unit I run entitled *Aesthetic Crossovers of Art and Science*. Saying all that, SymbioticA will open its doors for scientists who would like to follow a curiosity-based research that they cannot accomplish in their own labs due to financial or political

pressures, which usually puts profit-driven research as the first priority. In SymbioticA, we believe that there is a growing gap between our traditional perceptions and understandings of life in relation to what we know about life through the development in science and what we can do with life with the advance in technologies. This gap is a place where artists and researchers can work, speculate, question, provoke, and suggest alternative scenarios to the dominant ones.

*Would you consider this work a form of social or scientific activism?*

Some of the work I consider as social activism. The work may concern better understanding science and better informing the public about what is happening in the laboratories at the moment. Some of the most radical acts are happening currently in science laboratories rather than in art galleries. However, this is definitely not about science communication. It is about making meaning and making sense out of the radical changes to life, the life continuum, our own bodies, and the instrumentalisation of life.

*What type of criteria would one need to be allowed access to the lab for work or as an artist?*

For the basic laboratory work, each person must go through a health and safety induction run by the health and safety officer of our school. Then every researcher, whether they are artists, scientists or other, depending on their research, must comply with the University regulations and approvals.

*How are these artworks sustained for showing if they are time sensitive due to growth and formation?*

Works which contain living elements in them, if to sustain alive, there is a need to provide the appropriate conditions. Different lives need different conditions for survival, such as water for plants, to a more complicated scenario, special designed bioreactors and laboratories.

*How many people are involved usually in each project? How much work and time is required to study and observe?*

This depends on the project. Some involve a larger team and some are done by a sole artist. We recommend a residency of minimum six months and optimum of a full year, as some of the concepts and the techniques take time to fully understand and master, let alone bend and subvert for artistic purposes. Also,

in case the project needs to receive an ethical and health and safety approval, these are procedures that take time.

*Are some of the art experiments dangerous? What was one of the most bizarre or unexpected results of a person's project?*

The danger is more in the idea and the concept rather than the technology. When certain ideas, conceptions or values about life are challenged, some people may feel threatened. When certain cultures, such as the science or art culture, are being critiqued or questioned, it may create tensions. However, these dangers are what we thrive on in SymbioticA. We like to challenge our own understandings and take the alternative, uncertain alleyways to search for new truths. Another risk artists are sharing is that their work will be appropriated or used differently to their will or aims. In relation to Biological Arts, many of the more critical pieces are then being misused by certain interested people or groups to promote and hype biotechnology.

*Will you talk about the 3-D art from growth cells?*

Since 1996, Oron Catts and myself, as part of the TC&A Project, explore the use of tissue technologies as a medium for artistic expression. TC&A utilizes living tissue engineered constructs in order to create what can be referred to as Semi-Living entities. The Semi-Livings and Partial Lives are a new class of objects and beings constructed of living and non-living materials; cells and or tissues from a complex organism grown over/into synthetic scaffolds and kept alive with an artificial support. These Semi-Living entities are both similar and different from other human artifacts, homosapiens' extended phenotype, such as constructed objects and selective-bred domestic plants and animals, both pets and husbandry. These entities consist of living biological systems that are artificially designed and need human and/or technological intervention in their construction and maintenance. They are evocative objects that raise a cultural discussion about the ethics and epistemologies of technologically manipulating living systems for human-centric purposes.

*Does the art world recognize this work as art?*

Some people in the art world recognize it as art. SymbioticA won the inaugural Golden Nica for Hybrid Art at Prix Ars Electronica last year. In the last few months there have been exhibitions that include biological works shown in Liverpool, U.K., New York, Dublin, Ireland, and later this year in the Netherlands, Norway, and New Jersey. So I suppose it is now recognized, but

even Duchamp's urinal would have some members of the public querying its status as art.

*What are some future goals regarding the scientific advances in the labs and how this will affect the art developed there?*

My own goals concerning SymbioticA are that it will stay a place where alternative ideas and thoughts about life and its future will be addressed. Projects that subvert from the profit-driven agenda should be encouraged. Projects that question and provoke utopian or dystopian visions of our future. We are approaching, through development in our technological capabilities, a very different and unknown future. The natural environment is under stress, the species barrier is collapsing, life is being ever further instrumentalized and at the same time we are not becoming a more compassionate society. These factors will encourage researchers in SymbioticA to raise their voice, experiment with making new meanings, and hopefully take an active part in shaping the future.

## Acknowledgments

Thank you to Jennifer Joseph, Michael Slavinsky, Carlo Ottovi, Clemence Merat, Gioia Donati, White Cube Gallery, Ron Warren, Ruud Janssen, Ed Schad, Valerie Sevant, SymbioticA, School of Anatomy and Human Biology at the University of Western Australia, Ray Jensen, David Balliano, Nalani Jensen, Lisa Van Der Ploeg, and Ann Ameling.

## Photo Credits

Christine Cegavske - Don Spiro

Christina Augello - Laurie Gallant

Tessa Hughes Freeland - Laure Leber

Daria Nicolodi - Roberto Rocco

Liz McGrath - BABS Photography, Barbara Service

Penny Arcade - Jasmine Hirst

Kaia Selene - JK Potter

Michelle Handelman - *This Delicate Monster* still

Jessica Joslin - *Ludwig*, 24"x10"x15", Antique hardware, brass, bone, velvet,
    glove leather, steel, glass eyes

Aleksandra Mir - Ann Weathersby

Barbara Kruger - *Untitled (We Don't Need Another Hero)* 90"x117"
    photographic silkscreen/vinyl, 1987. Courtesy of Mary Boone Gallery, NY

Marina Abramovic - portrait by Chris Rozzi

Laurie Lipton - Melissa Williams

Lisa Petrucci - Matt Cyphert Photography

Ionat Zurr/SymbioticA - A Semi-Living Worry Doll, from *The Tissue Culture
    & Art(ificial) Wombs* Installation, Ars Electronica 2000